D0227155

THE POP REVOLUTION

Alice Goldfarb Marquis

THE POP REVOLUTION

The People Who Radically Transformed the Art World

Tate Publishing

First published in the United Kingdom 2013 by order of the Tate Trustees
by Tate Publishing, a division of Tate Enterprises Ltd,
Millbank, London SW1P 4RG
www.tate.org.uk/publishing

First publsihed in the United States 2010
by MFA Publications, Museum of Fine Arts, Boston

Copyright © 2010 by Alice Goldfarb Marquis

All rights reserved. No part of this book may be reprinted or reproduced or utilised in
any form or by any electronic, mechanical or other means, now known or hereafter
invented, including photocopying and recording, or in any information storage or retrieval
system, without permission in writing from the publishers or a licence from the
Copyright Licensing Agency Ltd, www.cla.co.uk

A catalogue record for this book is available from the British Library
ISBN 978 1 84976 112 3

Cover designed by ARPA (A Research Projects Agency)
Printed by Grafos SA, Barcelona

Front cover: Roy Lichtenstein, *Girl* 1963 (detail) from the volume *1¢ Life*,
colour lithograph, Museum of Fine Arts, Boston, 1983.397
© Estate of Roy Lichtenstein

LONDON BOROUGH OF SUTTON LIBRARY SERVICE (WAL)	
30119 027 051 55 8	
Askews & Holts	May-2013
709.04071	

"It was hard to get a painting that was despicable enough so that no one would hang it – everybody was hanging everything . . . The one thing everyone hated was commercial art; apparently they didn't hate that enough either." – ROY LICHTENSTEIN. "It's a fad, it's a trend, it's a way of life. It's Pop. It's a $5,000 Roy Lichtenstein painting of an underwater kiss hanging in a businessman's living room. It's a $1 poster of Mandrake the Magician yelling, 'Hang on, Lothar! I'm coming!' taped on a college-dorm wall. It's 80 million viewers dialing 'Batman' on ABC every week." – PETER BENCHLEY. "It was basically what could be considered an unholy assault on very holy ground." – IVAN KARP. "Pop is everything art hasn't been for the last two decades. It is basically a U-turn back to representational visual communication, moving at a breakneck speed in several sharp late models. It is an abrupt return to Father after an abstract 15-year exploration of the Womb. Pop is a re-enlistment in the world . . . It is the American Dream, optimistic, generous and naive." – ROBERT INDIANA. "Hard-core Pop Art is essentially a product of America's long-finned, big-breasted, one-born-every-minute society, its advantages of being more involved with the future than with the past." – LUCY R. LIPPARD. "If you could really envision a situation where at the end of Park Avenue there would be a huge Good Humor ice-cream bar and in the middle of Times Square a huge banana, I would say . . . that society has come to an end. Because then people cannot take anything seriously . . . I think it would be one of the most bloodless means to achieve a radical change." – HERBERT MARCUSE. "Once you 'got' Pop, you could never see a sign the same way again. And once you thought Pop, you could never see America the same way again." – ANDY WARHOL. "If you want to protest against society, the first person you should kick in the pants is yourself." – ROBERT RAUSCHENBERG.

CONTENTS

INTRODUCTION

The village that was the American art world after World War II had hardly absorbed the recent passage of European émigrés when an outrageous new kind of art suddenly appeared and seemed to threaten everyone: dealers, collectors, museums, and established artists. In the mid-1950s, the first generation of Abstract Expressionists had managed, barely, to attain some level of success in Europe and the United States — partly because abstract art had become an emblem of American artistic freedom, as compared with repression behind the Iron Curtain — and by 1960 some of the artists had begun commanding comfortable, even lavish, incomes. However, the second generation of Abstract Expressionists found itself faltering, and into that void rambunctious young Pop artists, first in Britain and then in the United States, rushed to attract the attention of dealers, writers, and collectors.

This book is a social history of Pop Art, a group portrait of both the artists and the people who made some of them rich and famous in just a few years and set in motion the drastically altered way art has been marketed and appreciated — in the monetary *and* aesthetic sense — up to the present day. The artists, their dealers, fans, and patrons starred in a cultural revolution that still resonates, despite the market crash of 2008 and the challenges it posed. Unheard-of prosperity encouraged people who had never been interested in art to flock to museums, and the line between avid art collectors and speculators blurred. Critics who for decades had guided the public's taste in art were suddenly brushed aside, tagged as hopelessly elitist; their colleagues in literature, sociology, politics, and economics were likewise overturned. After reigning for almost a century, the old modernist creed, with its aesthetic theories, successive avant-gardes, judgmental critics, and arrogant upper crust, was fading. This changing of

the cultural guard reflected a profound relaxation of previously ironclad rules, not only in art and literature, but also in behavior, dress, entertainment, and personal fulfillment. Those who had endured the privations of the Depression and the horrors of the Second World War basked in new opportunities — for education, housing, the pleasures of a comfortable income, and the time to savor them. They set off the "culture boom" of the 1960s, and were indispensable to the success not only of Pop Art but of all the varied approaches to art that followed.

— AGM, *spring 2009*

THE POP REVOLUTION

Chapter 1

HERALDS OF CHANGE

1954 – 1960

For some years during the supposedly quiescent 1950s, a genie was incubating within American culture. By the time it began drifting out of its bottle and was recognized as more than a fad, no one knew how to stuff it back in. An energetic new generation had started taking over. Battered in the Depression and disciplined in a brutal world war, this group was better educated and more affluent than any generation in American history; it could afford to take chances. Its creative members were unlike the 1930s radicals, who had banded together to embrace political ideologies, whether communism, socialism, Trotskyism, or even fascism. The artistic rebels of the 1950s barged into the prevailing culture alone, leaping to the podium in bookstores, colleges, and art galleries. They were on a mission and ready to preach. But preach what, exactly?

These rebels had no plans to redeem humankind, generate eternal bliss, or crusade for right thinking. Rather, in the midst of that hardworking, house-building, family-centered decade when most Americans first tasted prosperity, they put out a cry for personal liberation. Their vision of that Nirvana included exotic religions, mind-altering drugs (legal or otherwise), perpetual movement, and sexual experimentation. In 1955 Allen Ginsberg published the lengthy poetic diatribe *Howl*, which one critic described as an "apocalyptic elegy for the American Dream." Two years later, Jack Kerouac released *On the Road*, an account of his restless, bibulous journeys on the newly built freeways across the American West, always in search of a freedom he could not name but was certain existed. Although both men had studied at Columbia University, they had little in common except resistance to the everyday trappings of middle-class America: raising a family, working a job, getting and spending. Eventually

3

they would be linked with others, like the wealthy heir to an adding-machine fortune, William Burroughs, who in 1953 had published *Junky*, a sensationally frank account of his own quest for freedom through drug addiction. Along with kindred libertarians, they would later be seen and studied as prophets of the 1960s counterculture and grouped together as the Beats.

As these writers were becoming known, or notorious, the worldwide success of the first-generation Abstract Expressionists was tempered by Jackson Pollock's fatal car wreck: in a drunken rage, the painter had hurtled into a tree near his home in Springs, Long Island, killing one passenger and gravely injuring his girlfriend, Ruth Kligman. Just seven years earlier, *Life* magazine had posited him as the greatest living American artist; now he was dead at forty-four. Pollock was not the only Abstract Expressionist to seek release in alcohol. When Pollock died, writes Elaine and Willem de Kooning's biographer, "de Kooning boasted that he drank as much as Pollock, and, with public outbursts of alcohol-induced hostility, secured his reputation as a 'nasty drunk.'" Elaine, his estranged wife, reported that "around 1950 everyone just got drunk and . . . went on a long, long bender."

Nevertheless, the critical and financial profile of these artists and other Abstract Expressionists had never been higher. In the late 1950s, most of them abandoned the adventurous New York dealer Betty Parsons, who had given Jackson Pollock his first one-man show in 1949 and invested heavily in the others when buyers were scarce. They migrated to Sidney Janis, a powerhouse art broker who had developed a wealthy private clientele by selling European modernists like Picasso and Fernand Léger at his Fifty-seventh Street gallery. Janis had begun building his own collection back in Depression-ravaged 1930 by purchasing three small Paul Klees from an exhibition at the year-old MoMA. In 1935 the same museum had exhibited Janis's trophy collection, sixteen works including Henri Rousseau's *The Dream*. When MoMA organized a posthumous retrospective for Piet Mondrian in 1945, Janis bought every work by that artist he could find, reselling them for tidy profits when he opened his gallery three years later. In 1953 Janis sold the Rousseau he had bought for $33,000 to MoMA for $125,000, a considerable sum at the time.

The market for the Abstract Expressionists flourished briskly after they

moved uptown to Janis. "The moneyed people, who would not touch an American painter . . . started then collecting Pollock and de Kooning," one astute observer recalled. "It took a year or two, but it was Sidney who started the ball rolling." This observer, quietly watching from the sidelines, was a new player in the art game named Leo Castelli. Castelli was an immigrant who had arrived in New York from Paris barely ten years earlier. After a wartime stint in U.S. Army intelligence, he had reluctantly worked in his father-in-law's knitwear business while searching for a way to exercise his passion: finding, promoting, and marketing new artists.

Castelli was uniquely prepared to follow this dream. He was born in 1907 into a cultivated, well-connected family in Trieste, a crossroad of Central European cultures and a principal port on the Adriatic for the Austro-Hungarian Empire. Castelli's father was an important executive in a leading Austrian bank, so the family moved to Vienna in 1915, after Italy entered the First World War on the Allied side. Leo and his siblings spoke Italian in Trieste, but he had had a German-speaking nanny since the age of three, preparing him for Austro-Hungarian society. When the family returned to Trieste after the war, the city had become a part of Italy. Leo changed his surname from Krausz, a name associated with the defunct Austria-Hungary and hinting at his Jewish background, to the soundly Italian Castelli, his mother's maiden name.

At the age of nineteen, Castelli was sent to university in Milan, where he desultorily pursued studies for a law degree while spending most of his time playing tennis or skiing and mountain climbing in the nearby Alps. After he graduated — but just barely — his father arranged a job for him in the insurance business, an activity he found "terribly boring." He yearned to study literature, but instead was sent to a branch of the insurance firm in Bucharest, Romania. There he met and married Ileana Schapira, the seventeen-year-old daughter of the wealthy industrialist Mihail Schapira; afterward, Castelli told an interviewer, "the whole literary project naturally evaporated."

The teenage bride later recalled that she could "hardly wait to get out" of her native land. A frivolous heiress, she was, by her own admission, "more interested in my dressmaker than anything else." Nevertheless, she was alert enough to request that her fiancé buy her a Matisse painting in lieu of a diamond engagement ring. Once married, she happily

went along with Leo on visits to peasant villages, where they bought old ceramics and eighteenth-century painted chairs. Offering even "a modest sum," Leo recalled, "seemed enormous" to them.

In 1937, with fascism entrenched in his homeland, Castelli found a job through family connections with a large Italian bank. He considered the Mussolini dictatorship at home "intolerable . . . a vulgar kind of illiterate movement," as he put it much later. "The whole atmosphere was oppressive and certainly no one who had any kind of intellectual life would want to stay there." When the bank offered Leo and Ileana the chance to relocate to Paris, they jumped at it.

In Paris, Castelli's bank job was none too taxing, leaving him plenty of time to pursue his interest in art. He learned "what Cézanne meant and what Picasso meant" by reading Roger Fry, a British art critic who had tried to explain modernism to his compatriots. He also bought a Matisse drawing and strolled in the city's elegant core, a veritable Parisian boulevardier. One day he noticed an empty storefront near the Ritz Hotel on Place Vendôme. The rent was minimal for the first year, so Castelli and a friend, the architect and decorator René Drouin, opened an art gallery there; it was financed by Leo's father-in-law, who by then had established himself in Paris as well. Almost thirty years later, Castelli recalled the setting with delight, describing it as "absolutely splendid," with "entrance stairs between two large columns . . . five rooms . . . very high ceilings with windows on one side which looked out on the garden of the Ritz, where people would take tea." Drouin started making furniture for their inaugural exhibition, and when the Surrealists learned of the new gallery from Leo's old friend the painter Leonor Fini, artists like Salvador Dalí, Max Ernst, and Pavel Tchelitchew "rushed upon us like locusts" with urgent suggestions for what to show. The gallery's opening in May 1939 was a *succès de scandale*, said Castelli, but its future was shadowed by the outbreak of the Second World War only three months later. Drouin was drafted and the Castellis left for Cannes, where Ileana's father owned a house.

After France fell to the Nazis in June 1940, the Castellis, their four-year-old daughter, Nina, and her nanny escaped to Tangier, Morocco, where they were stuck for months, finally obtaining false Moroccan passports. "There were all kinds things you could do with money," Castelli later observed. Arriving in Spain, they were glad to board a rusting carcass

of a ship with too few lifeboats and insufficient food; the boat took fifteen days to cross the Atlantic. Nina's English nanny washed and starched the little girl's clothes every day, and joined the family in relief when they landed at Ellis Island in the spring of 1941 to find long tables set up with bread, butter, and milk. Ileana's father was already in New York; he had found them an apartment in an East Side townhouse, and there the family took up residence, along with their twenty-two suitcases.

The Castellis' move was part of a mass migration of talent and wealth out of totalitarian Central Europe to the United States. These immigrants were not the poorly educated and poverty-stricken masses who had fled persecution and lack of opportunity in the nineteenth and early twentieth centuries. Like Castelli, a large number of them were educated and sophisticated. Many brought fine furniture, valuable art, and jewelry, the portable wealth that had sustained generations of previous exiles from European upheavals like the Russian Revolution, arbitrary border adjustments following the First World War, and religious persecutions. They also brought a lofty European cultural sensibility that Americans both envied and admired.

In New York, Castelli began to contact some of the Surrealist crowd that had also made the crossing — including the painters Max Ernst, Yves Tanguy, and Roberto Matta Echaurren, known as Matta — as well as the American art dealer Julien Levy, who encouraged him to "start something." But Castelli had neither the money to put into an art venture nor the experience to make it work. Instead, he enrolled as a graduate student in history at Columbia University but was soon drafted into the U.S. Army. During basic training at Fort Bragg, North Carolina, a company captain discovered his European-language background, and he was sent for intelligence training at a camp that simulated the enemy environment; as he recalled, "At times you thought you were in Japan or in Germany." He was initially slated to enter Nazi-occupied France as a spy but eventually was sent to Romania, newly liberated by the Russians. His assignment was to act as interpreter for an American general, but his humble rank, tech master sergeant, disqualified him; he was told "just to be around." Castelli savored whatever luxury he could find in a postwar Bucharest already occupied by Russian troops. On furlough, he visited Paris, where he was surprised to see that the Drouin Gallery was once

again operating. His former partner was trying to sell a stack of paintings consigned by the widow of Wassily Kandinsky, as well as Picassos, Rouaults, Dubuffets, Manessiers, and Fautriers. "But everything was going very badly," Castelli recalled. "No money, nothing. No market, zero." He agreed to try to sell some of those works in the United States.

When he returned to New York in 1946, Castelli began to look seriously at the city's art scene. He found that hardly any galleries handled new art by emerging American artists. He mingled with intellectuals and literary people and was surprised by how much less they were respected in the United States than in Europe. Castelli also had lunch with Peggy Guggenheim, who had started the gallery Art of This Century in 1942, and was disappointed by her lack of knowledge about art and of original ideas about running a gallery. Whatever influence she might have had, he said, vanished when she left for Venice in 1947.

Castelli dreamed of starting his own gallery, but his income, as he recalled, was "very, very meager"; though his father-in-law provided a rent-free apartment, the Castellis had trouble even buying groceries. Ever entrepreneurial, his father-in-law had bought a textile mill and an interest in a sweater factory, and Castelli had no choice but to work there — "a horrible experience," he recalled, "one of those things like the bank and the insurance company." While putting in token time on the sweaters, Castelli dabbled in the art market. On behalf of the New York dealer Pierre Matisse, son of the famous artist, he organized an exhibition of works by Matta, Tanguy, René Magritte, and Joseph Cornell for a Los Angeles gallery owned by the wealthy artist Bill Copley. In 1950 he assembled works by Americans for another exhibition, "Young Painters in the United States and France," at the Sidney Janis Gallery. A lengthy roundup in the *New York Times* devoted only a few ambiguous words to the show.

Meanwhile, Castelli was developing social connections by other means, as he and Ileana hosted lively art-world parties in their East Side apartment. For the moment, they were seen more as collectors than art dealers, but this impression would soon change. When Castelli contacted the Nierendorf Gallery, whose owner had recently died, its stock included a consignment of more than thirty Kandinsky canvases, plus numerous watercolors and drawings. Asked what to do about those works,

Kandinsky's widow telegraphed from Paris: "Give everything to Castelli." Hilla Rebay, director of the Museum of Non-Objective Painting (later the Guggenheim Museum), was virtually the only New Yorker interested in Kandinsky, and she bought liberally from Castelli, not only those works consigned to the Nierendorf Gallery but also others that Drouin shipped from Paris in rolls. Decades later, Castelli proudly told an interviewer that a painting he sold for $4,000 in the late 1940s fetched $250,000 in 1969. Many of the Kandinskys that Rebay accumulated for the Guggenheim would be sold by the museum in the 1990s to pay for purchases of more contemporary — and controversial — pieces.

One way or another, Castelli was dipping more than his toes into the art scene. In the winter of 1947–48, the art critic Clement Greenberg had introduced him to some of his favorite artists, including Willem de Kooning. While Castelli respected Greenberg's views, he tactfully remarked that Greenberg "was focused too much on just one possibility," the heartfelt, nonfigurative Sturm und Drang favored by the Abstract Expressionists. Castelli relied for advice more on Robert Motherwell, who had spent years in Paris and had edited an anthology of writings by Dada painters and poets that was published in 1951. Motherwell helped Castelli migrate from European Surrealists to new American painters. Still, the Castellis continued to buy both kinds of paintings: an early Mondrian for $2,000, and, for another $2,000, two Paul Klee oils. Ileana, who had more money than Leo, bought several important Pollocks. Leo was also having lunch several times a week with Sidney Janis, whom he considered "the most interesting art dealer in town." Janis found Castelli's mind "fresh and . . . not influenced by current prejudices." For a time, Castelli considered going into partnership with his elder colleague.

In addition to all this, Castelli became active in the Club, a sometimes raucous gathering of artists on East Ninth Street, across from the Abstract Expressionists' favorite watering hole, the Cedar Tavern. The exhibition Castelli helped organize for those artists in 1951 was a milestone in their success. He managed to "wheedle out money from one thing or another," such as $450 to paint the exhibition venue, a vacant former antiques shop at 60 East Ninth Street, and to print announcements designed by Franz Kline. The exhibition was well worth the investment. The Ninth Street Show, as enshrined in New York art lore, was a turning point in the

history of contemporary American art; many of the sixty-one artists shown there found success later, and those not included were deemed lesser talents. Hundreds of New Yorkers attended the festive opening, the first glimpse for many of what might follow the Abstract Expressionists. Even Alfred Barr, whose MoMA had paid little attention to those Americans, spent several hours at the show. When Castelli hustled him to the Club's after-opening celebration, they were greeted by spontaneous applause. Some of the artists were so grateful that they gave Castelli paintings — among them "a marvelous oil on paper" by de Kooning, which Castelli "very regretfully" had to sell to the collector Ben Heller for $10,000.

By 1952 the Castellis were entertaining a congenial art crowd at their rented summer place in East Hampton, including Bill and Elaine de Kooning, who spent two summers there. Willem doggedly applied paint in his makeshift studio at the end of a huge porch while others organized picnics and went to the beach. In the evenings, the Castellis and their guests shared dinner, often with the art critic Harold Rosenberg and his wife, May. "Harold held forth on his pet ideas," the de Koonings' biographer wrote. "Bill, often drunk, held everyone's wary eyes as they nervously wondered what he might do or say next." Almost every day, Jackson Pollock would appear in a dilapidated vehicle that Castelli feared would blow up. While a guest of the Castellis, de Kooning said he was unhappy with his current dealer, Charles Egan, and suggested that Leo and Ileana open an art gallery. "I think Leo will open a gallery," Ileana told him softly, "and that you won't be one of his artists." Her husband, she said, "would be more interested in what was coming up than in what had already bloomed."

During the fall and winter art season, the Castellis had been organizing informal shows in their apartment in a townhouse at 4 East Seventy-seventh Street, mixing works by well-known Europeans with contemporary Americans. Taking the plunge at last in February 1957, they opened a full-scale gallery in what had been their apartment on the top floor of the building. The bedroom of the Castellis' grown daughter, Nina, became an office, the L-shaped living room was now the gallery, and a walk-in closet served as storage space. Two rooms at the back became the Castellis' bedrooms, deemed adequate by Leo because "the life we led then was entirely bohemian." Included in the exhibition were works by Europeans

— Picabia, Delaunay, Léger, and Giacometti — and Americans, such as de Kooning, Pollock, Arshile Gorky, and David Smith. Everything about this exhibition had been carefully thought out and lavishly executed. The gallery would emphasize younger European and American artists, read the published press release. The invitation was stylish and original: a three-by-fourteen-inch column of heavy beige cardboard, imprinted with a tall, black number one, followed by the names of the participants. This was the first of a multidecade series of remarkable invitations created by leading graphic designers. Sometimes, as in this case, the announcements were tall and skinny; others unfolded into two-by-three-foot posters. The *Times* gave that first Castelli show a brief review, cryptically commenting that "the taste displayed here is mostly chaste and pure."

Deciding that the sweater business had occupied far too much of his time, Castelli, now aged fifty, began devoting himself to what would be his life's work, and from this point on things moved quickly. Three months after his show, he had already abandoned the well-known European and American names in favor of "work of extreme individuality," as the art critic Dore Ashton described the offerings of his second exhibit in the *New York Times*. Included in this second show was a large abstraction by Clement Greenberg's protégé Morris Louis, the Color Field artist's first New York showing. Also included were abstract works by another Greenberg friend, Friedel Dzubas, and by Alfred Leslie, as well as an early sculpture-assemblage by Marisol. But most curious of all was Jasper Johns's strange yet somehow mesmerizing version of an American flag.

Much later, Castelli described his dilemma in deciding which artists to show. "I didn't want to take artists from other dealers," he recalled, "especially Janis." Furthermore, he believed that, like the Impressionists, most artists had for more than a century been involved in movements. "There had rarely been isolated artists," he concluded; hence his earlier interest in the Surrealists and his expectation that this current group of related artists would continue. Castelli also determined that his original plan of alternating shows of Europeans with shows of Americans was flawed. "There was not enough original European art," he said. "I had to put together a stable. . . . I never really thought of myself as a dealer [but] as somebody who would discover important artists — not only isolated artists, but new movements."

However, Castelli did not neglect buyers of older works, some of whom had been clients even before he opened the gallery — among them the Saint Louis collector Saidie May and Ben Heller, who then owned Pollock's *Blue Poles*. For his holiday show, the last of 1957, Castelli invited twenty New York art lovers to choose a single favorite work in their collection for an exhibit. This approach was so successful that he repeated it the following year. These shows brought in a wide-ranging survey of recent art and attracted many other curious, perhaps envious, collectors, not to mention a growing crowd of would-be connoisseurs. Years later Castelli admitted that the Collectors' Annual was "pure sheer propaganda. A social sort of Madison Avenue promotion." Whatever the motive, visitors were treated to an intriguing corner of European bohemia on the Upper East Side. "One rose four floors in a temperamental elevator, to be greeted by the furious barking of a longhaired dachshund," the biographer Meryle Secrest recalled. Then the visitor was "quite likely to be drawn into an animated conversation, centered around a comfortable sofa."

Another Castelli innovation was replacing the usual two-hour exhibition opening with an all-day event on Saturday. The art historian Robert Rosenblum eagerly trekked to New York from Princeton, New Jersey, to participate in the "European-style salon" whenever an exhibition opened at the Seventy-seventh Street gallery. Castelli himself had mixed feelings about his gallery becoming "a sort of club . . . people just wouldn't go away," he said. "They would sit there for hours." First, he tried moving the sofa downstairs, but then the salon crowd simply sat and chatted there. Eventually, he installed hard benches, but by then the gallery had become a New York fixture, and visitors still lingered for hours.

One of the attractions was Castelli's elegant European demeanor. He was shorter than average and slender, but he cultivated a reputation as a demon skier and fearless mountain climber. He spoke fluent Italian, German, Romanian, and French, and the melodic traces of those inflections evoked old Europe's elegance when he spoke, softly, in English. Impeccably dressed, he would greet visitors with a suave handshake, often reviving vanished Habsburg courtliness by kissing the hands of the ladies. Amy Newman, later an arts editor, described Castelli as having "a certain stature — courtly, very European, and classy. He had an aura." Robert Rosenblum fondly recalled "a capsule of Europe on East Seventy-seventh

Street . . . a link to the great dealers in Paris" before the First World War. When interviewed, Castelli enhanced that impression; he exhaled connoisseurship while describing himself as "a miserable salesman. I can only sell things that I'm really enthusiastic about," and he claimed to be "paralyzed" by anyone saying "they trust my judgment." But the profound impact of his first one-man exhibition for the twenty-eight-year-old Jasper Johns belies such modesty.

The exhibition, which opened in January 1958, "hit the art world like a meteor," wrote the critic Calvin Tomkins. The impact was heightened when a blizzard delayed shipment of the cover plates for *Art News* and the magazine's editor, Thomas B. Hess, sped to the Castelli Gallery, borrowed Johns's painting *Target with Four Faces*, and rushed by cab to the engraver so that it could appear in color on the magazine's cover. MoMA's Alfred Barr lingered for more than three hours at the opening and summoned the museum's American art expert, Dorothy Miller, to see it. Barr wanted to buy the entire show. He got angry when Castelli told him he could have "one or two, maybe even three," but no more. Barr threatened not to buy anything, though eventually, recalled Castelli, "between the museum and the staff and the prestige, they bought practically the whole show." In fact, a number of other collectors, including the architect Philip Johnson and the designer Emily Hall Tremaine, hurried to buy as well, and their purchases also eventually reached MoMA. Only two paintings remained unsold when the show closed; Castelli bought one, the most expensive in the exhibition, *Target with Plaster Casts*, priced at $1,200. Barr had wanted to buy this work, too, but feared the museum's trustees might not appreciate the painted molds of human body parts in lidded boxes that lined the top of the canvas — particularly one depicting a green human penis. Barr asked whether the lid on that particular box could be left closed, but Johns refused. More than thirty-five years later, the Hollywood producer and megacollector David Geffen bought this signature Johns work at many multiples of the original price. "It was a shame to sell it, of course," the self-styled miserable salesman told an interviewer, but at that time he "had an expensive business to run, a lot of starving artists to feed."

Castelli had hosted Johns's one-man exhibition after being "thunderstruck" in April 1957 by the young painter's *Green Target*, a work he had

discovered at a Jewish Museum group show organized by the respected Columbia University art historian Meyer Schapiro. Castelli recalled "the sensation you feel when you see a beautiful girl for the first time and after five minutes you want to marry her." Leo went home to tell Ileana, who was in bed with the flu, at great length about the green painting. Almost thirty years later, he described to a *New York Times* interviewer how he "was bowled over. . . . And then you get feedback from a mysterious consensus out there that you are right." By a now-legendary coincidence, Castelli had met Johns mere days after his *Green Target* epiphany. As it happened, Leo and Ileana had an appointment to visit the studio of Robert Rauschenberg, whom Castelli had been watching since seeing one of his paintings in the Ninth Street Show back in 1951. After they had climbed the three dingy flights up to Rauschenberg's studio on Coenties Slip, the artist, an attentive host, excused himself to get some ice from Johns's studio, located directly below his. "I must meet him!" said Castelli, and all three descended to a studio crammed with Johns's work. "I saw evidence of the most incredible genius," Castelli recalled, "entirely fresh and new and not related to anything else." To an interviewer, he said he'd witnessed "about a million dollars' worth of paintings." He immediately offered Johns a one-man exhibition, and Ileana bought a work called *Figure I*.

Johns's paintings were a radical departure from the prevailing drip-and-fling Abstract Expressionist style. They were meticulously executed in a medium dating from ancient Egypt, a blend of pigments and wax called encaustic, and they were not abstract, but rather commented mysteriously upon everyday images — targets, flags, maps, numbers. Peeping through the rhythmic brushwork was a further reminder of banal life: torn newsprint. The artist himself maintained an enigmatic silence, which counterbalanced the exuberant response to Castelli's exhibition. Calvin Tomkins described the "implacable logic" of Johns's paintings as "disturbing," conveying "a sense of cold denial that is in stark contrast to the sensuous, virtuoso brushwork." Johns himself seldom spoke about his rationale. In a 1965 BBC interview, seven years after his breakout show, he told the British art critic David Sylvester that "the painting of a flag is always about a flag, but it is no more about a flag than it is about a brushstroke or about a color or about the physicality of the paint."

Johns's extreme reticence may well have been the residue of a difficult

childhood and youth. Born in 1930 in Augusta, Georgia, he was shipped off soon after to relatives when his parents divorced. For a while he lived with an aunt, an uncle, and grandparents in Allendale, South Carolina, then was sent back to his mother, who had remarried. Finally, he went to live with an aunt in a tiny rural settlement called simply the Corner. There he attended the one-room school where his aunt taught all grades. He attended the University of South Carolina for eighteen months before heading to New York to study at a commercial art school. Told that he was not good enough to receive a scholarship, Johns worked as a messenger and shipping clerk before being drafted into the army. In 1954 he returned to New York and enrolled at City College, where he lasted barely six months.

He was working at a popular bookstore in 1955 when he painted his first flag. It took another decade before Johns threw some highly diffused light on his motivation. He attributed the inspiration for that initial flag to a dream and explained his oeuvre in a much-quoted sentence: "Take an object, do something to it, do something else to it." In that diffident remark, Johns summarized the essence of an aesthetic experience, the key to his overnight success at age twenty-eight and to Leo Castelli's stunned fascination the first time he saw *Green Target*. The ambiguity illustrates the disjunction between words and art: words cannot explain the impact of a work of art; the image affects the viewer in a visceral, not intellectual, way. To put it crudely, art speaks to the gut, not the brain, a fact that troubles many art critics who are still ruminating on the meaning of Johns's flags. In 2005 the *New Yorker*'s Peter Schjeldahl engaged precisely with this aspect when he noted that Johns's painting

> didn't just represent but, when you thought about it, *was* the American flag — a sign the same as what it signified. By taking an object from the realm of common fact — as he did . . . with paintings of targets, numbers, maps, and more flags — and then returning it to that realm transfigured, he rescued art from the endgames of modern art. Including lately played-out Abstract Expressionism.

Ultimately, the source of the flag paintings' enduring appeal may be found not in the intention of the artist but in the experience the viewer

brings to those images. While lovingly painted, Johns's patriotic symbols exude a faint mockery; they do not fully endorse the stars and stripes that "so proudly we hailed." Rather, they call attention to the bogus patriotism that so often surrounds Old Glory. Johns's repetitive depictions of flags undermine the real flag's symbolism, its summary of the nation's history of growth from thirteen stars to fifty. The artist's lavish details, the meticulous brushstrokes, and the thick encaustic medium seem overwrought for depicting a rectangular fabric available in any hardware store. Johns may have been motivated by fleeting memories of patriotic events in South Carolina, a flag flying over his school, or, of course, "The Star-Spangled Banner." But a more likely explanation is his own traumatic experience as an army draftee in 1953.

At the time, the United States was painfully extricating itself from three years of war in Korea, having suffered brutal losses without achieving unconditional victory. Among Koreans, there had been unspeakable suffering, starvation, and homelessness, resulting in some three million casualties. Despite a veneer of United Nations support, the war was fought principally by Americans, who brought home 142,000 casualties, including 53,000 dead. It was the first war that did not attract virtually unanimous support from the American people. It would be surprising if the flag waving that Johns had witnessed during his military experience had not left an imprint. And even more surprising if the viewers did not, however subconsciously, associate Johns's flags with the recent, less-than-popular war.

Buoyed by the Johns show's success, Castelli exhibited Rauschenberg two months later. This artist was much better known in New York, having shown his work since at least 1951, but what Castelli put on view startled even seasoned collectors and alienated the MoMA contingent. These were hefty canvases that not only dripped paint Abstract Expressionistically but sported news headlines, photos, magazine clippings, and the occasional fragment of street debris. What came to be known as combines had been shown for years — even Picasso had dabbled in recruiting everyday objects for artistic expression — but Rauschenberg brought a startling freshness to the technique. His use of homely objects was a splash of ice water on the ruling style's fraught abstractions: in his work, the ordinary suddenly mattered. Not many visitors to Castelli's Rauschenberg exhibition agreed, and only two pieces sold. One was a curiously troubling collage (*Bed*) featur-

ing the artist's rumpled bedding, a quilt and pillow splattered with paint, priced at $1,200, which Castelli bought for himself. The other was *Collage with Red*, purchased by a collector from Baltimore, who had second thoughts; Castelli refunded her twice what she had paid and eventually sold it for considerably more to an eager Italian collector, Count Giuseppe Panza di Biumo. More ominous than the meager sales was a scrawled "Fuck you" on Rauschenberg's signature work, *Rebus*, an eleven-foot-long, eight-foot-high combine executed on $2 drop cloths. In the guest book someone had written, "This is a very good show, but nothing like Jasper Johns."

Rauschenberg's background was similar to Johns's in its restless movement. He was born in 1925 in a remote backwater of the United States: the rough Texas waterfront town of Port Arthur, which was huddled beneath a perpetual, eye-stinging miasma emanating from a massive oil refinery, the town's principal employer. Rauschenberg's father worked for a local utility and relished hunting and fishing. Much like Johns's relatives, Rauschenberg's family was puzzled by the boy's penchant for drawing, collecting a live menagerie, and other solitary pursuits. His father was the son of a German doctor but had never gotten beyond the third grade, and his mother was a full-blooded Cherokee, he told Calvin Tomkins; both were active in the Church of Christ, a strict fundamentalist sect. At age thirteen, Rauschenberg wanted to be a preacher, and although he gave all that up later in New York, the images he created often evoked the sacrifice of Christ in their blood-red drippings, a stuffed goat representing, perhaps, the Paschal lamb, or numerous images of the martyred president John F. Kennedy. As he later told an interviewer, "The South never leaves you."

At the age of seventeen, Rauschenberg left Port Arthur behind for the U.S. Navy, where he was popular for the first time, as the other recruits appreciated his pencil portraits. Having told the chief petty officer at boot camp that he "was not going to shoot anybody," he was sent to a naval hospital in San Diego for training as a medical aide. Afterward, he worked at the nearby Camp Pendleton Marine Base, assisting mentally disturbed patients. On a short leave, Rauschenberg visited the Huntington Library and Art Gallery in San Marino, less than one hundred miles to the north, where he saw portraits by three English eighteenth-century painters: Thomas Lawrence's *Pinkie,* Thomas Gains-

borough's *Blue Boy*, and Joshua Reynolds's *Mrs. Siddons as the Tragic Muse*. Reproductions of *Pinkie* and *Blue Boy* on a deck of playing cards had been his only previous exposure to art; seeing the original works persuaded him that "there was such a thing as being an artist."

Rauschenberg acted quickly on that insight, but he had a harder time locating the training to make it happen. As soon as he was demobilized, he enrolled under the GI Bill at the Kansas Art Institute, but left for Paris once he had saved enough money from three outside jobs. He lasted only two weeks at the Académie Julian, a historic institution that in its better days had trained such French modernists as Henri Matisse, André Derain, Albert Gleizes, and Fernand Léger. Rauschenberg then roamed around Paris with Sue Weil, a young New York art student he had met at his Montmartre pension. She was planning to attend Black Mountain College in the hills of western North Carolina, and Rauschenberg tagged along. The college had provided a haven for many of the Bauhaus artists who had fled the Nazis during the 1930s, including the painter and color theorist Josef Albers. The school's vanguard ideals had also nurtured the dancer Merce Cunningham, the designer and futurist Buckminster Fuller, the composer John Cage, and artists such as the de Koonings and Franz Kline. Upon arriving in 1948, Rauschenberg became Albers's most obstreperous student, refusing to take the older artist's critiques, though he later called Albers his most important teacher. When Albers left Black Mountain to head the art department at Yale University, Rauschenberg left as well. He moved to New York, where he studied at the Art Students League and, in the summer of 1950, married Weil. Their son, Christopher, was born the following year.

After Robert and Sue divorced that winter, Rauschenberg went to Italy with his friend and fellow artist Cy Twombly. "Ran out of money in Rome," he wrote in a capsule biography. "Took chance getting job in Casablanca at Atlas Construction Co. Traveled Fr. & Sp. Morocco. Returned to Rome." In Casablanca he had begun selling boxes made with found objects; in Florence he had an exhibition of similar objects, which earned him a scathing review from a local newspaper. The works should be thrown into the Arno River, the critic wrote; a few days later, Rauschenberg did just that, saving only a few examples to take home. He arrived in New York in 1953 with two wicker trunks and $5.

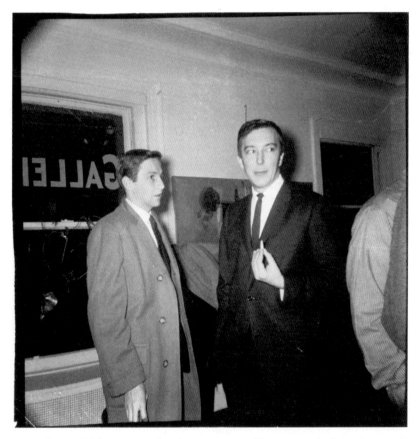

By the midfifties, Rauschenberg was working as a window dresser for the upscale Fifth Avenue department store Bonwit Teller and the nearby jeweler Tiffany & Co., earning $500 for each window he created. He sometimes drifted to a studio on Fifty-seventh Street and Seventh Avenue, where Sari Dienes, an artist who made nocturnal rubbings of manhole covers, hosted informal gatherings. Jasper Johns, who at the time was working at the nearby Marlboro bookstore, would also occasionally drop by for a drink after work. When the two artists met, Rauschenberg was instantly charmed by Johns's looks: "soft, beautiful, lean, and poetic," he recalled. "He looked almost ill." Johns was then living in a loft on Coenties Slip, and when another studio space opened up there, Rauschenberg moved in. Both artists had been disillusioned with hetero-sexual relationships and now developed a passionate romance, affirming

Rauschenberg and Johns at a gallery opening, 1958

their homosexuality at a time when such desires remained generally hidden and, in many states, unlawful. Rauschenberg asked Johns to join him in seeking better-paying commercial jobs. The two artists also went to view the Arensberg collection of Marcel Duchamp's art, newly installed at the Philadelphia Museum of Art. Rauschenberg playfully snatched a white marble "sugar cube" from Duchamp's proto-Dada construction *Why Not Sneeze Rose Sélavy?* He was caught by a guard and lamely explained that he was just checking to see whether the cubes inside the small birdcage were really marble. "Don't you know," grumbled the guard, "that you're not supposed to touch that crap?"

The Castellis were enchanted by the talents of Johns and Rauschenberg, as well as by the contrasts between them. Leo recalled that the two men's personalities "couldn't be more opposite." Ileana described them as "yin and yang. Jasper was so fascinating — so reticent, so ironic," she told an interviewer many years later. Leo had known Johns for decades by the time he concluded that this reserved and thoughtful artist "could, if he had to, become a philosopher." Not Rauschenberg, whose ideas he considered "bright and cogent," although "a bit helter-skelter." Castelli's purchases from both artists' exhibitions were paid in the form of stipends, monthly sums that he routinely disbursed to keep them working until they found success, and of course to discourage them from defecting to some other gallery. The two exhibitions in 1958 not only cemented the Castellis' professional relationship with two rising artists, but also inaugurated a genuine friendship that would last more than forty years, until the end of the two dealers' long lives. "We saw each other all the time," Castelli recalled with delight many years after Johns and Rauschenberg had left New York for warmer climes.

Although sales had been mixed, Johns's and Rauschenberg's homage to the everyday offered other artists a thrilling escape from Abstract Expressionist angst. Their run-down, unheated Coenties Slip digs also attracted many other artists. The frugal lodgings were obviously old, and yet few residents realized that many buildings on the site went back more than three centuries. In 1641 the Dutch governor of New York, to house his guests, built the City Tavern near the end of an inlet from the East River named Coenties Slip; two years later the building became New York's first city hall. Nearby, the first printing press in New York was

established by William Bradford in 1693. In 1835 a fire raged through the neighborhood for nineteen hours, destroying 650 buildings at a loss of $20 million; another fire ten years later destroyed 345 buildings. In the 1880s the waterway became the city's first landfill, and landmark offices and warehouses lined the street. By the late 1950s, the area still had a few ships' chandlers, but mainly it housed artists long on talent and short of cash, forming a putative Left Bank on the right bank of the East River.

Fred Mitchell pioneered the location in 1954, moving from nearby 26 Water Street to 31 Coenties Slip; a Mississippi native, he had studied at the Carnegie Institute of Technology before spending three years as a student at the Accademia di Belle Arti in Rome. Robert Indiana arrived at number 25 in 1956. Ellsworth Kelly settled in 3–5 Coenties Slip that same year after spending seven years in Paris. Among the many other Coenties Slip artists were James Rosenquist, Agnes Martin, and Jack Youngerman, who also moved there from Paris, along with his wife, the actress Delphine Seyrig. While architectural historians rhapsodized about the antique buildings' carved stone embellishments, the artists living in these places faced a struggle, as Johns and Rauschenberg had discovered. There was no heat, no hot water, and no cooking space, though these needs were conveniently filled by the cafeteria and showers at the nearby Seamen's Church Institute. Despite these hardships, the artists formed a collegial, sometimes boisterous, society, celebrating each other's successes, bemoaning disappointments, and dispensing criticism and advice — this according to one participant, Charles Hinman, who had arrived in 1959 to share a $50-a-month studio with Rosenquist. The street was busy on weekdays, Hinman recalled, but on weekends "the area was deserted; we had it to ourselves." In fine weather, the artists would gather on the roof for a glass or two, imbibing not only a beverage but the nearby spectacular Wall Street skyline.

Some artists might have been attracted to New York by the success of the Abstract Expressionists and the flourishing scene that ensued, but there were other reasons for the explosion of the city's artistic population. Most striking were the opportunities opened by the unprecedented wave of prosperity the United States experienced in the postwar years. As the lingering Depression was ended through war and recovery between 1941

and 1951, the disposable income of all Americans more than doubled from almost $93 billion to more than $226 billion; by 1961 incomes had surged again by more than 50 percent, to exceed $364 billion. The average annual income for the top 5 percent of Americans, those likely to become interested in art, doubled between 1941 and 1951, from $10,617 to more than $20,000, and by 1961 it had risen again to over $27,000. Better education underpinned a good deal of this momentum: between 1940 and 1950, the number of new college degrees almost tripled, from 186,000 to 496,000.

Such abundance was chiefly the result of government measures passed as the Second World War was ending; these were in response to widely expressed fears that a Depression-like economic slump would accompany the return of some sixteen million men and women to the labor market. The clumsily titled Servicemen's Economic Readjustment Act, quickly renamed the GI Bill, provided every veteran with tuition and monthly stipends for college or vocational education. It also helped to fund the purchase of a first house for the parents of what would be the baby boomers. For millions of young people, higher education opened the door to a middle-, if not upper-, class life. The subsidies diversified the American economic elite, adding recent immigrant minorities to the ranks of professionals and executives, which were long dominated by Anglo-Saxon surnames. The chance to buy a house gave masses of young people a stake in their neighborhood and a voice in its institutions. While considerable vitriol has been dumped on ticky-tacky suburban tract houses, most scholars of that phenomenon find these neighborhoods a hotbed of economic, political, educational, and cultural strivings. From those basic three-bedroom, two-bath homes, parents insisted on excellent neighborhood schools, art and music classes, and a rich diet of field trips (precisely those benefits threatened by the economic crisis of the early twenty-first century). For themselves, these people hungered for culture, including the kind one could hang on the wall.

Charge accounts, another upper-class privilege, were extended to the middle class in 1951, when William Boyle, a banker at Franklin National Bank in the exploding Long Island suburbs, invented the credit card. Owning a house also enabled millions of newly middle-class families to invest in the stock market via mutual funds; between 1940 and 1950, such

investments increased fivefold, from $500 million to $2.5 billion, and five-fold again by 1960. Clearly, it was a time when the United States, in the words of the chronicler Brink Lindsey, "crossed a great historical threshold." Lindsey finds a profound irony in the fact that Americans had left behind the "realm of necessity," as Karl Marx described brute nineteenth-century capitalism, and reached what Marx had expected from a Communist revolution, "the realm of freedom."

Such significant leaps in prosperity and education were vividly reflected in the New York art world; even as the Second World War raged, between 1939 and 1946 the number of art galleries in the city quadrupled to 150, often bolstered by the expertise, and sometimes the capital and property, of the European refugees. In just a single season, 1944–45, the value of art sales tripled. However, the prices for art by well-known European artists still hovered far above sales for American art; in an exhibition of graphics at the Martha Jackson Gallery in May 1957, a Picasso ink drawing of his companion Dora Maar went for $4,250, while a de Kooning pastel cost just $650; three drawings by Hans Hofmann cost $675, and a Franz Kline collage and ink could be bought for $90. It was just such a disparity in prices that had persuaded Leo Castelli to include Europeans and Americans in his opening show, a policy he changed only a year later. Whether by luck or by design, his new gallery was at the crest of a cultural tsunami never before seen in New York.

In the *Art News Annual* for 1956, Thomas B. Hess had written a lengthy assessment of twenty-one new artists. All but three believed that "New York is the only place to be." Hess's scholarly analysis stretched over thirty-eight pages, an eyebrow-raising length even by the wordy standards of that time. A contemporary reader might also be taken aback by the fact that the artists Hess interviewed cited the influence of European painters from Cimabue to Courbet, as well the later modernists. But while they acknowledged "descent from European painting," he wrote, "they consider Europe a museum and no longer a River Styx in which the young artist must be immersed to gain any chance at immortality." Hess was struck by how radically these views differed from the prewar atmosphere, "when New York was a province of Paris."

London, too, was coming out of its thrall to Paris. In 1952 a group of young artists, including Richard Hamilton and Eduardo Paolozzi, began

meeting intermittently at the Institute of Contemporary Arts (ICA). Encouraged by the curator Lawrence Alloway, the institute's deputy director, and several architects and art critics, the group's discussions of a new aesthetic reflected the consumer culture emerging from the rubble of World War II. They were part of the cultural reassessment that accompanied years of postwar privation, the loss of empire, and the crumbling of a rigid class system that had long dominated British life. The reforms of the Labor Party, which took power immediately after the war, had opened doors to education for many a working-class youngster and, for the first time, promised comfortable, healthy lives for all. But continuing shortages and rationing plagued the British public. Furthermore, the nation's humiliating invasion by American culture had not ended when the GIs went home. Rather, the brash, noisy behavior of those overseas "cousins" had now translated into annoying consumerist messages in the British media, especially in its advertising.

The ICA group held wide-ranging discussions about the role of art in this new milieu. Echoing the government's concerns with improving everyday life, the talks assessed the impact on British culture of movies, fashion, science, and mass media. Others participating in the as-yet-unfocused grumblings were the architects Alison and Peter Smithson and the writer Reyner Banham. As one observer noted, "They looked out at the drear of Fifties London and shuddered." Encouraged by Alloway, the Smithsons and Paolozzi organized an ICA exhibition in 1953 called "Parallels of Life and Art."

The exhibition was a tentative step toward rocking contemporary British visual art off the lofty pedestal erected by such critics as Herbert Read, the poet and academic whose interwar writings were produced for upper-class readers and, emanating from an expert on Surrealism, were tightly focused on France. "The definition of what is fine and desirable for the ruling class, and . . . ultimately . . . desired by all society," wrote the Smithsons in 1956, "has now been taken over by the ad-man." They pointed out that a single page of advertising often required more effort than painting a portrait; the advertisement, while ephemeral, contributes more to "our visual climate," they argued, than any of the traditional fine arts.

A second show, "This Is Tomorrow," held at the Whitechapel Art Gallery in 1956, further developed the message by exploring themes from

such popular genres as science fiction. The novelist J. G. Ballard later called the exhibit "the most important event in the visual arts in Britain until the opening of Tate Modern" and said it was "the first time the visitor . . . saw the response of imaginations tuned to the visual culture of the street, to advertising, road signs, films and popular magazines, to the design of packaging and consumer goods, an entire universe that we moved through in our everyday lives but which rarely appeared in the approved fine art of the day."

The varied members of the independent ICA group espoused changing and wildly differing views as they attempted to formulate a coherent philosophy that might result in what European modernists like the Futurists and Surrealists had issued — a manifesto or other codified statement of purpose. Some, like the Smithsons, expressed qualified respect for "the ad-man," and others, like Richard Hamilton, sought to lampoon advertisements with deliberately clumsy collages redolent of post–First World War Dada art. To underline that connection, Hamilton later created a replica of Marcel Duchamp's unfinished signature work, *The Bride Stripped Bare by Her Bachelors, Even (The Large Glass)*. Eduardo Paolozzi, by contrast, simulated the look of popular print media as early as 1947, with the collage *I Was a Rich Man's Plaything*, featuring Coca-Cola and other advertising logos and the cover of a pulp magazine alluringly titled *Intimate Confessions*. No matter what the approach, as Alloway pointed out some years later, the result was a more complex layering of everyday reality. "When an artist uses a pop art image," he wrote, "its significance is doubled: its original meaning is there, but the artist has also added new meanings, a meditation on celebrity or on new means of communication."

The group could be seen as the colleagues of the Angry Young Men, who upended British literature and theater with strident, vigorous, and irreverent novels and plays conveying their disappointment in the postwar reforms. Colin Wilson's study of alienation *The Outsider*, John Osborne's play *Look Back in Anger*, and John Braine's *Room at the Top* depicted the enduring importance, despite reforms, of money, power, and class privilege. The ICA group did, however, succeed in toppling Herbert Read as aesthetic arbiter and, as the historian Marco Livingstone wrote, "set the theoretical foundations for an involvement with popular culture that was soon broached far less self-consciously by other British artists."

THE POP REVOLUTION

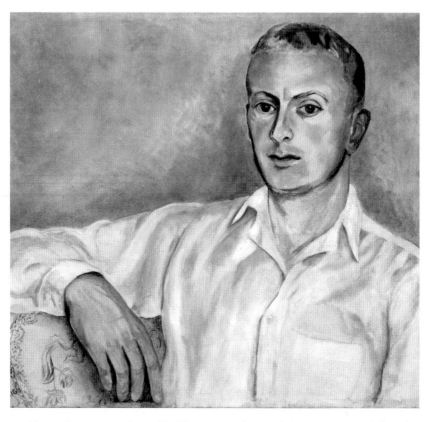

From the perspective of half a century later, Livingstone noted that the ICA group was united principally by "an intellectual approach to cultural and sociological issues rather than a pragmatic application of such material to the production of paintings or sculptures." Alloway, the group's mentor, provided its output with a name, Pop Art, which would soon migrate across the Atlantic — as would Alloway himself; having developed a reputation as "the most abrasive and determined art critic in London," he set off for a new career in America in 1961. By then, Alloway's writings in American art publications and frequent appearances at museums had also established his standing in New York. There he energetically extended his definition of Pop Art to include newly emergent works based on popular imagery. His impact on both continents was made possible by that recent invention, the jet airliner, which rendered transatlantic travel quick and relatively cheap and helped inaugurate an international culture.

Lawrence Alloway in 1952 by Sylvia Sleigh

Alloway had been writing about new directions for art in *Art News* and *Art International* as early as 1953. In 1958 he pointed out that the cultural elite had lost its power to dictate aesthetic standards, whereas "mass art is urban and democratic," deserving thoughtful review. In this, he challenged America's most influential art critic, Clement Greenberg, whose 1939 essay "Avant-Garde and Kitsch" still resonated as a call for high-minded discrimination. Greenberg, wrote Alloway, is "fatally prejudiced when he leaves modern fine art."

In the late fifties, such a judgment by a European still carried extra prestige among educated Americans. When a cultivated Englishman like Alloway spoke, art people listened, as they did to the courtly dealer Leo Castelli. The fact that two such figures could single out for admiration works that seemed questionably lowbrow necessarily had repercussions: collectors and critics took notice and tastes began to change.

One aspect of the change was the increasing inclusion of native New Yorkers in the art world. Not all of them were Ivy League–educated or born to wealth. Ivan Karp, for instance, is emblematic of the art world that was then forming. He brought the city's quintessential flair, insouciant wit, and impudence to a milieu often weighted down by heavy prose and pretension. Born in the Bronx, New York, in 1926, he was raised in Brooklyn, the only child of culturally ambitious immigrants. Karp's parents changed apartments frequently, papering each one with flimsy Van Gogh reproductions acquired with coupons in the *New York Post*. Unlike many striving Jewish immigrants, they were "tolerant and affectionate," he said, but they also dragged him every Sunday from the age of six to the Brooklyn Museum for a band concert and, perhaps, a visit to the art collection inside. At Erasmus Hall High School, Karp read little but "knew that someday I was going to read." He barely passed the English Regents exam and flunked everything else; instead of graduating, he joined the air force.

Mustered out, Karp spent a year collecting $20 per week in unemployment insurance, then took a job at a department store and saved up $730. In 1949 he bought a student berth on a ship to Europe and spent the rest of his money on a ten-month stay, mostly in Paris. "It was a tragic and dramatic time," he said. "There was still rationing in Paris." Karp and two companions subsisted on food packages his mother occasionally sent. He wept while reading Van Gogh's letters, three every day, "as if they

were a Biblical thing," and took up the troubled artist as "my own private hero; nobody understood him as I did."

After returning to New York in 1950, Karp worked for six months as a Good Humor Man, earning the then-munificent weekly income of $75, and began visiting art galleries in search of new painters. He also used the GI Bill to enroll at the New School for Social Research. His motivation, he claimed, was "to flirt with girls," but he emerged with a diploma in film editing and spent two years editing African safari documentaries made by the Museum of Natural History's intrepid explorer, Osa Johnson. In 1955 he became the first art critic of the fledgling *Village Voice*. "Somebody said they needed writers who would work for nothing," he explained. Among the exhibitions he reviewed were those at the Hansa Gallery, a modest showplace managed by Richard Bellamy, who boasted that he exhibited new art at reasonable prices. As early as 1954, at a time when the Abstract Expressionists ruled the New York art scene, Bellamy was organizing "Four O'Clock Forums" questioning that dominance; an invitation for a panel titled "The Crisis of Form in Modern Art" asked "whether modern art is really moving anywhere." Soon Karp was employed at Hansa; his salary was $10 per week, plus commissions that sometimes lifted it to as high as $50. But attendance was sparse. "We'd see ten people a week there," he recalled, "besides a few students and friends of the artists. There might be two or three collectors." Karp needed to keep two other jobs: one was for a Brooklyn lawyers' service, appearing in court to obtain continuances so that cases would drag on for years; the other was selling advertising for a Brooklyn Heights newspaper.

As happens with many adventurous artistic projects, scant income led to "major turmoil" at Hansa, said Karp; he recalled elaborate "conversations . . . about life and thought and philosophy and art and the future of man" — the upshot being that he was out of a job. Then a friend suggested he go see Martha Jackson, an art collector who also ran a contemporary art gallery on fashionable East Sixty-ninth Street. Karp was astonished that Jackson would give him a small drawing account against commissions. From Hansa, he brought along John Chamberlain, whose work was his first sale, for about $275, to a man "looking for really aggressive new art." That man was Robert Scull, a brash collector with a humble background similar to Karp's, who would soon become a major client. Another

visitor to galleries where Karp worked was Leo Castelli, who had just opened his own space some five blocks north of Martha Jackson's. "He was the hero," Karp recalled, "the outpost for really threatening new things." Johns's first show at Castelli's gallery struck Karp and his art-world friends as "the kind of art that we really wanted to be caught up in." It was a time, Karp said, of "tremendous enthusiasm . . . when American art seemed to become so important and arts activity in New York was the dominant activity."

Despite his multiple jobs, Karp went to "all the openings and all the social occasions." For him, "it was a great unfolding," peopled by collectors, museum folk, art historians, and art critics. "Everybody was identifying themselves in the things they preferred. The artists were locating their own images. It was a great tumultuous period, the late fifties." Karp himself observed the new sensibility as often as he could by heading uptown to 4 East Seventy-seventh Street whenever Castelli had an opening. "People always received a very courteous entrance into the gallery," he recalled. "Every Saturday was an important event. . . . Dozens of people standing around in the back room discovering each other. There was a lot of romantic atmosphere. Always a lot of beautiful girls." One of them would become his wife.

A year after joining Martha Jackson's gallery, Karp would be thrust into the epicenter of that tumult. He was invited to lunch with Ileana and Leo Castelli at the elegant Stanhope Hotel. "I had no suit," he remembered, "so I went to Barney's and bought one in the boys' department where they were cheaper." He expected some kind of "ritzy" meal, maybe foie gras or sweetbreads, he said, but instead "I got white gravy, *goyische* food." But he also got a job offer, starting at $100 per week. The Castelli Gallery was expanding out of its top floor into other spaces in the East Seventy-seventh Street building and, Leo said, Ileana thought "we should have somebody to help us in . . . all the problems that began snowballing." So when he went to work at the Castelli Gallery, Karp bought his "first really good beautiful formal suit" and fully donned his new role. "You went on the floor and very nicely dressed people came in," he said. "It was very decorous. And you spoke about the paintings in a scholarly way."

Karp also discovered that Ileana Castelli was both strong and sensitive. So strong, in fact, that in 1959 she managed to obtain a divorce from Leo

that was amicable enough for them to carry on an intimate business relationship for the next four decades, until Leo's death in 1999. Ileana married an amateur Dante scholar, filmmaker, and art lover named Michael Sonnabend, whom she had met while attending classes at Columbia University. She took with her a large chunk of the impressive art collection Ivan Karp noticed when he arrived on the scene: "a number of powerful Dubuffets of the very best period [1946–47] . . . some Giacomettis . . . three Pollocks. Fabulous paintings . . . a number of de Koonings." Karp was impressed, "but being relatively new to a very sophisticated situation," he offered no judgments; he just observed with "fascination and amazement" — and in atypical silence.

The Sonnabends left New York for Rome, then settled in Paris, where in 1962 they would open a groundbreaking gallery of their own, all the while maintaining an advantageous affiliation with the Castelli Gallery back in New York. For most of that time, the Sonnabend Gallery would enjoy an exclusive on European representation of Castelli's rising stars, offering them a privileged position when the Old Continent finally made its peace with the art of the New World. With Karp's ebullient personality fully engaged in finding and promoting new artists, the Castelli-Sonnabend partnership was free to develop international sales contacts for the ones already under representation. In the spring of 1960, works by Robert Rauschenberg and Cy Twombly were exhibited in Rome and at Galerie 22 in Düsseldorf. In the two years after the Jasper Johns "bombshell," as Castelli described it, his gallery would give one-man shows to what the editor of *Art in America* called an "eclectic bunch indeed." Among these were John Chamberlain, master of car-crash sculptures; Lee Bontecou, stitcher of disturbing canvas objects; and Yves Klein, a headstrong Frenchman who appropriated and named (as well as patented) a vibrant shade of blue.

During that time, the New York art scene was brimming with activity. In the first week of 1959, some seventy-five art exhibits were opening — a record — and almost all the works shown were contemporary. One afternoon around 1960, a few regulars were sitting in a booth at the Cedar Tavern, the AbEx hangout at the eastern edge of Greenwich Village. Franz Kline and Willem de Kooning, in their usual paint-stained jeans, were well into their cups, chatting with Ruth Kligman, who had barely sur-

vived Jackson Pollock's fatal crash. She looked up and saw three men in elegant suits and narrow ties — Jasper Johns, Robert Rauschenberg, and the dancer Merce Cunningham. "I knew right then who they were," she told the art critic Peter Plagens, "and I realized the total sea change in the art world. They were smart, media savvy, wearing suits, and gay."

THE ARTS TAKE CENTER STAGE
1961 – 1965

The election of John F. Kennedy, and with it the federal government's reinvigorated focus on culture, persuaded a new generation of Americans to become interested in art, perhaps even to buy a work or two for the living room. Bathed in the light of optimism that accompanied the young president's ascent to power, the grave philosophical message of Abstract Expressionism seemed a bit passé. In a prosperous country where television and mass magazines coached the newly affluent in upscale behavior and jet-set posturing, the public was ready to embrace whatever — and whoever — offered a fresh take on the world, along with the illustrations and talking points for discussing it.

For the first time in American history, a presidential campaign had been waged on television; some 86 percent of American families owned at least one set and spent an average of forty-two hours a week watching images flickering on the screen. As the candidates went on their vote-seeking rounds, the ubiquitous TV camera brought every smile, every slogan, and every handshake to a national audience. The vast crowds that would travel miles to hear the likes of Al Smith were long gone, as were the fireside chats that had brought the silken voice of Franklin D. Roosevelt to every living room radio. Much more powerful, and also much more deceptive, was the nightly reality show on the living room screen. The sensation was heightened when a record seventy-five million Americans, some 37 percent of the entire population, watched the first televised presidential debates. Many voters reacted negatively to Vice President Richard Nixon's saturnine, bristle-bearded, uneasy persona, especially when set against the handsome, athletic, smiling war hero who looked so right for the job.

The flags that Jasper Johns had painstakingly created and that had puzzled so many viewers suddenly appeared to convey a new meaning; what for many had become a limp, tired symbol now fluttered with the winds of renewal and hope for the future. Still, widespread anxiety over the evidently potent medium of television tainted the general optimism surrounding the new administration. The pioneering historian Daniel J. Boorstin was only one of the experts who agonized over the impact of a mediated environment constantly delivered into American homes. It led the public to "extravagant expectations . . . of what the world holds," he wrote, "and of our power to shape the world."

For several impressive years, one man in particular seemed to have the answers to anxieties over the power of mass media. He was Dr. Marshall McLuhan, a Canadian professor of English literature with a specialty in James Joyce. Back in 1951, when fewer than four million American households owned televisions, McLuhan had published an oversize paperback intriguingly titled *The Mechanical Bride: Folklore of Industrial Man*. In it, he attempted to analyze how "the sheer technique of worldwide news gathering" was separating its consumers from "local or national political opinions." He saw the outcome as reinforcing "a deep sense of human solidarity."

The cheap paper and careless printing of that untidy booklet languished until 1962, when sociologists joined advertising executives in intense speculations on the impact of television; the new medium appeared to be the universal teacher and taste maker of the American public. That year, McLuhan issued another spiffily titled take on media, *The Gutenberg Galaxy*, an *omnium gatherum* of texts and quoted snippets that added up to a funeral oration for printed media. It proposed instead a division of newer media into "hot" radio and "cool" television and contained enough pages of dense prose to earn it the Canadian Governor General's Award for nonfiction. Few outside academe took notice until 1964, when McLuhan published another intriguing title, *Understanding Media*. Soon after this book's publication, the *New York Herald Tribune* called its author "the most important thinker since Newton, Darwin, Freud, Einstein, and Pavlov." Even thirty years later, the erudite editor of *The Atlantic*, Lewis H. Lapham, could still describe McLuhan as "the foremost oracle of the age."

THE POP REVOLUTION

As the oracle made his way around the TV networks, his rumpled garb and sometimes mismatched socks, his scholarly stoop and obscure language seemed unmistakable tokens of authenticity — so much so that his books, including *The Medium Is the Massage*, an ostensibly explanatory redraft of *Understanding Media*, sold more than one million copies and were translated into twenty-two languages. On the cover of a mass-market paperback edition of *The Gutenberg Galaxy*, the author's name filled the top third, far overshadowing the title. Inside, the reader was promised "a dazzling mosaic of unique insights and searching speculations." And on the back cover was an anonymous endorsement from "an average professor" who confessed that merely being in the book's presence made him feel "like a cross between a dodo and an astronaut with a heart condition."

In the spring of 1965, Tom Wolfe, *New York* magazine's mordant chronicler of the passing parade, met McLuhan at Lutèce, the city's headquarters for the "status lunch." Wolfe couldn't take his eyes off the clip-on tie — an 89¢ item found at any corner drugstore — tucked under McLuhan's collar. To Wolfe's mind, this detail hammered a chink in his subject's armor of authenticity and left an opening for some damning quotations: "Of course, a city like New York is obsolete." "Of course, packages will be obsolete in a few years. People will want tactile experiences." "The human family . . . a global village . . . a single constricted space resonant with tribal drums." Such was the terse message embedded in McLuhan's impenetrable writings. Yet it was enough to propel the English professor far from his modest office at the University of Toronto, to sketch the future for executives at IBM, General Electric, and Bell Telephone. And it was dense enough for Tom Wolfe to title his thirty-five-page essay "What If He Is Right?"

The question betrayed the unease that Wolfe and many other observers felt in the face of such hypnotic chapter headings as "Reversal of the Overheated Medium," "Challenge and Collapse: The Nemesis of Creativity," and "Telegraph: The Social Hormone." The leftist writer Dwight Macdonald described McLuhan's writings as "nonsense adulterated by sense." In *The New Yorker*, the art critic Harold Rosenberg called him "the first Pop philosopher." McLuhan's fellow Canadian and erstwhile mentor Hugh Kenner, a leading literary critic, described his protégé as "the writer his public doesn't need to read."

It was not so much the text that captivated the public as the democratic, empowering subtext McLuhan conveyed through all the hoopla. He had magically transmuted the leaden Marxist slogan "Power to the People" into a golden insight: by means of universally available media, ordinary folks could now feel free to choose whatever they cared to buy, read, watch, or appreciate. The eager reader attempting to get through McLuhan's writings behind the slogans soon found him- or herself slogging through a bog of unrelated and unorganized verbiage. Yet McLuhan's endless appearances on radio and television telegraphed an electrifying message: the irresistible idea that one did not have to devote years to study or command any expertise in order to understand serious literature, art, or music. Thus armed, many people who previously were intimidated by high-minded screeds about the nobility, the transcendent, near-religious experience of art gravitated toward whatever tickled their fancy, whatever was "fun" and maybe even profitable to own into the bargain.

The choices were staggering. In 1959 D. H. Lawrence's *Lady Chatterley's Lover* was banned by the U.S. Postmaster, a ruling soon overturned on appeal; the steamy, erotic novel romped to the top of best-seller lists. Brevity was the soul of fashion as miniskirts became the rage and radios poured out a novelty hit celebrating the "Itsy Bitsy Teeny Weenie Yellow Polka Dot Bikini." Sex was "hot," the more so as the first oral contraceptive, Enovid, reached the market.

At MoMA a slightly different frisson titillated a well-dressed throng in the sculpture garden as Jean Tinguely's *Hommage à New York* erupted; its fifteen motors dismembered a gigantic assemblage of eighty wheels, toy wagons, a bathtub, and assorted junk. This was the year when an estimated 850,000 war babies entered college, where total enrollment reached a record 4 million. Unlike the seasoned veterans who had studied under the GI Bill, these youngsters had virtually been raised by Dr. Benjamin Spock's indulgent best-seller *Baby and Child Care* and averaged allowances of around $10 per week, more than the total weekly income of a typical 1940s family. On a more elevated level, widespread higher education gave many Americans the scholarly wherewithal to make intelligent aesthetic decisions, or at least to watch the next big thing arrive on their television screens. A cultural revolution — what one observer called "the great American berserk of the Sixties" — was at hand.

THE POP REVOLUTION

The upheaval expressed itself vividly at the Castelli Gallery, where Ivan Karp became the lead scout in discovering new artists. In 1961 he learned from Allan Kaprow, an art history teacher at Douglass College in New Jersey, that a colleague of his was producing some new paintings worth seeing. In a few days, that colleague, Roy Lichtenstein, arrived with a parcel of canvases strapped to the roof of his station wagon. Karp was astonished to see painted enlargements from comic books and advertisements. They were "strange, unreasonable, outrageous," he recalled. "You really can't do this," opined Karp, to which Lichtenstein laconically replied: "Well, I seem to be caught up in it. Here they are."

The paintings Karp saw seemed to apply lighthearted American pragmatism to the more theory-based British movement that Lawrence Alloway had christened Pop Art. Although Karp "got chills" from Lichtenstein's pictures, he hid them in a closet before mustering his considerable bravado to show them to Castelli. "Leo was not distressed," Karp recalled. "Leo didn't even know the comics they were based on. He didn't have the American background, but he saw right away that there was something going on there." The paintings "had that special sex appeal," said Castelli. "Only it's a sort of primary, infantile, adolescent sex appeal [that] his comic strip characters have, and that was there for the first time to a very large degree."

In an unusual burst of caution, Karp also showed the pictures to an artist friend, Ben Berillo, who exclaimed, "These are the most terrible paintings I have ever seen. You better grab the artist fast. He's great." Meanwhile, Castelli was also wary, quietly showing a few of the paintings to his steady clients — Richard Brown Baker, Emily and Burton Tremaine, and Philip Johnson — before deciding to give Lichtenstein a show in early 1962. The exhibition was hardly encyclopedic. Rather, it demonstrated the pattern of many future Castelli exhibitions: a focus only on the artist's most recent and most notoriously challenging work.

Like many artists, Lichtenstein had taken many paths on his road to this recent style. Born in 1923 on the Upper West Side of Manhattan, he had attended Ohio State, one of the few universities with a degree program in art, then served three years in the military before returning to Ohio for what today would be an MFA. Having "no idea of what he would do with art," he first tried out the Abstract Expressionist idiom,

then moved on to American themes and objects — cowboys, Indians, and paper money. By the time he showed Ivan Karp his latest paintings, Lichtenstein was thirty-eight years old and teaching at a state college in New Jersey. A defining moment came when one of his two sons pointed to a comic book, saying, "I bet you can't paint as good as that." Challenged, Lichtenstein *père* painted an outsize version of Donald Duck wrestling with a fishing rod whose line is hooked into the seat of his pants. The speech balloon rising from his delighted bill exclaims, "LOOK MICKEY, I'VE HOOKED A BIG ONE!!" *Look Mickey* was one of the paintings shown at Lichtenstein's first exhibition. Hanging near it were others showing the exaggerated Benday dots that became his trademark — so much a trademark, in fact, that the following year, the cover of the Sonnabend Gallery's Lichtenstein catalogue showed only an angled strip of dots and the artist's name.

The art world's reaction hardly matched the enthusiastic rave that had greeted Jasper Johns four years earlier. Karp himself found Lichtenstein's works "very blunt, very bland, very cold, very numb," and worried that "people were appalled by them." A New York museum curator who had previously enjoyed the innovations shown by Castelli turned grim, warning he wouldn't return if this kind of work was going to be shown there. Karp recalled "a great deal of turmoil [and] very unpleasant moments" when visitors were taken to the back room and exposed to Lichtenstein's paintings. The artist himself wasn't much help. He had been "fiddling with drawing cartoon figures expressionistically or aping other styles," he told an interviewer, when one day he "mimicked industrial or commercial texture dots [without] paint quality or texture in the School of Paris sense." *Look Mickey* was his first: "It just all happened in one day." In fact, Lichtenstein had considerable experience in commercial art, having done engineering drawings for Republic Steel Co. (The professional comic book artists, meanwhile, dismissed Lichtenstein's work as too "arty" and "old-fashioned in its flatness.")

By the time the Lichtenstein exhibition opened in February 1962, *Newsweek* had received a preview from Castelli, who "glided into the main gallery in soft black loafers and a gray flannel suit" to give his Lichtenstein lecture "with a conviction that only a dealer could muster." Art, the dealer told the reporter, "is what you will it to be. One must rise

above one's own taste, sometimes." A few weeks later, at the Guggenheim Museum, the process of ushering Lichtenstein into the canon began. The museum's director, Thomas Messer, gave a lecture linking him with Cubist art. Lichtenstein's comic-derived images actually sold out, at prices ranging from $400 to $1,200, to the relief of Castelli and Karp.

In showing Lichtenstein and what would be a startling array of new artists, Castelli and Karp were developing a reputation as the good cop–bad cop duo of contemporary art, or what Karp later described as a "one-two punch." While the "good cop" Castelli spoke softly in continental tones and kissed the hands of socialites, Karp took a more bullish approach, talking, as one newspaper later put it, "about pop art the same way as [Billy] Graham talks about redemption or being damned, instructing, proselytizing, encouraging, exhorting you to believe in what he says."

Moreover, Karp's sales pitch was couched in a New York streetwise patois that appealed to collectors like Robert Scull, who had built a booming taxi business, already owned a number of Abstract Expressionist works, and was pushing forward to the next big thing. Scull lacked any formal art education and was devoid of "seemliness," said Karp, but he had "a terrific eye." The man's vulgarity did not deter Karp from introducing Scull to Richard Bellamy, who had managed the Hansa Gallery but was at loose ends since its demise. Scull quickly hired Bellamy to run a new space called the Green Gallery, promising to buy at least $18,000 worth of paintings there every year. The collector admired Bellamy's instincts, but he also appreciated meeting the artists, and within a few more years, he would own more than forty Pop paintings and sculptures.

On a Sunday in 1961, Scull and Bellamy rendezvoused in front of a building on Coenties Slip, and as the taxi king recalled, "after the usual shout-from-the-street-instead-of-a-doorbell," they climbed steep stairways to the studio of James Rosenquist, a painter of giant Times Square billboards who, they'd heard, was also making paintings. The artist was a taciturn North Dakotan who had been in New York for six years and had to be urged to show his work. Scull asked for an explanation of a painting titled *The Light That Won't Fail*, which depicted a television screen surrounded by pieces of a Spam sandwich and a girl's profile. The artist pondered Scull's question and finally blurted out: "Man, this is our new religion — the cathode-ray tube — and the painting *is* the explanation."

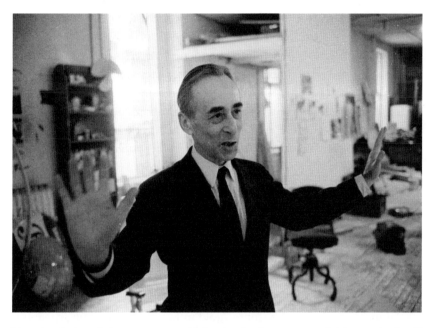

Despite being "almost annoyed" by both the man and his work, Scull bought the picture on the spot, Rosenquist's first fine-art sale.

Karp arrived at the Rosenquist studio by a more circuitous route. As if he weren't too busy managing a trendy gallery and finding new artists for Castelli to show, he was also managing the Anonymous Arts Recovery Society. He described it as a sizable army of volunteers who prowled the city in search of ornamental sculptures felled by the wrecking ball, as Manhattan endured one of its endemic construction booms. By 1962 a hardly anonymous Karp was accosted by a *New Yorker* reporter while rummaging through "a pile of choice debris in the East 80s." His old De Soto V-8 was parked nearby with a tethered U-Haul trailer, as several burly young men were "coaxing a large stone bas relief into the trailer with crowbars and block and tackle." Two years later, Karp scored more than two pages in the magazine's "Talk of the Town," where he asserted that it was the salvaged carving that was anonymous, not the society's members, "who are perfectly explicit about their period and school." (Many years later, Karp admitted that the army of salvagers described in those articles actually consisted of "about five people, whichever of my friends was out of a job.")

Leo Castelli mustering conviction in Rosenquist's studio, 1966

THE POP REVOLUTION

The society was still making headlines in 1965, when some 125 salvaged items were exhibited at the Kornblee Gallery. *Newsweek* described Karp as "a frizzle-haired, cigar-chomping writer, man-about-art and tastemaker," and related how he and his associates were once arrested for collecting what he termed "rubble without applause." However, Karp added, "The desk sergeant was an old New Yorker, fond of the buildings in which he grew up. He ended up giving hell to the arresting patrolman for not having any sensitivity." It was early in this publicity blitz that Karp was lunching at Sloppy Louie's, near the Fulton Fish Market, when a stranger asked him: "Aren't you that guy that saves old stones?" When Karp then climbed the stairway on Coenties Slip to his new acquaintance's studio, he, too, was bowled over by James Rosenquist's paintings and soon had him signed up at Castelli's.

While Karp was busily gathering stones and artists, Leo Castelli was weaving a different kind of web. In November 1961 *Life* magazine published a ten-page spread on how junkyards, "monuments to the affluence of the machine age," had become "gold mines" for artists. The article featured mostly Castelli artists, including Robert Rauschenberg as "both old master and enfant terrible of the junk school." A black-clad Richard Stankiewicz posed beside *Bride*, a woebegone apparition with a refrigerator as head, bolts as eyes, and bedsprings as a veil. "If you forget that a wheel is a wheel," he said, "it becomes very interesting." John Chamberlain defended his sculptures of crushed automobile bodies by citing the marble quarry in Michelangelo's backyard: "Nobody said, 'Wow, marble.'" Chamberlain said he was simply using a similarly ubiquitous substance close at hand: "Big steel production . . . why not use it?" The article drew on a massive exhibition of "junk art" assembled at MoMA and touring around the United States.

Such wide-eyed coverage of the new aesthetic paved the way for the acceptance of Pop outside New York. Barely a month after the *Life* article, the *St. Louis Post-Dispatch*'s Sunday magazine devoted its cover and two inside pages to pictures of Castelli demonstrating "a new style of painting . . . causing excited talk among the avant-garde of the New York art world." First-time exhibitions of works by Lichtenstein and Rosenquist at the Castelli Gallery in the next few months, said the paper, "could generate some of the most heated reactions of recent years." In the *Kansas City*

Star, an article about new art filled nearly two pages; the author noted that, faced with Pop, Abstract Expressionism was fading, "taking its place in history." Among the illustrations was a Lichtenstein in the collection of a local couple. Nearby, Kansas State University sponsored a fine arts festival featuring contemporary works from Castelli and other New York galleries, even though the school had no formal art department. In San Francisco, the respected critic Alfred Frankenstein reported that the new art "makes The Establishment scream like a wounded rhinoceros, just as [it] screamed at people like Gorky, Pollock, de Kooning and Kline a quarter of a century ago." At the Philadelphia Museum of Art, a group of Lichtenstein posters were snapped up before noon at a Curators' Choice sale.

Such priceless publicity did not come cheap. Karp described Castelli as "helplessly generous," citing as examples that the dealer had hired an in-house designer to create the striking graphics for the gallery's invitations, as well as an in-house architect in case "a wall had to be painted gray." There is little doubt that Castelli also employed a public relations consultant to spread word of the gallery's activities. The resulting clippings, texts, and illustrations were carefully preserved in the gallery's files.

A similarly strenuous effort went into the powerful network of galleries with which Castelli had forged links across the United States. Over the next few years, at least one gallery in every major city — from San Francisco and Los Angeles to Saint Louis, Chicago, and Houston — would have such an affiliation. Though the new jet airplanes enabled collectors anywhere in the United States to visit New York, many still preferred to buy locally from galleries they liked and trusted. To nurture his web of dealers, Castelli pioneered a new financial structure: he paid stipends to artists who signed up with his gallery but expected to keep 50 percent of a sale, as opposed to the usual one-third commission. Castelli could then use the excess, or maybe even a bit more, to pay a commission to cooperating dealers. Castelli's carefully woven web also benefited his artists. Since Lichtenstein's first Castelli exhibition, when paintings were stickered at under $1,000, prices had tripled.

Castelli also called on his European connections — and those of his ex-wife, Ileana Sonnabend — to get his artists exhibited abroad. In June 1961 Rauschenberg and Jasper Johns were included with Tinguely and Niki de Saint Phalle in an exhibit at the American Embassy Theater in

Paris. The following year, the two were shown with Alfred Leslie and Richard Stankiewicz in "Four Americans," an exhibition at the Moderna Museet in Stockholm. Sonnabend had opened her Paris gallery in 1962 on the Quai des Grands-Augustins with Johns's first European show and followed up with Rauschenberg. The artist had arrived at midnight on Christmas Eve, she recalled, wearing "a huge Alaskan coat. . . . His hair was white with snow." Everyone at the opening cheered, and "Bob was a legend in Paris after that."

Sonnabend may have exaggerated Rauschenberg's impact in Paris, but there was no question that the European world of contemporary art was looking west for the next sensation. Most impartial observers believed that the American Abstract Expressionist Franz Kline should have won first prize in painting at the 1960 Venice Biennale. The artist himself was so angry that he engaged in a "symbolic scuffle" with the winner, the French Tachiste Jean Fautrier. Near the end of 1962, the critic Robert Rosenblum published a landmark article about Johns's recent work in a pillar of French cultural journalism, *XXème siècle*. A few months later, a German art critic wrote admiringly of Johns and Rauschenberg in the influential Hamburg newspaper *Die Welt*: "These works shock not because they mock art, but because they plunge the viewer into a visual dilemma."

Meanwhile, back in New York, Sidney Janis shocked traditional modernists by scheduling a show titled "The New Realists" in the coveted month of November. Janis had long been New York's leading purveyor of School of Paris art and had lately also represented the leading Abstract Expressionists. The show was packed into his spacious gallery at 19 West Fifty-seventh Street, and into another, rented venue directly across town. The invitation was an ironic sidelight; it resembled a Victorian billboard, a backward glance that clashed with an exhibition featuring the newest of the new. These young artists' average age was thirty, and they included such iconoclasts as Claes Oldenburg, Lichtenstein, and a nobody named Warhol. In the catalogue essay, Janis avoided the label *Pop*, arguing that artists so named were British. Nor, he said, were the Americans reviving Dada, a movement he considered "violently anti-art," insisting that "the angry young men of 1918 [Dada] and the cool young men of today are diametrically opposed." Instead, Janis located their inspiration in their

environment, the popular images and objects surrounding them, from which they "enthusiastically create fresh and vigorous works of art."

Thomas Hess of *Art News* shrugged off the New Realists as "nothing particularly new." Their only virtue was being "eminently writeable-about, as against the Abstract Expressionists whose masterpieces convince you at non-verbal levels." He singled out Lichtenstein for "falling for the banal . . . doing it about — like Norman Rockwell." The show's "New Realists" were "eyeing the old abstractionists," wrote Hess, "like [Nikita] Khrushchev used to eye Disneyland — 'We will bury you.'" When he was through, the usually literate Hess had punched out a single paragraph eighteen inches long, as though he were building a wall against the new art. Writing in the *New York Times*, Brian O'Doherty zigzagged between his own ambivalent responses to the show; while he deemed the work "zippingly humorous" and "audaciously brash," he also claimed to see a "satiric attack on Madison Avenue. . . . America has been a pioneer in throwaway cups and saucers, milk containers and tablecloths. Now it is a pioneer in throwaway art."

Of the Abstract Expressionists, only de Kooning showed up for the "New Realists" exhibition. He was seen "pacing up and down in front of the paintings for two hours, then leaving without a word." At the party after the opening, the artists were being served drinks by uniformed maids at the home of the collectors Burton and Emily Tremaine, when de Kooning appeared in the doorway. "Oh, so nice to see you," said Emily, who owned a number of de Koonings, "but please, at any other time." James Rosenquist saw the conversation and was shocked. "Something in the art world had definitely changed," he said. Within days, the Abstract Expressionists held a meeting, and all, except de Kooning, agreed to leave the Janis Gallery.

Years later, Robert Rosenblum and Henry Geldzahler would point to the "New Realists" show as a landmark of worldwide acceptance of Pop Art. The exhibit's combination of the Americans with Parisians gathered by the French critic Pierre Restany — Yves Klein, Arman, Martial Raysse, César, and others — reassured Europeans who had not invested with quasi-religious passion in the idea of abstraction. They noted that "Europeans were better prepared for something new out of America than was America." In the moment, the growing American art community was

stunned by how quickly Pop had captured the spotlight. In October 1963 the critic John Coplans linked Abstract Expressionism and Pop Art as he summed up the turning of the tide. Both movements, he argued, had been dealing with the same issue: developing a distinctly American kind of painting, free from earlier European authority, "a tradition which had lain like a frigid wife in the bed of American art since the [1913] Armory Show." In New York there seemed to be no end to the Pop-oriented artists suddenly appearing at prestigious galleries. And no end to the breathless anticipation for the next set of delightful — or, depending on your taste, horrific — visual images to appear.

Who were these new artists emerging in those eventful years — among which 1962 seems a kind of annus mirabilis? One was Jim Dine. In early 1962, the Martha Jackson Gallery exhibited Dine's canvases embellished with carpentry tools. The artist was just twenty-nine years old and had arrived in New York three years earlier. The exhibition was titled "Red Suspenders," after the pair of suspenders Dine had glued to a red canvas — "like a fresh tube of paint," he explained, adding: "I like painting red on red." Even *Time* magazine's usually skeptical reviewer was impressed by the "learned interpretation" of these works by Lawrence Alloway. Alloway had built a scholarly context around the artist, writing that he was not a Surrealist, as "he does not distort the objects or place them in absurd contexts." Rather, Dine "brought the everyday object to a state of isolated glory." The mention in the review that collectors had bought out three-quarters of the show added to Dine's aura.

Another emerging artist was Wayne Thiebaud. In April 1962 Allan Stone's uptown showplace sold out Thiebaud's lovingly painted cakes and pies as a nearby bakery plied gallery goers with samples of sticky desserts resembling the canvas ones. Stone was the son of a wealthy couple, avid collectors who sent him to Andover and Harvard. He would eventually own a fifty-five-room Stanford White house in Purchase, New York, a place in Bar Harbor, Maine, and another in San Francisco, each crammed with art and exotic objects, plus seventeen Bugatti automobiles. Stone also had a taste for popular culture; after his death in 2007, his daughter, Allison Stabile, vividly recalled her father at her wedding "walking her down the aisle wearing a Mickey Mouse tie." Wayne Thiebaud had stud-

ied art at Sacramento State College in California and had worked for Walt Disney, before teaching art at Sacramento City College. In 1961 he packed his wife, family, and paintings into a station wagon and drove across the USA to New York. Stone immediately signed him up for a show, stunned that Thiebaud had never exhibited in New York. The artist then went home, discovering only when he returned to New York with a group of students that his show had sold out. Among the purchasers were MoMA, the Wadsworth Atheneum in Hartford, the connoisseur James Thrall Soby, and Philip Johnson.

And in May, the West Coast dealer Irving Blum ran into a third up-and-comer, Andy Warhol, at the Guggenheim Museum in New York. The artist urged the dealer and his client, Betty Asher, to visit his nearby home and studio. Blum was so impressed by Warhol's paintings of Campbell's soup cans that he took several of these now-iconic images along and promised Warhol an exhibition at his Ferus Gallery in July. Asher was fascinated by *64 S & H Green Stamps*, a painting featuring enlargements of bonus stamps that virtually every American housewife was diligently pasting into a little booklet, which she could then exchange for gifts. Asher immediately bought it.

Such impulsive purchases were part of the fun for Pop Art collectors. Some camped outside galleries on opening day to be sure of first dibs on whatever was being shown. In some cases, exhibitions sold out before the opening, as regular customers obtained previews. The atmosphere was a foretaste of the frenzied preopening maneuvers at twenty-first-century art fairs where most works shown are presold. The British critic Edward Lucie-Smith, visiting New York in 1962, observed "an air of frantic speculation. 'Captive clients' buy what they're told to buy simply on the grounds that 'it's sure to go up.'" The "intricate financial game," he said, reminded him of "the tulip mania in seventeenth-century Holland."

While collectors swarmed to buy, critics and art historians struggled with the problem of fitting this rambunctious new art into the story of modernism. Since the mid-nineteenth century, a pattern had developed in how new art emerged: a group of artists — say, the Impressionists — overturned the traditional canon, developed a theory to justify what they were doing, and appealed to critics and collectors for patronage. After years of struggle, these artists found success, only to be challenged by a

new group with a new style and a new theory. Such was the trajectory of the most recent arrivals, the American Abstract Expressionists and their European cohorts. But this time, the new current had developed in two parallel contexts — England and the United States — with the Americans hardly aware of what the British were up to until some alert observers pointed out the similarities.

For the artist and MoMA curator William Seitz, a defining moment came in the spring of 1962, while he was preparing for a symposium titled "The Role of the Avant-Garde" at Brandeis University; he realized that the new art was "no longer a radical, beleaguered venture bereft of public, patrons, and financial support," but instead was being absorbed into the "American way of life." Perhaps most surprising was that this essay about the avant-garde was published in the mainstream magazine *Vogue*. Lawrence Alloway, who had named Pop in Britain, noted that the new artists had abandoned concepts of high and low art, and instead suggested a continuum to "accommodate all forms of art, permanent and expendable, personal and collective, autographic and anonymous." These artists tended to define culture as anthropologists did: to mean "all of society," not "a treasury of privileged items." For his part, G. R. Swenson, the author of an *Art News* series titled The New American Sign Painting, struggled with what to call this latest trend. He cited one observer, who recommended "Commonism," before enthusiastically suggesting that these painters "vitalize our sense of the contemporary world. They point quite coolly to things close at hand with surprising and usually delightful results."

One of the reasons the Pop artists achieved such speedy success is that their works offered a lighthearted, irreverent aesthetic that captivated not only America's youth, but also the middle-aged public yearning to feel young again. Tom Wolfe told a historian that middle-class America in the 1960s was "much more adventurous" than its European counterpart. Nor is it surprising that the advent of Pop set off a media explosion: the works were bold and colorful and the artists themselves good copy. Coverage extended beyond the art magazines proper to the tabloids and even to high-fashion periodicals such as *Vogue*, which published an essay on the letter *Z* illustrated with work by Jasper Johns, "a foremost American painter."

The meteoric rise of another key figure, Robert Indiana, vividly illus-trates the feverish aesthetic climate of the time. Indiana had lived at Coenties Slip, where Johns and Rauschenberg also nested. In his drafty lodging, he had found stencils discarded by the previous tenant, a ship's chandler, which he used to create bright posterlike emblems, embellished with words — EAT, HUG, DIE, LOVE, the "vocabulary of the American dream, the 'optimistic, generous, and naïve' philosophy of plenty" — that intrigued collectors scouting several group shows. His submission to "New Forms, New Media" at the Martha Jackson Gallery in 1960 was bought and donated to MoMA; the following year the first of many paintings titled *American Dream* was also acquired by MoMA, whose director, Alfred Barr, said he didn't understand why he liked it so much but called it "one of the most spellbinding paintings" in the museum's show of new acquisitions.

By October 1962, when the thirty-four-year-old artist had his first one-man show at the Stable Gallery, his works (in addition to the two at MoMA) had been bought by such bellwether collectors as Philip Johnson, Richard Brown Baker, the art-book publisher Harry Abrams, and William Burden. Indiana would also be included in the Janis "New Realists" show the following month. With prices ranging from $75 to $1,600, total sales reached almost $15,000. Gallery director Eleanor Ward was delighted with Indiana's success and planned another one-man show in the fall of 1963.

Raised on the wealthy East Side of Manhattan, Ward had developed a career in advertising and promotion that earned her a job as an assistant to Christian Dior in Paris. She struck David Bourdon, then the art critic for the *Village Voice*, as "a commanding woman with an air of glamorous hauteur" who resembled "a 1940s movie queen . . . Bette Davis flashing her eyes as she waved a cigarette, and Joan Crawford, casting a withering glare on whoever dared to oppose her." Since starting her gallery in 1953, she had exhibited the Surrealist boxes of Joseph Cornell, the abstractions of Joan Mitchell, the sinuous wood sculptures of Isamu Noguchi, and the abstract calligraphy of Cy Twombly, all to mixed receptions. The *New York Times* critic Paul Gardner called her an elegant woman, "with an aesthet-ic eye and no interest in the business side of art." Repelled by openings at other galleries, "where cheap wine was served in plastic glasses," Ward

paid $165 to a party consultant for the Indiana opening and insisted on good champagne in glass flutes.

In under three years, Indiana's iconic creations would bring him life-long fame and fortune. In 1963 alone, the Michener Foundation bought his *Highball on the Redball Manifest* for $1,800 after it was shown at the Whitney Museum of American Art and the Tate Gallery in London. His twelve-by-twelve-foot *Demuth American Dream* was shipped to Dunn International Exhibitions, priced at $6,000. When Ward organized another Indiana show in 1964, two paintings were sold before the opening on May 12, each for $2,100; prices of other works in the show ranged to $6,000.

One of the aspects that most appealed to collectors and critics alike was the resolutely flat, untextured surface of the canvases. *Time* magazine's anonymous reviewer praised Indiana's "bright, unmixed colors . . . so unpainterly that his brush stroke cannot be detected," and contrasted his straightforward icons of the American Dream with Abstract Expressionists "interested [only] in painting out their mental turmoil on canvas." (Despite his admiration, he couldn't help noting Indiana's electric "mural of EAT in a criss-cross, which was supposed to flash on and off, but every time it was turned on, it blew its own fuse.") *Art News*'s G. R. Swenson, too, was entranced by the paintings' "flawless . . . surface quality, balance, subtlety of color — as fine as any work being done today," and deemed Indiana "as contemporary and colorful and as American as *Newsweek*." Indiana himself (who considered impasto "visual indigestion") described his work, with typical artist-speak ambiguity, as "a disciplined high dive — simultaneous and polychromous, an exaltation of the verbal-visual . . . my dialogue."

In the first half of 1965, fifty-two of Indiana's paintings had sold through Ward's gallery, netting the artist more than $51,000. In addition, Rolf Nelson's Los Angeles gallery, which had entered into a partnership with Ward similar to the commission-sharing arrangement Castelli had negotiated with other galleries, was exhibiting twenty-two Indiana works. By the end of the year, Galerie Alfred Schmela in Düsseldorf had received ten paintings for exhibition at the museum in Eindhoven; the director of Amsterdam's prestigious Stedelijk Museum was also interested in showing them. By the following spring, the once-isolated Coenties Slip artists'

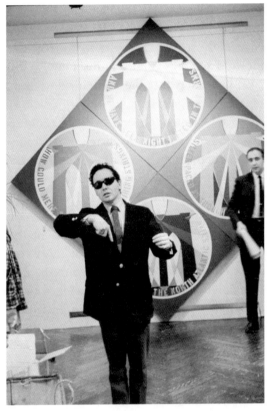

colony was dispersed, overrun, as Swenson described it, by "publicists, hostile but opportunistic young critics, indifferent reporters for big-audience mediums, sympathetic but nearsighted curators."

These visitors were only part of a new public eager to participate in the excitement over the kind of art that was actually fun to appreciate. Television, a mass medium obsessed with increasing its audience, took an interest in the new artists. In March 1964 CBS's *Eye on New York* had presented "the strange, mad, awful, wonderful world of pop art," as Paul Gardner put it in the *New York Times*, helping make it "the liveliest topic of cultural conversation." The program took viewers to George Segal's chicken farm in New Jersey, where the artist created life-size plaster sculptures of everyday people, and to Robert and Ethel Scull's Fifth Avenue apartment, where the family dined "overshadowed by James Rosenquist's *Silver Skies* — Coke bottles and old tires." PBS devoted an

Robert Indiana lays it down in front of The Brooklyn Bridge*, 1964*

hour to Henry Geldzahler, a curator at the staid Metropolitan Museum of Art, discussing Pop Art "seriously," he said, "because I feel it is serious." Museum attendance was soaring: after the 1960–61 season, MoMA estimated it had received 500,000 visitors; in the 1968–69 season, it took in exactly 1,033,254, indicating that the museum now had an interest in keeping precise track of its growth.

When the art critic Clement Greenberg railed against popular culture as "kitsch" in 1939, no one expected that barely two decades later the public would be able to choose from a vast array of unadorned entertainment and create its own hierarchy of taste. By 1960 new recording technologies and an enlarged radio spectrum disseminated vast amounts of popular music and talk; free television delivered to virtually every American living room was biting into the movie industry; theaters flaunted onstage sex and nudity; and inexpensive paperbacks appealed not only to the vast audience for sleazy thrillers and romance novels, but also to the increasing readership for serious fiction by John Updike, J. D. Salinger, and James Baldwin, as well as reprinted classics. Pop Art seemed to bridge the gap between short-lived popular entertainment and the timeless value of serious art. "No movement in art history ever established itself so swiftly," wrote the critic Calvin Tomkins. Pop "seemed to thrive without benefit of friendly critics or curators." Half a century later, many art-world people interviewed about Pop Art's impact break into a broad, nostalgic smile.

The Abstract Expressionists were horrified at the intrusion of these upstarts on their hard-won turf. At a Hamptons beach, where these artists now summered, a sign appeared: "No Pop artists beyond this point." Despite their eventual success, the Abstract Expressionists were too outraged and bitter to realize that *they* had created the liberated atmosphere where new kinds of art could thrive. "The paint can had to be tipped over before the hot dog or comic strip panel could be considered an object for aesthetic investigation," wrote the art historian John Rublowsky.

> Abstract Expressionism was a turning within; pop art is a turning without. . . . Democratic, expansive, irreverent, brimming over with confidence and vitality, pop art accepts our world and seeks the beauties produced by this world. With the pop movement, American art becomes truly American for the first time and thus becomes universal.

In sharp contrast with such enthusiastic observations, the British museum curator and art writer Mario Amaya offered a more elitist description. He observed that while demand for "Art with a capital A" had never before been more intense, "few people know what to expect from a work of art. . . . [It] washes over them like a giant beach-wave. . . . They move like stunned sheep through galleries."

There were few "stunned sheep" at the newly renovated and enlarged spaces of New York's Jewish Museum, where an exhibition of fifty-five new Rauschenbergs opened on March 29, 1963. According to Rauschenberg's biographer Calvin Tomkins, the event was "the first of the wide-open, see-and-be-seen roaring art world galas" that became defining landmarks of the sixties art scene. Cigarette smoke mingled with the sweet aroma of marijuana as men and women in evening clothes took the measure of each other while mingling with grungy artists and hangers-on, all casting an occasional glance at the art on display. The audience could hardly ignore one work titled *Broadcast*, which emitted a raucous sound from three radios tucked behind the painting. The piece was also interactive: a viewer could twist the control knob to switch to a different screeching.

The museum's director, Alan Solomon, had bought the first Rauschenberg to enter a museum collection from the first Castelli show when he was still curator of the Andrew Dickson White Museum of Art at Cornell University. An art historian with a Harvard PhD, Solomon was a specialist in contemporary art and had formed such a keen friendship with Castelli that some art-world observers insisted the dealer had paid him to exhibit Rauschenberg. Castelli recalled Solomon as "an elegant man with a great deal of authority" when he first appeared at his gallery. He wore carefully styled long hair and custom-made suits and had recently undergone surgery that freed him from needing a hearing aid.

Solomon's catalogue essay for the Rauschenberg exhibition was a model of erudite "artspeak": the curator cited the artist's recent interest in Marcel Duchamp, to the extent of buying a replica of Duchamp's *Bottle Rack*, an early readymade, and dedicating one of his combines, *Trophy II*, to the Dadaist elder. However, Solomon noted that tracing an artist's influence had become "increasingly difficult . . . because the modern press transmits ideas so rapidly . . . that a photograph in a picture magazine may have a profound effect on a painter."

THE POP REVOLUTION

A week or two after the Jewish Museum opening, and just two blocks south, the Guggenheim presented its own take on Rauschenberg, including him and Johns with Pop artists Lichtenstein, Warhol, Dine, and Rosenquist in "Six Painters and the Object." The exhibition was organized by Lawrence Alloway, who had been hired as the museum's chief curator. He connected Rauschenberg with such precursors as Courbet and Van Gogh, who had also taken inspiration from common life. In the catalogue's introduction, the museum's director, Thomas Messer, gingerly approached this group's work. "Is it art?" he asked, answering, "Yes and no." A concurrent lecture series further stressed the connections of Johns, Rauschenberg, and the Pop artists with the earlier tradition of using everyday subject matter in art. This tack, especially the parallels drawn between the two artists and the Pop aesthetic, irked the historian Barbara Rose, who was then married to the minimalist artist Frank Stella and writing her landmark history *American Art since 1900*. She insisted that Johns and Rauschenberg "want nothing to do with Pop, whereas Pop wants a lot to do with them." She also argued that earlier depictions of the everyday were intended to elevate popular taste, while Pop Art was made for the same limited public that had appreciated Abstract Expressionism. She deplored the widespread media coverage that had attracted a wider audience as "irony to the third power."

These exhibitions found an echo in London, where the Whitechapel Gallery organized a large Rauschenberg retrospective for February 1964 — forty important paintings and thirty-four drawings illustrating Dante's *Inferno*, which had already been acquired by MoMA. The exhibition broke all attendance records, attracting even curious working-class Cockneys living nearby. A Sunday night BBC cultural telecast, *Monitor*, featured Rauschenberg, described in the London magazine *The Spectator* as "a humorously quiet, intensely serious explorer of thirty" — he was actually almost forty — who "has extended the Surrealist frontier into our gadget day when art has finally lost its definition." A columnist in the London paper the *Daily Herald* wondered, "Can the man paint? There is plenty of evidence that he can. But he is keeping very quiet about it." Still, the *Times* called the show "the most exhilarating art exhibition in London," and the *Telegraph* critic named Rauschenberg America's most significant artist since Jackson Pollock.

That same year, Alan Solomon was selected as commissioner for the American pavilion at the thirty-second Venice Biennale. Solomon intended to exhibit a cross-section of current American art: Color Field painters like Morris Louis and Kenneth Noland; what he called "germinal painters," Johns and Rauschenberg; as well as younger artists they had influenced: Jim Dine, Claes Oldenburg, Frank Stella, and John Chamberlain. "I want this show to do for Europeans," he said, "what the Armory Show had done for Americans." The Americans seemed unlikely to win any prize this time; since the Biennale's revival after the Second World War, this prestigious international art competition had been dominated by School of Paris artists. Furthermore, Sam Hunter, a Brandeis University professor, was the only American on the seven-person jury. Still, Hunter admired Rauschenberg. A year earlier, he had organized "New Directions in American Painting" at Brandeis; his catalogue essay linked Rauschenberg with the 1920s Dadaist Kurt Schwitters in his "sentiment for the disreputable, expendable, disenfranchised object fragments of the contemporary junk heap."

In Venice the American pavilion was considerably smaller than those sponsored by other, mostly European, countries. It had been built in 1929 by New York's Grand Central Galleries, which had been founded just seven years before that by the Impressionist Edward Greacen and John Singer Sargent. After the hiatus of World War II, the revived Biennale soon became embroiled in the cold war. In 1948, when a Communist coalition victory seemed likely in Italy's first postwar election, MoMA took over management of the pavilion in order to buttress the American presence in Venice. In 1962 "an opening to the left" by the Italian government prompted the American government's foreign propaganda arm, the United States Information Agency (USIA), headed by the respected newsman Edward R. Murrow, to take over the pavilion. The architect Philip Johnson had volunteered to design a replacement for the absurdly small imitation-Georgian building, but budget problems prevented any action.

Touching down in Paris on November 22, 1963, while en route to Venice to look over the American pavilion, Solomon learned of President Kennedy's assassination. Worldwide grief over this tragic event was bound to cast a shadow on and perhaps influence the outcome of the Biennale, opening just five months later. Because the American pavilion was so

small, Solomon decided that only one of Rauschenberg's twenty-two submissions would be shown there; the rest would be exhibited in the former American consulate on the Grand Canal, next to Peggy Guggenheim's palace.

A week before the opening, the city was already buzzing about rumored machinations, negotiations, and intrigue. Each day, promptly at noon, 7 P.M., and midnight, the international art world assembled for fresh gossip on the terrace of Café Florian in Piazza San Marco. Rauschenberg was often mentioned, his biographer Calvin Tomkins observed, though it was "usually in an also-ran context." Heightening the turmoil, Venice's Cardinal Urbani forbade all Catholic priests, nuns, and monks to visit the Biennale. The Vatican's official publication *L'Osservatore Romano* backed the cardinal. Its editor explained to Alexander Eliot, who was covering the Biennale for *Art in America*, that current painting and sculpture pointed to dire "social perils. The seismograph needle may vibrate even though we feel no motion . . . leading to decadent subjectivism." Eliot concluded that the church considered making new art "a quasi-criminal activity." But Leo Castelli seemed determined to change that outcome. He relied on his

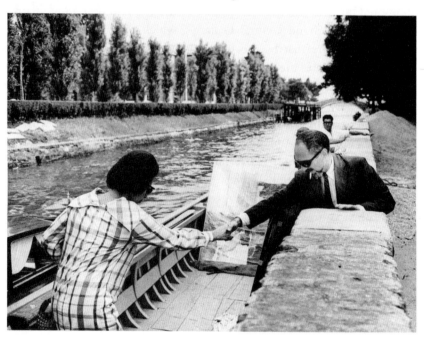

Alan Solomon ferries paintings and guests at the 1964 Venice Biennale

own prestige among European art folk, his native command of Italian, and the extra weight lent to Rauschenberg's cause by the presence of Ileana Sonnabend, whose Paris gallery had given the artist three exhibitions since 1961. Indeed, in the months leading up to the Biennale, in no small part owing to Sonnabend's efforts, European publications had been packed with articles about Rauschenberg; the extensive coverage was both good and bad, but all of it helped garner his name wide attention.

One of Castelli's first tasks was to help Sam Hunter reverse a decision by the six other judges to ignore the twenty-one Rauschenbergs at the former American consulate. Leaping into the fray, USIA hosted its own opening at the former consulate. Some four hundred journalists were invited to a cocktail party, but nearly eight hundred people showed up, eager for free drinks and glimpses of celebrities and perhaps to see for themselves what all the fuss was about. Then the judges sent word that they, too, would visit the consulate but insisted that they would judge only works exhibited on the grounds of the Biennale. At that point, Alan Solomon announced that if Rauschenberg were disqualified, he would remove the works of all other Americans from the exhibition. Meanwhile, Venetian bookstores and newsstands were flooded with brightly illustrated magazines, pamphlets, and posters about the American painter. At the very last moment, the Biennale organizers allowed the Rauschenberg works to be moved from the consulate to the Biennale grounds, an event accompanied by ample hoopla, including photo ops of gondolas ferrying precious paintings along the canal. The gambit paid off; when the judges finally handed down their decision, the Golden Lion went to Rauschenberg.

The Venice Biennale was the most venerable and respected international art exhibition in the world. Held in the historic Arsenale and in public gardens built by Napoleon, some three thousand artworks from thirty countries were exhibited in twenty pavilions. One critic described it as a survey of Western civilization "in a gilded nutshell, a fine essence of culture and commerce and . . . trash." In the Soviet pavilion were portraits of "smiling smelters" and "mustachioed Uzbeks," in which even the Italian Communist newspaper *L'Unità* found "little to report." A correspondent for *Arts Magazine* described a voyage in which he was jammed into a vaporetto when he heard "a thin saturnine man whisper the name

Rauschenberg. The lenses of his dark glasses are perfectly blank; he uses a tone in which one warns that there is plague in the city."

When Rauschenberg's first prize was announced, the painter was at a dinner party hosted by Castelli; only around midnight did he show up for a rollicking celebration hosted by young Italian artists at Angelo's bar and restaurant. They lifted him to their shoulders and paraded around the Piazza San Marco before returning to Angelo's, where waiters were preparing to close. Instead, they stayed on until 4 A.M., drinking vodka supplied by the Polish juror and on-the-house champagne. After the formal award, which included a $3,200 prize, Rauschenberg underwent rapid-fire questioning by surging paparazzi, while sipping a giant screwdriver. His cheeky replies to shouted questions seemed to have been drawn from the Beatles' playbook at their New York press conference six months earlier ("Won't you please sing something?" "We need money first"): "Why do you make big paintings?" "Because I get paid more." But there was more to Rauschenberg than this glib banter would suggest. At a lavish celebratory lunch Castelli organized on the island of Burano, Calvin Tomkins, who was then working on a *New Yorker* profile of the artist, asked

Rauschenberg at the Biennale awards ceremony, Venice 1964

him how he felt about winning. Rauschenberg replied that the artists' party "really got to me . . . it really did mean something after all."

For many Europeans, Rauschenberg's award was shattering. No American had ever won a first prize in painting, and only one, Alexander Calder, had won a first prize in sculpture; lesser prizes had gone to James McNeill Whistler in 1895 and Mark Tobey in 1958. The very idea that those overseas upstarts had seized an honor established by — and expected to be awarded to — Europeans led to bitter reflections. *Le Figaro* attributed Rauschenberg's prize to error, false values, and "an apocalyptic atmosphere," possibly even treachery, and *Le Monde* reminded its readers that not a single member of the Biennale jury was French. Then cultural columnists weighed in. Raymond Cogniat accused the United States of aggressively undermining France's leadership in art, Pierre Mazars deplored Pop Art's military-style scheming, and Pierre Cabanne dramatically denounced the Americans' use of Pop Art to "colonize Europe." In Italy, Turin's *La Stampa* furiously denounced the new Americans as "modern savages, psychically close to those redskins who a century ago celebrated their rites wearing crushed top hats on their heads and sardine cans

around their hips." Milan's *Corriere della Sera* wrote that Pop artists contributed to "the disintegration of the world" and demonstrated "a frightening mental squalor." Conservative Europeans, who desired a return to subject matter after decades of abstraction, were not pleased either. Having hoped for a return to "naturalism . . . with its green meadows, little pink nudes, galloping horses, dripping sirloins of beef," they were confronted instead by Pop visions of things they considered wretchedly vulgar.

These anguished laments were carefully preserved in the Castelli Gallery files as American media reported Rauschenberg's triumph. *Life* magazine devoted four pages to the "lanky Texan" who said he had actually slept in the rumpled pile of pillow and quilt he immortalized as *Bed*, a work Castelli later gave to MoMA. "I think of it as one of the friendliest pictures I've ever painted," the artist told *Life*. "My fear has always been that someone would want to crawl into it." On the cover of the same issue was a photo of Kennedy's killer, Lee Harvey Oswald, and his wife, Marina; the juxtaposition suggested that worldwide sympathy for America's loss might have affected the judges at the Biennale. A rare by-lined article in the same issue attempted to explain Rauschenberg's motivation. "He is a kind of Noah, shepherding into his art everything he thinks is worth salvaging from contemporary America," wrote Rosalind Constable. "Take another look at 'ugly' America, he seems to be saying, there is more beauty in it than meets the eye."

While declining to discuss accusations that he had manipulated the Biennale result, Castelli clearly took the negative comments to heart; almost a decade later, he told an interviewer that "people thought of me as . . . a sort of monstrous schemer, that I had Alan Solomon in my pocket, that I was . . . corrupting the whole art world." For an article in *Partisan Review*, he insisted that "Ileana Sonnabend and I had absolute faith in his importance and worked very hard to make Rauschenberg a famous painter." And more than twenty years after the Biennale, he was still calling such conspiracy accusations "ridiculous." Rauschenberg's prize had resulted from the artist's many European exhibitions before the Biennale, "so the stage was set."

Still, though art insiders may have been grumbling about Castelli's soaring international influence, artists were increasingly beating a path to his door. At first, Ivan Karp had been seeing ten or fifteen artists each

week, but the numbers steadily increased, until by the end of the decade he was seeing thirty-five to forty hopefuls armed with slides and photos and, on occasion, a station wagon piled with canvases. They were arriving from small college towns, from every corner of the country, and often presenting works that Karp considered better than much of what was being shown in New York. Part of the influx was due to Castelli's vigorous national outreach on behalf of his artists. The gallery was always ready to help newspaper art writers from anywhere in the country with photos and information about the latest New York art scene. Often, their articles were prompted by local galleries that were working in partnership with Castelli or by local collectors.

But for at least one powerful art critic, rancor over Castelli's supposedly Machiavellian activities at the 1964 Biennale persisted for more than three decades. Robert Hughes, the longtime arts commentator at *Time* magazine, host of a television series on American art and author of the best-selling *American Visions: The Epic History of American Art*, devoted a long paragraph in his book to how Rauschenberg's first prize caused a "severe case of aesthetic heartburn among Italian and French critics." Furthermore, the artist's victory sealed not his evident talent, but "what the art world already knew, that . . . collecting power, museum clout, promotional and dealing skills" had made New York the locus of artistic talent and "the imperial center of Western contemporary art." As for the American institutions meant to protect and preserve aesthetic excellence, he warned, "the wider culture of middlebrow spectacle was encircling the museum."

Chapter 3

BUT IS IT ART?

1962 – 1966

"Pop Art Sells On and On — Why?" went the plaintive headline in May 1964, above John Canaday's sardonic article in the *New York Times Magazine*. After five years as chief art critic of America's newspaper of record, Canaday had acquired a reputation for witty prose, as well as an urbane resistance to various art factions that attempted to browbeat his taste. He was also the first *Times* critic with a solid background as an art historian. A graduate of the University of Texas, he held an MA from Yale, had studied at the Ecole du Louvre in Paris, taught at Tulane University, directed the Philadelphia Museum of Art's Education Division for nine years, and prepared a popular book series, Metropolitan Seminars in Art, for the venerable New York institution. When he joined the *Times*, he was fifty-two years old and steeped in the modernist canon. Understandably, Canaday reacted warily to the advent of Pop Art. He wondered about the staying power of works he saw as "just something old (commercial art) dusted off and jazzed up." Still, he noted that the 1964 Biennale was "loaded with Pop," and the blatant new direction was also "bulldozing its way through the groves of academe." Pop's improbable success "transforms the natural shudder of horror," he wrote, "into the artificially induced frisson of pleasure that . . . is the first test of a work of art."

Canaday was among the many experienced art historians and critics put off by a kind of art for which its friends couldn't even settle on a name; it was still being called, he wrote, "the New Realism, the New Romanticism, the New Social Consciousness, the New Landscape, or the New Fantasy," while its detractors called it "the New Fake and the New Tragedy." One commentator dismissed Pop as "a form of aesthetic slumming," and a bewildered viewer wrote to a West Coast magazine, "I am

now convinced that the true mission of art is to stink." Little wonder that Ivan Karp later recalled the art world's hostility as "palpable."

A devotee of the Museum of Modern Art, Canaday was especially confounded by the new art's deviation from the pattern that had distinguished all previous avant-gardes since the advent of modernism almost one hundred years earlier. As described by the Impressionism scholar John House, the four essential ingredients were "the primacy of pictorial, formal qualities . . . an underlying notion of progress towards the goal of 'pure' painting . . . the notion of an avant-garde . . . [and] qualitative judgment." Such criteria for judging a new art movement were widely shared, most prominently by the leading American art critics of the day — not only Canaday but also Harold Rosenberg, Clement Greenberg, and Thomas B. Hess. These men were simply unable to countenance an art style that mocked formal qualities, that had no intention of progressing toward any "pure" painting, that drew its subject matter from the popular culture Greenberg had dismissed as "kitsch," that proposed none of the kind of theory offered by past avant-gardes, and that was annoyingly successful without the noblesse oblige of the critics' "qualitative judgment." In fact, the whole notion of critics' handing down a judgment on art, the foundation of their careers, seemed threatened with irrelevance.

Canaday's best-selling text *Mainstreams of Modern Art* was published in 1964, abruptly halting its lively account of modernism in the late 1940s. It steered clear of Abstract Expressionism, whose members had been bombarding the *Times* with complaints about his antagonistic reviews. The devotion of Canaday and his colleagues to high culture seemed to reach back into ancient history, but in fact the barrier between high and low art had hardly existed before the mid-nineteenth century and the advent of widespread literacy and mass media. New technology, especially photography and lithography, first broadened the public's access to art, and highbrow critics responded with ever-narrower definitions of what art *was*. In the late 1860s, when Edouard Manet began exhibiting his revolutionary compositions, they were assailed by the prominent French critic Jules-Antoine Castagnary as incoherent, lacking in "intelligible characters" and a "clear moral and ethical standpoint." Each figure in a painting "must be in its place, play its part, and so contribute to the expression of the general idea. Nothing arbitrary, and nothing super-

fluous, that is the law of every artistic composition." Castagnary accused Manet of assembling images "merely for the pleasure of astonishing . . . without any reason or necessity." The challenge of Manet and his fellow Impressionists to such conventional aesthetics formed the bedrock of the modernist narrative.

A similar event took place on the downhill side of the twentieth century. Taking their cues from such figures as Johns and Rauschenberg, the Pop artists undermined the previous ruling style, Abstract Expressionism, and in a very few years replaced modernism with an as-yet-unnamed new era eventually to be called Postmodernism. Like Manet and his colleagues in their day, the Pop artists were expressing, as the feminist writer Gloria Steinem wrote, "the spirit of 'Now.'" It was Robert Rosenblum, an art historian at Princeton specializing in the nineteenth-century French scene, who first noted the parallels between angry reactions to the Impressionists' enterprise and the critical furor over Pop, pointing out that in both cases, the artists had overturned traditional definitions of what constitutes a work of art. Rosenblum contended that criteria for judging art had changed many times in the past, as critics reacted to new art that flouted established expectations. He concluded that the Pop artists of the 1960s were following a long-established pattern of avant-garde rejection of previous standards, just as the Impressionists had rejected the academic artists and the Fauves had rejected the Impressionists. Rosenblum counseled "a pluralism that can find pleasure in the widest range of different types of art," a liberating marketplace of aesthetic notions. In his first essay about Pop Art, published in the summer of 1964, he asserted that these new works had been "seldom looked at very closely and questions of definition and discrimination were ignored." Instead, the artists were "quickly lumped together into a movement" demanding "wholesale approval or rejection." As Rosenblum defined it, real Pop "offers a coincidence of style and subject"; its artists depict "mass produced images and objects by using a style . . . also based upon the visual vocabulary of mass production."

Rosenblum said he came by his views about what would come to be known as the Pop aesthetic during the late 1950s, "almost by accident," when he felt "deep down responses" to the works of Rauschenberg and Johns. He had arranged to spend several days each week in New York, often dropping by the Castelli Gallery — "Leo was my god," he said —

but ultimately it was his own "raw, visceral experience" in seeing the work of Lichtenstein and his fellows that shaped Rosenblum's affection for Pop. The young professor paid dearly for that affection. When he presented his views at a symposium at the Detroit Institute of Arts, another participant, the artist Robert Motherwell, treated him as though he "had left the Catholic Church"; and, Rosenblum added, "a series of excommunications followed." The artist and art writer Cleve Gray was aghast that, after writing about Cubism, Rosenblum supported Pop, "as though I'd defiled the canon." Barbara Rose and Robert Hughes treated him with "snooty" disdain, he said, and Harold Rosenberg insisted that the Pop artists were "mindless, uneducated American boys." Nevertheless, Rosenblum had the last word as he moved to a prestigious named professorship at New York University and curated important exhibits of Pop Art at the city's museums.

What Rosenblum's colleagues, on both sides of the Atlantic, seemed to be missing was that the Pop artists were not so different from some of the predecessors being nostalgically lamented. Like Brueghel's peasants in revelry, Rembrandt's dissections, and the Impressionists' depictions of *petits métiers*, Pop Art reflected the visual landscape surrounding it — even if that landscape didn't correspond to what the general populace (or, more to the point, its putative tutors) considered "good" art. The fact that this landscape, in both America and Britain, was increasingly dominated by commercial signposts and products, the fact that Pop "regressed" to a representational approach after a half-century of increasing abstraction surely raised many hackles, and perhaps intentionally so. But it's difficult to listen to the vehemence that greeted Pop without hearing an undertone of panic, the kind that greets not just a new artistic style but a true upheaval. Like the Impressionists who ushered in modernism, the Pop artists were harbingers of an undeniable change in aesthetic perceptions and attitudes, and not everyone was ready to accept it.

While critics grappled over a cold war in a paintpot, the New York art scene, what John Canaday had called "the art circus," was rapidly expanding as it showcased new performers on the high wire. In a single week in early 1964, there were eighty-two art openings, with some four hundred galleries exhibiting more than fifty thousand paintings. The impetus was "a bigger and richer public eye for art." So wrote Grace Glueck, a *New York*

Times reporter charged with gathering art-related news. Augmenting John Canaday's weekly critiques, she busily trod the art beat and published animated tidbits in a weekly column called "Art Notes." Glueck had no specific training in art, but she had a keen nose for what readers might like to know and a direct, friendly style for presenting it. For twelve years after graduating with a degree in English from New York University, she had been shunted around various *Times* departments, as a flunky booking models and registering clothes for the men's fashion section, as a typist and receptionist in the women's news department, and occasionally composing a fictitious letter to the editor. As she later joked, "I clawed my way to the bottom." When she asked for a writing job, the Sunday editor replied, "Why don't you go home and get married?" Finally, on November 22, 1963, the day after the Kennedy assassination, she was assigned to write a breezy art column to balance the Canaday reviews that the editor considered too pedantic. For his part, the "august art critic," she said, deemed such writings "trivial." However, the overall editor for the paper's "Arts and Leisure" section, Seymour Peck, urged Glueck to expand her newsy column to include art reviews and to cover the downtown art scene. "Interview all the crazies," he urged.

Given that assignment, Glueck's first stop was a visit with Ivan Karp, who, she assumed, was well acquainted with "the crazies." For seventeen years, Glueck enthusiastically covered her beat, educating her readers while also entertaining them. In a single column in February 1964, she interviewed the A & P supermarket heir Huntington Hartford, who opened the short-lived Gallery of Modern Art on Columbus Circle; reported that national art museum attendance in 1962 had soared to forty-five million and was still rising; and announced that a London gallery had acquired three hundred Soviet paintings that "will seem to Western eyes decidedly *derrière-garde.*"

Meanwhile, she also pursued Happenings and other bohemian revels downtown. In April 1965, for example, she was at 222 Bowery, "a beehive of art studios." In his sixth-floor walkup there, Wynn Chamberlain, "the painter of people unadorned by clothes," was hosting some 130 "culture lovers." They listened to William Burroughs read his consciousness-altered prose and watched as he "ripped down a white-sheet backdrop . . . uncovering a painting of horrifying tarantulas." Like a Broadway name-dropper,

Glueck described the crowd as "a fairly sedate lot": a slender girl named Kiki "dressed like the heroine of an old Western"; the painter/jazz musician Larry Rivers, whose wife, Clarice, appeared in an eye-catching "white fluffy coat"; the photographers Diane Arbus and Richard Avedon bustling around; the painters Larry Poons, Barnett Newman, and "the pop art guy" Andy Warhol; the German electronic composer Karlheinz Stockhausen; Eve Auchincloss, an editor at the highbrow *New York Review of Books*; the artist Marisol in slacks and a green hair bow; and Patrick Lannan, "a distinguished gray-haired businessman known for art collecting and financing of little magazines," and, later, for creating a foundation to support avant-garde arts. As the party crowd left shortly before dawn, Glueck took note of the dead-drunk denizens of that tragic street splayed out around the doorway.

Although Glueck's prose seemed to flow in a chatty, informal stream, as a colleague observed, "she bleeds when she writes, and rewrites, and rewrites." She was also considered a heroine in a defining 1960s crusade: erasing the inequality of women in the workplace. Six years after she started writing "Art Notes," the *New York Times*'s publisher, Arthur Ochs Sulzberger, circulated a memo to the staff asserting that the paper "believes in equal opportunity employment because it is morally, economically, and socially right." He mentioned "advancement for blacks and Hispanics," to which Glueck replied with a question: why was the newsroom totally dominated by white men? She never heard another word from upstairs. Several months later, an announcement of top editorial staff changes again listed not a single woman. By then, activism for women's rights was sweeping across the country; in 1971 Glueck helped organize the Women's Caucus at the *Times*. A colleague, the correspondent Nan Robertson, described her as the movement's "resident wit . . . she leavened its serious purpose" as the newspaper's management was forced — perhaps shamed — into implementing the publisher's promise of equal opportunity.

Collectors were among Glueck's most eager readers; they could breeze through her chatty reports without being slowed down by weighty critiques. More important, she was not shy about mentioning art prices. Such market data had been dropped by art publications decades earlier; nor did this crass information sully the reviews of serious critics. Still, a

growing group of devoted art collectors were interested in the value of what they owned or what they might consider buying. These considerations were reinforced by the stunning appreciation of Impressionist works at auction, beginning in the 1950s. A single painting by Edouard Manet, the landmark *Bar at the Folies-Bergère*, had sold for an auction record of $40,000 before the Gabriel Cognaq sale in 1952, when a far lesser work, *Portrait of a Young Girl*, brought in $45,000. By 1958 *La Promenade*, which Manet's dealer Durand-Ruel had sold in 1922 for some $8,000, was bought at the Jacob Goldschmitt sale for $356,000; and *Rue Mosnier aux Drapeaux,* sold in 1898 for $1,960, went for $452,000. (These sums may seem paltry in today's inflated market, but they astounded art insiders at the time.) Works by such recent American artists as Jackson Pollock were already selling privately for as much as $25,000. Such dramatic profits for patient collectors were bound to influence the thinking of those buying new art in the late 1950s and early sixties. Mostly people from the business world, they were naturally enchanted with access to the art, the artists, and the art galleries populating this new form of leisure. But they were also aware that this enjoyable pastime could prove a wise investment.

Harry N. Abrams had been collecting art since 1936, when he began assisting Harry Scherman, the founder of the Book-of-the-Month Club. In 1950 Abrams struck out on his own to publish art books; by the early 1960s, the postwar wave of interest in art had brought him financial success. Paintings by Cézanne, Picasso, Matisse, and Modigliani covered the living room walls of the Abramses' Manhattan apartment, but perhaps swayed by recent stratospheric prices for works by the younger artists, by the mid-1960s, Abrams was ready to replace everything with Pop. A George Segal environment, *Artist's Model*, had already commandeered an entire room, and other Pop works were rambling throughout the hallways. Abrams sometimes hung a potential Pop purchase among his French masters. "If it holds its own in this company for ten days," he said, "I keep it." He was excited to live with "an art that's really contemporary," he told *Life* magazine. "These young painters are so filled with vitality and ideas — they've given us a new way to look at things. . . . They may even be changing our whole idea of what art is."

Leon Kraushar was fifty-two years old and "sad eyed" when interviewed at his modern house in Lawrence, Long Island, by William

Zinsser, a professor and author who was curious about Pop Art. A partner in a New York insurance firm, Kraushar had never collected anything before encountering a Lichtenstein in the fall of 1961. "I couldn't get it out of my mind," said Kraushar. He bought it and soon had snapped up more than one hundred other Pop works. "There is no other art," he said. "The other stuff is all history." Kraushar warned visitors that they would encounter "a lot of strange art." The dining room was dedicated to food, mostly Claes Oldenburg's plaster replicas of edibles, but also an oversize Warhol titled *Campbell's Beef Noodle Broth*. When he brought home Lichtenstein's *Hand with a Sponge* in 1963, Kraushar recalled, his wife had joked that "if you want to see a hand with a sponge, you can always watch me." But she had no objections when her husband added seven rooms to house the Pop collection. He liked to go into his study around four in the morning, he said, and smoke three or four cigarettes. "I don't even look at the pictures," he said. "I just know that they're there . . . and I have the biggest collection in the world." He compared his art collection to his stock holdings. "This is the time to buy," he said, "because Pop is never going to die. I'm not selling my IBM stock either." Kraushar died at the age of fifty-four in 1967, shortly after experiencing the thrill of exhibiting the cream of his 200-item collection at the Castelli Gallery.

A few years later, Castelli described a typical collectors' scramble for works by Jasper Johns. The artist had created another version of his maps to sell at a benefit for the Merce Cunningham dance troupe. Frederick Wiseman, founder of a chain of Southern California car dealerships and an avid art collector, telephoned to ask Castelli his opinion of the latest Johns map. The dealer limited himself to the quiet observation that "it's very beautiful." The artist had expected $9,000 for it, but Castelli told the collector it would cost $15,000, and Wiseman agreed to buy it. Before he could go to the gallery to pick up the painting, another ardent collector, Vera List, dropped by and offered to buy it back from Wiseman for $25,000. He refused. She then picked another Johns painting, *Diver*. "How much is it?" she asked. Castelli wanted $30,000. List turned to her husband, Abe, dozing in a nearby chair, who woke to ask for "a little discount." Castelli demurred, saying, "I know you've got it, Abe." "All right," said Abe, "if Vera wants to buy it."

The "collectors with a capital 'C,'" stood out, said Castelli, "because

they go at it with a fantastic . . . violence. You can see them really shining with desire." They want to be closely connected with the art world, whether artists or "higher-ups in the museums," partly for "social prestige." As Castelli saw it, the investment aspect was only a secondary motivation, although "they are happy when prices of what they own go up. Then their action was confirmed." But at the point of purchase, "they don't give a damn if it is up or down . . . they are buying just because it's . . . the important thing . . . they want to help choose the important." More than anything else, said Castelli, "they want people to say, 'these . . . people really understood what was going on and had selected, invariably, the right paintings.'" At the same time, Castelli recognized that the new collectors, unlike most of their predecessors, "had worked for their money rather than inherited it, and they wanted their money in turn to work for them." Moreover, the dealer noted, while "buying status by buying art" had long been a motive, collectors in the sixties demanded more of their artists than just the work; increasingly, the artist was "expected to grace the wall and the dinner table."

William Zinsser, for his part, wondered if these collectors were "climbers, connoisseurs, or nuts," suggesting that many of them sought "a quick ride to cultural and social status," and that no previous art form had been so easy for "an instant collector" to embrace. Nor had it been as friendly. Zinsser quoted the pioneering architect Philip Johnson as saying that Pop made "the world a pleasanter place to live. I look at things with an entirely different eye — at Coney Island, at billboards, at Coca-Cola bottles. . . . It's fun to go into a supermarket now." The new art "is no shy maiden whose secrets need to be teased out," Zinsser concluded. "'Here I am,' it shouts, slapping us on the back, and we recognize it immediately."

With the hindsight of half a century, such snap judgments echo dully; conclusions drawn in the heat of the moment ring shallow. The art historian Barbara Rose was no friend of Pop, but she pointed out that many collectors of it were steeped in art history and had been steadily buying art as early as the 1930s. She, too, named Philip Johnson, who had founded MoMA's department of architecture in July 1932 and had served without pay, as well as William Rubin, MoMA's chief curator of painting and sculpture. The pressure from patrons and visitors to keep the museum's

collections up-to-date, she wrote, had pushed curators into aping collectors in a rush to acquire the new.

Richard Brown Baker could be described as a semiprofessional collector; sometimes he served on a jury selecting artists for a magazine article on new talent, sometimes he interviewed art-world personalities for the Smithsonian's Archives of American Art, and sometimes he wrote about new art, but most of the time he indulged his collecting passion, thanks to a trust fund built by a long line of Rhode Island entrepreneurs dating back to the founder of Brown University in 1804. His New England heritage at first made him wary of any kind of collecting. "It breathes of self-indulgence," he wrote, while "self-denial is our Puritan goal." However, he equivocated, in the mid-twentieth century, "not to be a collector may be as sinful as to be one." His trust fund did not extend to subsidizing artists, but, "quite selfishly," he determined to collect the works of artists barely emerging from obscurity. In 1952 he had started buying art haphazardly, but he soon began to focus on abstract art, including works by Hans Hofmann, Georges Mathieu, and Robert Motherwell. In December 1955, he had bought a Jackson Pollock, a Franz Kline, and a Jean Dubuffet "from sheer enthusiasm, and at greater cost." The Pollock he had bought for $2,500, *Arabesque*, was worth around $15 million when it starred in a MoMA restrospective in 1998. When Baker's collection was shown at the Yale University Art Gallery that year, it included an acquisition from 1961, a time, he wrote, when "few people . . . would ever wish to own a canvas by Roy Lichtenstein." Baker had bought *Washing Machine* for $500; a year later, he bought Lichtenstein's signature piece *Blam!* for less than $1,000.

Baker had studied at Yale and Oxford and worked for some years as a State Department specialist on Spain and Portugal. He began collecting art in 1952, scouting the few galleries in Washington, DC. He settled on contemporary works — a necessity, he said, "unless one is extraordinarily rich or tasteful. . . . So I would rather spend twelve hundred or two thousand dollars on a major Franz Kline than on a lesser Picasso." After leaving government service, Baker moved to New York's East Fifties, an easy walk to the galleries then centered on Fifty-seventh Street. "I was like a tourist with a new camera," he said, "going snap, snap, snap." Baker's perseverance and thrift became a legend among dealers. He was sometimes

spotted on a crosstown bus lugging a large wrapped painting. Asked why he didn't have it delivered, he snapped, "Too expensive." Every three months, he would make the rounds of galleries, handing out envelopes from a stack in his pocket: his quarterly trust payment had arrived. Asked why he didn't mail the checks, he replied, "Do you know the price of stamps?" Eventually, he acquired more than sixteen hundred canvases, most of which he gradually gave to Yale. When the consummate collector died in January 2002 at the age of eighty-nine, his *New York Times* obituary described "a tall, reserved man who . . . had the uncanny ability to seem aloof and approachable at the same time."

Richard Brown Baker and Robert Scull form the mismatched bookends to the chronicle of mid-twentieth-century art collectors. Whether by background, demeanor, aspiration, or social class, they contrasted in every way but one — their fascination with, and diligent search for, new art and artists. Their divergence illuminates the profound social change summarized as the sixties, a time when new wealth began invading Old Money's traditional preserves. Baker was a patrician to his fingertips, personifying the typical collector of the past — an individual of independent means and cultivated taste. Robert Scull and his wife, Ethel, were the children of Jewish immigrants, the first in their families to become aware of visual art — not only aware of but also passionately involved in. When they met, Ethel was a student at the Parsons School of Design and Robert styled himself an industrial designer, though in fact he had spent nine years working as a sign painter while attending college part-time. Married, they lived in a single room a few blocks from MoMA and entertained in the museum penthouse. Just as Leo Castelli described MoMA as "my university," the Sculls regarded the museum's exhibits as their personal art education. Although they genuinely loved art, they were also aware of the bottom line. Robert's first art purchase was an Utrillo bought at auction for $254, which turned out to be a fake. Still, he boasted of selling it for a $55 profit. By 1962 Scull would be far bolder, spending $1,400 for *Silver Skies*, James Rosenquist's sixteen-foot-long, six-foot-high depiction of a tire, a car windshield, a section of a soda bottle, and a girl's knees on a bicycle seat. "Even the artist thought I was crazy," said Scull; but when he was interviewed just three years later, the painting was already worth $10,000.

The Sculls had come into a modest gift when Ethel's father retired in

the mid-1950s and divided his taxi business among his three daughters. No doubt the most lucrative aspect of this business was the medallions, the permit that gives drivers license to pick up passengers. The supply of these medallions was restricted by city officials, and as demand for cabs began to rise in the early 1960s, the value of the permits rose with it, increasing from a few hundred dollars to $30,000 when sold at auction. (As of early 2009, the cost of a New York taxi medallion ranged between $600,000 and $750,000.) In a few years, Robert had transformed Ethel's share of the family business into a flourishing money-making machine. When *New York* magazine and *The New Yorker* caught up with the Sculls in 1966, their empire, Scull's Angels, included 130 taxis manned by 400 drivers — the medallions alone were worth $2,625,000 — as well as a taxi-insurance business, an apartment house, garages, and a few warehouses and factories in the Bronx.

By then, the pair had traced a glitzy trajectory across the New York art skyline. Like Richard Brown Baker, they had been collecting postwar art, mostly Abstract Expressionists, since the mid-1950s; but unlike Baker, the Sculls had sold a selection of these earlier purchases at Parke-Bernet Galleries on October 31, 1965, at an invitation-only evening sale. Included were works by Joseph Albers, Adolph Gottlieb, Mark Rothko, Philip Guston, and William Baziotes, all of which the Sculls had owned for under eight years. A de Kooning the Sculls had bought for less than $500 sold that evening for $37,000; the total proceeds of the auction were $165,000. Meanwhile, the Abstract Expressionists they still owned, plus works that Scull had bought from artists he "felt sorry for" in 1960 and 1961, were resting comfortably in a warehouse on East 107th Street.

The Sculls had begun visiting the Castelli Gallery soon after it opened in 1956, and they became clients two years later when they bought Jasper Johns's *Target with Four Faces* from the artist's first exhibition there. Leo Castelli described them as "rabid collectors," consumed by "a real hero worship of artists," though he deemed their attempt to buy out the entire show "vulgar." In addition to which, said Castelli, "when they give these things [to museums] and get good tax deductions, it is very satisfactory." Robert Scull agreed with Castelli's views. "The *real* art lover," he said, "buys knowing that he couldn't sell it for a nickel tomorrow." Scull enjoyed "freedom from anyone telling me what to buy.... It's all very well

to walk around a gallery and say, 'That's nice,' but when you actually buy it you commit yourself." Ivan Karp, for one, came to detest Scull — "rightly so," Castelli recalled, "because Scull really presumed enormously. [He was] immensely arrogant."

That arrogance and vulgarity became legendary among art-world denizens, to the delight of the gossip columnists — as well as to such assiduous society watchers as Andy Warhol. In Warhol's description, a typical Scull soiree might feature Ethel (who favored the nickname Spike) "instigat[ing] little intrigues and feuds that would peak in embarrassing scenes," and on at least one occasion screaming after James Rosenquist's wife, who had plucked a carnation from a centerpiece, to "put that right back! Those are my flowers!" Bob, meanwhile, handed one of the artists in attendance a fifty-dollar bill and ordered him to go buy some more refreshments. "Who could ever figure out how a man who behaved like that socially could have such a keen sense for art?" the awestruck chronicler wondered.

As the taxi business prospered, the Sculls moved from their tiny New York apartment to a spacious house in Great Neck, Long Island. There, Scull would regale visiting artists around his long dinner table with stories about "operating in the taxi business." Sometimes artists would turn up at his garage in the Bronx and loiter there all day. "It was crazy," Scull said later. "I wanted to talk about beauty and all they ever wanted to talk about was gangsters and dough." The critic Vincent Canby would later describe the Sculls, as they appeared in Emile de Antonio's documentary *Painters Painting*, "looking pleased and modest, and just slightly uncomfortable as if waiting for the next attack by the philistines who refer to him as the taxi tycoon when he is really the Lorenzo de' Medici of Pop."

Only after the collecting couple moved into a spacious apartment at 1010 Fifth Avenue, facing the Metropolitan Museum, did they attract the turned-up noses of the major media. In early 1964, an anonymous *Time* visitor described with bemusement "a normal, unpretentious, upper-middle-class American family" managing to "live with Pop, sleep with it, relax with it. And love it." The Met's director, James Rorimer, was coming for dinner "and finding out how avant a garde can get." The family's "mostly antique" furniture "cowers in the center of the [living] room," *Time* reported, "to make place for paintings." The Sculls' oldest son, aged

fifteen — who only recently had been taunted at school about his "old man the nut" — was now "buying Pop on the installment plan." When *Life* appeared at their door the following year, Ethel Scull described how her parents visited and said "not one word" about the art surrounding them. Scull exulted over living with Pop: "It's a ball . . . I love it."

In October 1966, Tom Wolfe described for readers of *New York* magazine the painting hanging above the headboard of their king-size bed — an *American Nude* by Tom Wesselmann, "with two erect nipples sitting up like hot cherries." Wolfe, a Yale PhD in American studies and himself a would-be artist, cited the Sculls as "the folk heroes of every social climber who ever hit New York." Their meteoric rise "in a blaze of publicity illuminated the secret route: collecting wacked out art." No stranger to celebrity himself, Wolfe wore his baroque writing style and white suit as boldly as Robert Scull presented his vulgarian manner and critical eye. Barely a month after Wolfe's piece was published, *The New Yorker*, then in an intense scuffle with the upstart *New York*, published its own lengthy — and only slightly less snippy — profile of the Sculls. Robert "is the patron of the moment of the art of the moment," wrote Jane Kramer. She asserted that collectors had become "the prime movers, promoters, and arbiters of taste," among whom "Scull is the busiest, the most powerful, and very probably the most ambitious." Both Robert and Ethel appeared enchanted with publicity, wrote Kramer; Ethel pasted all their clippings into a heavy red leather scrapbook, with "'The Sculls and the Press' embossed in gold leaf on the inside cover."

The Sculls were by no means the only outsiders to raise eyebrows in New York. Henry Geldzahler also managed to raise many an art lover's blood pressure during his seven-year tenure at the Metropolitan. A dropout from the doctoral program in art history at Harvard, Geldzahler was hired as a curatorial assistant in American painting and sculpture in 1960 at the age of twenty-five. Soon afterward, he appeared at a Provincetown cottage rented for the summer by Ivan Karp and his wife, Marilyn. "He wanted a full run-down on the New York art world," said Karp: "who are the luminaries, how to approach them." For some years, Karp met with Geldzahler regularly to share expertise. Geldzahler relished touring artists' studios with Karp or Richard Bellamy — Rosenquist, Lichtenstein, Warhol, Wesselmann, Dine, Oldenburg, Marisol, Segal — and introducing

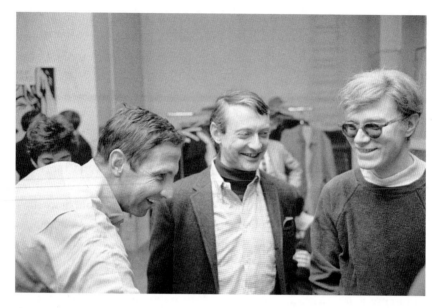

them to each other; he was surprised that many of these artists grouped into the Pop style weren't already acquainted. Geldzahler also relished visiting the back room of the Castelli Gallery, chatting with the artist Frank Stella "on many, many afternoons with a show by Rauschenberg or Chamberlain or Johns in the front." After about an hour, Geldzahler recalled, Castelli came out "in his shirtsleeves, clapping his hands and saying, 'Boys, boys, we run a business here.'" Geldzahler also recalled being thoroughly underpaid; at the Met, he said, the trustees viewed curators as "church mice who dedicate their lives to research in the corner somewhere" and paid him accordingly, $28,000 per year.

Still, income was not really a central concern for Geldzahler. Ivan Karp described Geldzahler's parents as "old Austrian patricians" who lived in "an imperious setting" on Central Park West. His father had been a diamond dealer in Antwerp, Belgium, when the family fled to New York, ten days before the Nazis arrived in the fall of 1939. Like the Castellis, the Geldzahlers brought ample resources to establish themselves comfortably. Henry, the younger of two brothers, was a pudgy boy who lisped and struggled at P.S. 166 on Manhattan's Upper West Side. After receiving speech therapy, he became sociable and popular at Horace Mann School in Riverdale and was elected president of the senior class. Following a BA

"Kings of Pop": Rauschenberg, Lichtenstein, Warhol, 1965

at Yale, he went on toward a PhD at Harvard but left after two years. Hired at the Met, perhaps with his father's help, he found a pleasant apartment in a brownstone at 112 West Eighty-first Street, a ten-minute crosstown ride to work. The street was gentrifying, as Puerto Ricans who had transformed the neighborhood into a barrio were displaced by young professionals and families who reconverted the interiors into deluxe urban dwellings. The gingko trees lining the block had carefully planted flowers at their base. Then, on December 13, 1962, just two years after joining the Met, the twenty-seven-year-old arts connoisseur would face the most difficult challenge of his career.

The event was a symposium at MoMA organized by Peter Selz, another refugee from the Nazis who was sixteen years older than Geldzahler. Selz presented a daunting résumé. Born in Berlin, he left Europe in 1936 at the age of seventeen and was taken in by a distant relative, the photographer Alfred Stieglitz. He worked at the New Bauhaus while pursuing an MA and PhD in art history at the University of Chicago, and went on to a Fulbright fellowship at the University of Paris. Beginning in 1955, he taught art history and directed the art museum at Pomona College; in 1957 he was named a trustee there. Selz had also published two important books, *Understanding Modern Art* and the definitive study *German Expressionist Painting*. Upon his appointment as curator of paintings and exhibitions at MoMA in 1958, he proposed an ambitious series of exhibitions, beginning with "New Images of Man" in 1959. For this show, he avoided contemporary artists and relied on well-worn modernists such as Dubuffet, Bacon, Baskin, and de Kooning. The symposium panel Selz was now assembling, though ostensibly about Pop, seemed to take a dim view of anything beyond familiar modernism. It included Stanley Kunitz, a poet and editor who had recently been named to the National Institute of Arts and Letters; Hilton Kramer, then managing editor of *Arts* magazine; Leo Steinberg, Hunter College professor of art history; the art critic Dore Ashton; and Geldzahler.

The audience packed into the auditorium included Andy Warhol, Robert Rauschenberg, Roy Lichtenstein, Leo Castelli, Sidney Janis, Robert and Ethel Scull, Ivan Karp, John Cage, and Marcel Duchamp. Acting more like a prosecutor than a moderator, Selz showed slides of works by Rauschenberg, Johns, Indiana, Rosenquist, Warhol, Thiebaud,

and Wesselmann and assemblages by Marisol, Kienholz, Niki de Saint Phalle, and H. C. Westermann. Geldzahler then presented the case for the defense. "Pop art is the new landscape painting," he stated, citing an Ogden Nash quatrain from 1933:

> I think that I shall never see
> A billboard lovely as a tree.
> Indeed, unless the billboards fall
> I'll never see a tree at all.

"The billboards haven't fallen," said Geldzahler, "and we can no longer paint trees with great contemporary relevance. So we paint billboards." Responding to charges that Pop was not art, he noted that after Duchamp and Johns, "the artist defines the limit of art," and the critic or the curator "should not predict [or] goad the artist into a direction" that would make the critic more comfortable. He also pointed out how swiftly Pop Art's dealers, critics, museums, and collectors had overcome "nostalgia for the good old days when the artist was alienated, misunderstood and unpatronized."

Rising for the prosecution, Hilton Kramer simply asserted that Pop had no value. He then identified Marcel Duchamp, "the most overrated figure in modern art," as the archinstigator of that movement. Someone who sat near Duchamp thought he discerned tears in the elderly artist's eyes, but according to a journalist in the hall at the intermission, Duchamp mildly suggested that Kramer was "insufficiently lighthearted." The rest of the panel was uniformly critical of Pop. Dore Ashton vaguely described it as "only a chance encounter in the continuum of random sensation"; Leo Steinberg equivocated; and the poet Stanley Kunitz said Pop struck him as "neither serious nor funny enough to [be] more than a nine days' wonder." When the audience was consulted, a free-for-all ensued. And then the media discussion began. In the *Village Voice*, Jill Johnston mocked the panelists as "excellent representatives of the public, because they barked up all the dark alleys that always manage to confuse the actual situation" — except for Geldzahler, who "made the only knowledgeable statement on the panel." Afterward, Ivan Karp told an interviewer that the audience was more hostile than sympathetic and that he felt "surrounded by Apaches."

Sensing support from the inconclusive symposium, Peter Selz continued to pummel Pop Art; he seemed to take Geldzahler's challenge as a personal insult to his heritage and education — the spare, intellectual aesthetic of the Bauhaus. Had he not guided a generation of students through the orderly parade of avant-gardes from the Impressionists through the Fauves and Cubists, the German Expressionists and on to the triumphant American Abstract Expressionists? Did no one care about his prolific writings on modernism? Had he not already contributed the article on painting to the *Encyclopedia Britannica*, as well as individual articles on Delaunay, Kandinsky, Franz Marc, and several others? Did his status as a director of the College Art Association signify nothing? In the summer of 1963, Selz unburdened his pain and dismay in *Partisan Review*, the left-wing periodical that had published Greenberg's "Avant-Garde and Kitsch" twenty-four years earlier. In a tone of certainty similar to that of French critics damning Manet's innovations, Selz decried the current kitsch of Pop: "absolutely nothing at all to say . . . hardly worth the kind of contemplation a real work of art demands . . . limp and unconvincing." Taking a psychoanalytic tack, he suggested that the abundance of food depicted by many of these artists revealed "infantile personalities capable only of ingesting, not of digesting or interpreting," while the "blatant Americanism" of many of these works conveyed "a willful regression to parochial sources." He bitterly accused Pop Art of being as "easy to consume as it is to produce." Better yet, he said, it was "easy to market," allowing "eager collectors, shrewd dealers, clever publicists, and jazzy museum curators" to bring "the great American device, obsolescence, into the art world." He even accused Pop Art of resembling Nazi and Soviet art in its "complacent acquiescence to the values of the culture" and found it "most ironic" that this "extension of Madison Avenue is presented as avant-garde."

Selz reprised much of this anti-Pop tirade at the Los Angeles County Museum of Art in August 1963, when six selections from a Pop exhibition assembled by the Guggenheim were shown with six comparable California artists. *Time* magazine's art writer caught him picking an argument with the curator, Lawrence Alloway. To Selz's recap of his *Partisan Review* article, Alloway replied that he was "talking nonsense" and defending "an elite view of culture." Selz's views, however, found strong support

in the *Los Angeles Times*, where the art critic Henry J. Seldis employed the very same phrases Selz used in *Partisan Review* to lambaste their common enemy: "least iconoclastic and most chauvinistic . . . crass commercialism . . . built-in obsolescence."

There was more at stake in these confrontations than a mere curators' debate when Selz carried his anti-Pop campaign to the very place where the movement had originated, the London Institute of Contemporary Arts. Invited to talk about the current exhibition, "The Popular Image," Selz provided "an amazing evening," according to the British art critic Norbert Lynton. The critic had never heard "an eminent man in the modern art field denounce a contemporary movement in such extreme terms." Nor had he expected almost the entire audience, most of whom had never seen an American Pop work, to agree so enthusiastically with Selz. Lynton believed that most of the sneering was due to Pop's success, that "museums and the smart private buyers got in there before the wise men had time to pin down . . . the species . . . or perhaps before they had flirted and slept with the new star."

While Selz was still fuming, Geldzahler moved steadily on. In 1963, he joined H. Harvard Arnason, a Guggenheim Museum administrator and author of a leading textbook on the history of modern art, and the artist and critic James Brooks in judging the Sixty-sixth Annual Exhibition of American Painting and Sculpture at the Art Institute of Chicago. He also appeared on a public television program about Pop Art, telling the *New York Times* that he intended to discuss this new art "seriously . . . to prove that what the Pop artists are doing just didn't happen to — shall I say pop? — out of the sky." In 1964 Barbara Rose named Geldzahler second to Richard Bellamy as "the person dearest to budding artists. . . . His enthusiasm and accessibility are a constant source of encouragement for those who have yet to arrive." In 1965, now named the Met's associate curator of American painting and sculpture, Geldzahler authored a comprehensive illustrated catalogue for the exhibition "American Painting in the 20th Century." That same year, the National Endowment for the Arts was founded, and Geldzahler took a leave from the Met to serve as first director of the agency's visual arts program, doling out hundreds of thousands of dollars while being paid just $12,500 per year. While he willingly took charge of decision making, recalled a colleague, he furiously demanded to

know why letters went unwritten and checks to grantees unmailed; he had no idea that these details were part of his job description. One day the agency's lead lobbyist, Livingston Biddle, was showing a congressman through the NEA office. They saw Geldzahler seated at the director's desk, wearing a white linen suit and white broad-brimmed hat and smoking a foot-long cigar. "Just *what* is that?" whispered the congressman, and Biddle hastily launched into a soothing discourse on the close links between eccentricity and genius.

Meanwhile, Peter Selz was by no means alone in attempting to disembowel the Pop bête noire. Immediately after Lichtenstein's Castelli exhibition in early 1962, Max Kozloff, art critic for *The Nation* and a professor of art history at New York University, sounded the alarm. In *Art International*, he warned that "art galleries are being invaded by the pin-headed and contemptible style of gum-chewers, bobby-soxers, and worse, delinquents." Lichtenstein's work, he wrote, "is a pretty slap in the face of both philistines and cognoscenti." And he concluded that "if there is a general rule underlying the new iconography, it is that there is no rule, no selectiveness about it. Anything goes, just as anything goes on the street." Kozloff also deemed any message in these Pop works opaque, "a demonic Pentecost of hipsters." The following year, when Selz was on the Fulbright screening committee, Kozloff received a grant for a year of study in France.

Clement Greenberg, who had done so much to establish the Abstract Expressionists at the center of the art scene, was no longer writing regularly after 1960, but he lectured widely at museums and colleges, never failing to dismiss Pop as "Novelty Art," a passing fad not to be confused with anything avant-garde. Harold Rosenberg, the other grand old man of modernist criticism, also envisioned Pop Art quickly circling down the drain, but when it remained afloat after 1962, he waved it off as "Gagart." *Art News*'s Thomas B. Hess flogged "the vanguard audience" for trying to make up for "the lost dimension of meaning" in Pop works by simply inviting "the artist himself to dinner."

While these condemnations of Pop Art germinated in more or less scholarly environments, the more popular media seemed to take a comparatively benign view. "Much as it may outrage Pop, not to mention Grandpop," wrote *Time*'s still-anonymous critic, Pop Art had arrived at center stage. "Symposiums discuss it, art magazines debate it, galleries

compete for it." The article quoted the respected architect Philip Johnson, long a supporter, who called Pop "the most important art movement in the world today." Popular magazines took to Pop Art "with an outraged, scandalized, priapic delight," observed Tom Wolfe; he saw art openings as the focus of New York "social excitement," replacing theater openings as magnets for "the chic, the ambitious, and the beautiful."

Nor were the tabloids the only ones starting to lend a favorable ear. Alan Solomon, in an essay for the catalogue of the 1963 exhibition "The Popular Image" at the Washington Gallery of Modern Art, remarked on the "extremes of unabashed delight or renewed anguish" that greeted Pop. The anguish, he noted, was expressed mainly by "unsympathetic critics," while the Pop artists were enjoying "a spectacular success in a relatively short period of time" among "advanced" observers and collectors.

Such widespread attention may have persuaded Thomas Hess to reconsider Pop as more than a fad. In November 1963 he dispatched his correspondent to conduct a series of interviews with Pop artists that he hoped would clarify what this "most successful of new Isms" was about. G. R. Swenson's conversations with eight artists have since become classic source material for historians. Often cited is his description of de Kooning's tirade against Jasper Johns. The older artist had complained about Castelli: "That son-of-a-bitch; you could give him two beer cans and he could sell them." Johns, who was making casts of light bulbs and flashlights, told Swenson: "It seemed to fit in perfectly with what I was doing." So Johns made castings of two Ballantine beer cans, and, he said, "Leo sold them."

Also of note is Tom Wesselmann's complaint about lovers of Pop: "Some of the worst things I've read about Pop Art have come from its admirers. They begin to sound like some nostalgia cult — they really worship Marilyn Monroe or Coca-Cola. The importance people attach to things the artist uses is irrelevant." And finally, there is Robert Indiana's pugnaciously nationalistic explanation of Pop's essence:

> America is very much at the core of every Pop Work. British Pop, the firstborn, came about due to the influence of America. The generating issue is Americasm [sic], that phenomenon that is sweeping every continent. French Pop is only slightly Frenchified; Asiatic Pop is sure to

come (remember Hong-Kong). The pattern will not be far from the Coke, the Car, the Hamburger, the Jukebox. It is the American Myth. For this is the best of all possible worlds.

Self-confident as the statement sounds, however, Indiana was bypassing a crucial element. Though clearly taken with American popular imagery and attitudes, the creators of "Britpop" were drawing largely on a European model — mainly the Futurists, Dadaists, and Surrealists — and European avant-garde sensibilities, as opposed to the native and naive entrepreneurialism of U.S. Pop. As the historian Marco Livingstone pointed out, it was difficult for the British Pop artists, having experienced the austerity of the war years and the deprivations that continued in England for many years afterward, "to share the naïve optimism of an American dream in which they had no part." As such, while both sides made frequent use of popular culture and its imagery, the Americans seemed content to view it with cool detachment, even reveling in the abundance of mass culture surrounding them, whereas the British tended to take a more critical, often savagely mocking, stance toward that culture and its products. Moreover, like their avant-garde predecessors, the British maintained a more interdisciplinary profile and a strong verbal component (in addition to Alloway, the group included several writers and critics), while the American Pop artists were not known for their verbal facility: one has only to think of Andy Warhol's famous monosyllables. (Like all generalizations, this contrast of U.K. and U.S. Pop has its limits; in 1963 the English writer Reyner Banham, evidently caught up in both the art and the slang culture behind it, enthused that the "way in which Roy Lichtenstein can take one narrative square out of a comic strip . . . and transform it into an icon demanding attention in its own right is something wild, man.")

The British were not the only ones taken aback by the Americans' brash iconography. In an editorial accompanying Swenson's article, Hess attempted an explanation for the shock he felt when the simulacrum of "the billboard on the noisy parkway" turned up "in the hushed museum." Intellectual to the core, he compared it to the "alienation effect" of Bertolt Brecht's theater, where the actors play their roles but also convey a political message. This analogy was particularly timely in that Brecht and

THE POP REVOLUTION

Kurt Weill's *Threepenny Opera* had captivated theatergoing New Yorkers during a record-breaking seven-year run that ended in December 1961. If only Pop Art could highlight "a detail of ugly Americana" as *The Threepenny Opera* excoriated capitalism, then Hess could approve of it. But instead, he lamented, it "keeps urging that everything is pretty rosy," a message as sugary as that of the French nineteenth-century salon artists.

By the mid-1960s, two massive challenges routed leading art critics like Hess, Greenberg, and Rosenberg: a growing public was educating itself about art without resort to their magisterial rulings, and fresh young competitors brandishing Ivy League PhDs in art history were challenging the very notion of having any opinion at all. Like Robert Rosenblum, they believed there were many kinds of worthwhile art and many ways to appreciate what artists were creating. Meanwhile, dealers and collectors, relishing the increased affluence, were pushing these potent tastemakers of the past toward the margins, as the same affluence emboldened museums to speed new artists into their exhibitions and collections. Technical changes added to the ferment. The brilliant hues of fast-drying acrylics dominated the new art as the new offset printing process enabled the colorful blooming of magazine illustrations and advertising. The modernist pattern of an embattled minority struggling over the years for recognition was finished. Like it or not, Robert Rauschenberg's victory in Venice signaled the birth of a new era and a new catch-all category: contemporary art.

Not that Pop's opponents went quietly. Alfred Frankfurter, who had edited *Art News* during the 1930s, when modernism itself was under attack, deplored Pop Art and may well have ignited the skepticism of his colleague Thomas Hess. In 1964 Frankfurter thought he spied a connection between Pop's success and the nomination that summer of the vociferously conservative Arizona senator Barry Goldwater as the Republican presidential candidate. Frankfurter, an old-fashioned socialist, blamed both phenomena on "the American bourgeoisie"; he worried that the well-paid working class was joining that retrograde caste, acquiring homes and cars and moving into "deadly dull suburbs." He described "this herd" as waxing angry over "a literature too candid, an art not immediately legible," and always susceptible to "sales-expert hypnotists."

Still, a milder, more thoughtful breeze, perhaps warmed by the sunny art itself, was beginning to temper the frosty winds blowing at Pop Art. Neither the critics nor New York's narcissistic social elite, it seemed, could argue with the economic benefits the new art was delivering. In the *New York Times*, Paul Gardner filled almost a column with a description of a springtime opening at MoMA: an orchestra playing popular tunes as guests danced amid imposing sculptures; flowers floating in pools lit by flickering candles; trustees downing "ice-cold champagne with artists and collectors." The Whitney hosted similar events, where "an ambassador's wife in a Dior gown and a chapeau by Mr. John sips a dry martini" while chatting with "an artist who is so famous that he looks elegant in blue jeans and a plaid shirt." At a Martha Jackson opening, such was the sociable buzz, Gardner wrote, that when "an outsize Picasso ceramic fell off the wall, the guests continued talking as they quietly moved away from the scattered fragments."

The London art critic Edward Lucie-Smith found New York "the most exciting [place] in the world for anyone with a serious interest in contemporary painting." He marveled that 150 exhibitions would open in January 1963 and noted that MoMA was displaying new acquisitions "as if the only duty of art was to astonish." New York's politicos took note. An annual report to the mayor in 1964 put gallery, museum, and exhibition sales in the city at $67.8 million. The following year, the city's Cultural Alliance sponsored a conference, "The Municipality and the Arts," at the exclusive Carlyle Hotel on Madison Avenue. More than 250,000 New Yorkers had arts-related jobs, the alliance reported, and visitors' spending on arts pumped some $2.5 billion into the municipal economy.

These figures reflected inordinate prosperity, not only in New York but elsewhere in the United States and in Western Europe. Even the British historian Eric Hobsbawm saw his lifelong Communist beliefs challenged by the postwar "escalator which, without any special effort, took us higher than we had ever expected to be." While the middle-aged clung to traditional chores, he noted, "youth was the secret ingredient that revolutionized consumer society and western culture." He cited American sales of rock 'n' roll recordings, music appreciated almost exclusively by people in their teens and early twenties, which zoomed from $277 mil-

lion in 1955 to more than $2 *billion* in 1973. The American left-wing sociologist C. Wright Mills also sensed that "our basic definitions of society and of self are being overtaken by new realities. . . . Our major orientations — liberalism and socialism — have virtually collapsed." He took a more pessimistic view of affluence. "Society," he wrote, "has become a great salesroom. . . . In the mass-society, fashion becomes universal."

In the mid-1960s, popular magazines sought to connect with the evident social change that scholars described. The cover of *Esquire* magazine's July 1964 issue featured a traditional-looking couple romantically touching foreheads above a Lichtenstein cartoon couple. He: "Why do you bore me all the time!!!"; she, teary-eyed: "Rat!!" Inside, the magazine spotlighted Pop Art to illuminate a long pop-sociology essay, "The New Sentimentality." It argued that traditional American values — Patriotism, Love, Religion, Mom — as depicted by Norman Rockwell, had been replaced by "personal interest . . . your primary objective is to make your life fit your style." The old sentimentality included the war hero and president Dwight D. Eisenhower, the sports hero Jackie Robinson, and the film heroine Grace Kelly; the new sentimentality featured the diva Maria Callas, the rock star Elvis Presley, and the dealer Leo Castelli. In art, Jackson Pollock was old because he personified "the Romantic artist, the life burned out, the garret," whereas Lichtenstein was "new because he puts art on, sees no terror in humor, has no values."

Six months later, Harold Rosenberg, whose writings in intellectual periodicals had been key to establishing Abstract Expressionism's dominance in the postwar years, dissected "The American Art Establishment." In that tarnished but lucrative world, he wrote, "talk is the most potent propellant for art or artist." Readers wishing to enter were urged to drop names in the right places, pass along gossip, learn the jargon, and appear at "exhibition openings, parties, bars, and beaches where to be seen creates a presumption of belonging." However, he warned newcomers that "there is no center, only individuals and institutions without a dominant authority or etiquette." Rosenberg lamented the fact that crass publications — *Fortune*, the *Wall Street Journal*, and *Barron's* — were now focusing on high art prices; the stress on money, he complained, had left the public's taste floating "on tides of fad." The irony is that Rosenberg was now preaching not from the highbrow pages of *Partisan Review*, the peri-

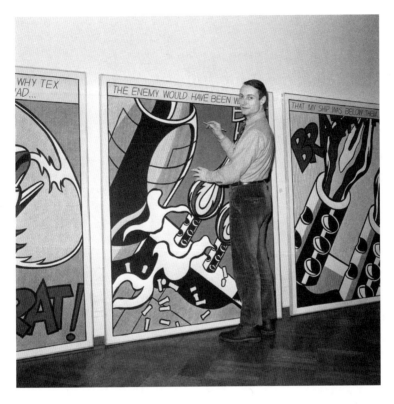

odical with which he had long been associated, but from with-it *Esquire*, arguably the same kind of "crass publication" he was lambasting.

Rosenberg was not alone in his pilgrimage from the tendentious to the tony; a number of other midsixties intellectuals also found their way to middlebrow, big-circulation magazines. In 1965 William Seitz, a Princeton MFA and MoMA curator, explained the new avant-garde to readers of *Vogue*. His article, tucked among advertisements for Dior and Yves St. Laurent, explained that the artist's path to acceptance no longer involved years of deprivation and scorn; instead, "scouts of the mass media" now behaved "like hunters in duck season," scanning the horizon "for any flutter of wings that could herald the next trend." The result was a chaotic free-for-all, in which "unknowns become blue chips before museums and scholars, with their concern for thoroughness, significance, and truth, have time to react." Barbara Rose waded into the fray with a tart think piece in *Encounter*, a transatlantic (and, it was later revealed,

Unafraid of humor, Lichtenstein "sketches" his triptych As I Opened Fire *in pencil*

IT WAS AN ITSY BITSY
TEENY WEENY YELLOW
POLKA DOT BIKINI

CIA-funded) monthly. She, too, blamed the mass media for conjuring up a "glamorous fictive art world, in which super-stars 'make it'" on the "Big Board." But academe was equally to blame, she charged, as the number of symposia, seminars, and other discussions dealing with Pop in the previous two years "might well equal the total campus discussion of all 20th century art." Pop Art, she said, attracted "the kind of morbid curiosity that the prurient businessman feels toward the prostitute he patronizes . . . revulsion is mixed with admiration."

As the experts were summoning reinforcements for established taste-makers, the fearsome stain of Pop Art was seeping into the hinterlands beyond the Hudson River, often aided by the Leo Castelli Gallery. One engagement took place in March 1965 at Lafayette College in Easton, Pennsylvania, a small liberal arts institution, where thirteen Pop works loaned by Castelli were shown as "Emblems Public and Private." The local organizer, Dr. Johannes Gaertner, professor of languages and fine arts, told

"A parody of art itself": Mondrian Comb *by Ray Johnson (1969)*

the local newspaper's reporter that Pop Art "is really a parody of art itself
. . . not to be taken seriously." The article also noted that an average Pop
painting could be had for $2,000, whereas a Pollock abstraction was sell-
ing for more than $100,000. A month later, Ivan Karp lectured at the
opening of a Pop show in Milwaukee and smiled when someone suggest-
ed the exhibits were "so bad they are good." Afterward, some 750 visitors
"gyrated among the eighty-six works," the local newspaper reported, as
jukebox music "rocked the gallery." A woman studying a painting of a
pinball machine said she had viewed half the show and "hadn't stopped
smiling yet." Six weeks later, Castelli himself gave a talk at the opening of
a Rauschenberg exhibition at the adventurous Walker Art Center in
Minneapolis. He told the audience that painting was "a better form of the
moment than writing," that the public had lost interest in "longwinded
essays. They want to see it at one stroke."

At the same time, Castelli was pioneering European sales via the
Sonnabend Gallery, which had made a number of strategic connections
with dealers on the Continent, especially in Germany. Castelli, who
believed in the artists he championed, was determined to get them "into
museums or into collections" that would afford them the greatest visibil-
ity, even if this meant forgoing income for himself. Rather than a
"Machiavellian plan," he had "an inkling that the American collector
would respect an American artist much more if you sold in Europe." And
the equally energetic and committed Sonnabend, to whom he entrusted
exclusive European rights, was just the woman for the job — to the point
where some American museum directors eventually began fearing that,
like their French counterparts in the Impressionist era, they would one
day find that all the period's best and brightest homegrown work had
migrated abroad. But despite brisk sales, the Castelli Gallery was always
short of money, said Ivan Karp. "If we have a little success, we spend it on
some new drapes, or we redo the floors, or we fix moldings." Seven peo-
ple worked there full-time; two photographers, two conservators, and a
frame maker were on constant call.

In 1966 Castelli attended the Venice Biennale and "went hoarse lob-
bying" for Lichtenstein, but an Argentinean kinetic artist, Julio Le Parc,
won first prize instead. By a fluke, Henry Geldzahler was the commis-
sioner for the American pavilion. Lawrence Alloway had initially been

appointed, but his boss at the Guggenheim, Thomas Messer, did not care for Alloway's selections. Alloway then quit his job at the Guggenheim, and oversight of the pavilion went to the Met, which chose Geldzahler. *Time* described the thirty-one-year-old curator as "a plump underdone dumpling in granny spectacles" who had already sat for several artists "as a pop statue." In the catalogue, the dumpling asserted that the experiments of the artists he chose — a tactful mix of Helen Frankenthaler, Jules Olitski, Ellsworth Kelly, and Roy Lichtenstein — "are successful. They paint beautiful pictures."

By now, even many of Pop's critics were getting on board — though some notable holdouts still remained, and one of the staunchest was Peter Selz. In 1964–65 Selz had been chair of the Fulbright committee screening artists' applications for scholarships, a position that effectively kept grants out of the hands of Pop artists and their sympathizers. At around the same time, he tried putting his weight behind a "counterweight to Pop," the short-lived Op Art movement, though the visually dazzling approach soon devolved into fabric patterns and decorative clichés. And Robert Rosenblum, who worked with Selz at MoMA, recalled him vowing that the museum would acquire a Lichtenstein canvas "over his dead body."

Shortly before the 1966 Biennale, Selz stepped down from his job at MoMA to take up a far less prestigious position at the University Art Museum in Berkeley, California. In a long memo to MoMA's founding director, Alfred Barr, he suggested several possible replacements for himself. But in a parting shot he emphatically urged that the museum *not* hire Lawrence Alloway, Alan Solomon, Henry Geldzahler, or any other friends of Pop.

Chapter 4

A MOST UNLIKELY
AMERICAN HERO
1964 – 1969

On a spring day in 1961, a slight, ghostly pale young man shyly ambled into the Leo Castelli Gallery on East Seventy-seventh Street and told Ivan Karp he was looking for something by Jasper Johns. The dealer doubted that this unimposing fellow could afford a substantial Johns work, then selling for at least $2,500, so he brought out a small pencil-and-graphite wash drawing of a light bulb, listed at $500. The visitor balked at even that price and eventually agreed to pay $350 in installments. He wondered if there was anything else of interest, perhaps in the back room. Karp brought out a painting by another artist, delivered personally by the latter just a week earlier and depicting a cartoonish bathing beauty holding a beach ball above her head; it was titled, appropriately, *Girl with Ball*. The visitor was astonished, and after seeing another work by the same artist, he stammered: "Oooh, I do paintings like that." Now it was Karp's turn to be astonished. Could the work of this shadowy, retiring fellow form another in the string of successful exhibitions that in just three years had vaulted the Castelli Gallery into the forefront of New York's vanguard art scene?

That same afternoon, Karp loped two blocks east to Lexington Avenue and twelve blocks north to number 1342. Accustomed to finding new artists in cold-water flats and grungy tenements, he was surprised to see only one name on the doorbell of this four-story townhouse in an elegant neighborhood: Andy Warhol. To prepare for the dealer's arrival, the artist had hurriedly cleared the front parlor of any evidence of his lucrative commercial art career, leaving Karp to discover what had formerly been a psychiatrist's office. It was "a very dark place," he recalled, "beautifully decorated with fine, elegant furniture and beau-

tiful paintings . . . generally surrealistic." A single record, the bouncy pop tune "I Saw Linda Yesterday" by Dickey Lee, played and played for some three hours, the entire time Karp was there; it was so loud that the two men could hardly hear one another. Still keeping to the shadows, Warhol explained that by listening to the same song all day he could feel "what the guy was trying to get around to." (According to the biographer David Bourdon, replacing his preferred classical recordings with blaring rock 'n' roll was also Warhol's way of keeping "important visitors from the art world" off balance.) Looking at the paintings stacked against one wall, Karp experienced an aesthetic roller coaster: "Very much taken . . . and astonished . . . and refreshed . . . and amazed . . . and affronted . . . all at the same time." Karp had encountered the work of Lichtenstein, Rosenquist, Oldenburg, and Wesselmann in the space of just a few months; now, finding another artist focused on popular images gave him "a sitting-up-in-bed" feeling: "Something very strange was going on in the art world." Years later, he described "a state of thralldom . . . experiencing tremors day and night."

The paintings Karp saw that afternoon were all drawn from the most ubiquitous popular images — cartoons, Coke bottles, dollar bills, and tabloid advertising — but they were executed in wildly contradictory styles: some bore drips and slashes reminiscent of Abstract Expressionist work, and others simply enlarged bald newspaper advertisements for nose jobs and corn plasters, and oversize comic-strip characters like the hard-boiled Dick Tracy and porcupine-headed Nancy. Karp immediately sorted the two styles. He told Warhol that the hard-edged works were "the only ones of any consequence," the artist recalled, whereas those with dribbles and drips were just "homages to Abstract Expressionism and are not." Perhaps trying to soften the blunt verdict, Karp asked, "Am I being arrogant?" As Warhol remembered it, Karp also said he had "intimations" that "something shocking was about to happen." Karp had barely returned to the gallery before a messenger arrived with an enormous package tied with a red bow. It was the Nancy painting, with Warhol's thank-you note on the back.

This was the kind of gesture Andy Warhol had perfected during his ten-year climb to the summit of New York's commercial art world. In 1957 he had won the Art Directors Club Medal, and three years later, a

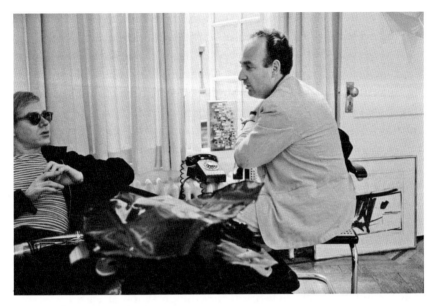

time when the average engineer was earning $1,000 a month, he plunked down $60,000 in cash for the Lexington Avenue townhouse. *Women's Wear Daily* had anointed him "the Leonardo da Vinci of Madison Avenue." A good deal of Warhol's financial success can be attributed to his brilliant ideas and diligent execution, and certainly his career and biography attest to a vaulting ambition. But he also benefited from the unprecedented growth of the advertising industry. Between 1950 and 1960, spending on national magazine advertising jumped from $515 million to $941 million; the space devoted to newspaper advertising, much of it created in New York City, more than doubled.

During this decade, Warhol worked his way into almost every corner of the commercial art scene. His nervously blotted lines were signature touches on illustrations for I. Miller shoes, record album covers, magazine articles, advertising brochures, theater programs, book jackets, art gallery invitations, magazines, shopping bags, and lingerie promotions. In 1957 *Life* magazine featured a double-page spread of his fanciful exhibition titled "Crazy Golden Slippers," named for such celebrities as Zsa Zsa Gabor and Julie Andrews and for such of his heroes as James Dean, Truman Capote, and Elvis Presley. Every art director in New York regularly received flyers, postcards, holiday greetings, and, occasionally, a little book with hand-

Andy Warhol and Ivan Karp, 1965

colored illustrations. But all that transitory success had faded as he cleared out the evidence of his commercial activities just before Karp's visit.

The very next day, Karp showed up again at the Warhol townhouse, this time bringing with him Henry Geldzahler. Geldzahler relished meeting an artist on the verge of a professional breakthrough, and Warhol was impressed with the Metropolitan Museum connection. The artist also shrewdly observed, "Henry doing an instant appraisal of every single thing in the room," as he wrote much later, lingering on "the Carmen Miranda platform shoe, four inches long with a five-inch heel that I'd bought at an auction of her effects." When Geldzahler invited him to view Florine Stettheimer's naïve paintings in storage at the Met, Warhol appeared there the following day. He was certain that "anyone who'd know just from glancing around that one room . . . that I loved Florine Stettheimer had to be brilliant." The shy young man concluded that Henry would be "lots of fun. . . . Right away we became five-hours-a-day-on-the-phone-see-you-for-lunch. Quick — turn-on-the-Tonight-Show friends."

For his part, Geldzahler understood Warhol's dream of being a fine artist "and, though he never mentioned it, to be a star." Years later, he recalled Andy's urgent, late-night call, insisting they meet immediately. "Couldn't it wait?" asked Geldzahler, pointing out that it was 2 A.M. and he was in bed. Warhol insisted, "We've got to talk." When Geldzahler arrived a half-hour later at a restaurant, Warhol was sitting silently in a booth. "Finally," Geldzahler wrote, "I asked him why he had gotten me out of bed. Andy said, 'We've got to talk . . . say something.'"

Ivan Karp's boss, Leo Castelli, on the other hand, took a different view of Warhol. Brought to the townhouse by his younger associate, Castelli was unenthusiastic about Warhol's works, but nevertheless he bought two paintings of Campbell's soup cans for $30 each. Warhol's work was too similar to Lichtenstein's, he told Karp; furthermore, the artist seemed "terribly peculiar, and his work even more peculiar." That decision left Karp free to market Warhol on his own, which he did to important effect. He carried slides, photos, and sometimes actual paintings to other dealers, persuading the dealer Allan Stone, among others, to take several works for his gallery on upper Madison Avenue. Warhol's paintings "had no surface life," Stone said, but he liked "the bravura of the soup cans." Karp also took potential collectors to see Warhol, hoping to pique their interest.

For some eighteen months, in fact, Karp acted as Warhol's private agent, with Castelli's tacit approval. In contrast to the public's negative response to the Lichtenstein show, the fifteen collectors Karp brought to Warhol in the first three months all bought something. Among the biggest buyers were Burton and Emily Tremaine, who told David Bourdon: "We thought he was naïve, a new Douanier Rousseau — how wrong we were!" In 1962 they bought fifteen Warhols, at prices ranging between $100 and $400. Karp received the standard 25 percent dealer's commission from the artist.

Some of the works Warhol sold during that time had already appeared publicly in New York but had stayed under the radar of art-world scrutiny. Just before his first encounter with Ivan Karp, several of the paintings — *Popeye*, *Nancy*, *The Little King*, *Superman*, and the nose-job painting, *Before and After* — had been displayed in the windows of Bonwit Teller, the posh Fifth Avenue department store: Warhol's job as window dresser was another part of his perennial quest for income. But it was his series of soup cans, precise depictions of the thirty-two varieties of Campbell's soup, that finally caught the art public's attention.

The soup cans were first exhibited in July and August 1962 at the Ferus Gallery, one of the handful of contemporary art venues in Los Angeles. Its director was Irving Blum, a transplanted New Yorker, who had dropped in on Warhol's studio at Geldzahler's urging, in search of the comic-book paintings. Warhol told him that "a guy in New Jersey" (Lichtenstein) was doing such paintings "better than I did, so I'm doing these now." He brought out the soup series, and Blum agreed to show them. Still, although Warhol was "thrilled" about the exhibition, it attracted few buyers. Blum himself had paid $50 for six or seven of the paintings; he sold them for twice that amount to the actor Dennis Hopper and several other enthusiastic collectors.

Most people who saw the show, including local artists, were mystified, even hostile. There was hardly any serious interest, Blum said, but "a lot of carnival-like activity." A nearby art dealer caught the media's attention by stacking hundreds of real Campbell's soup cans in the window with a sign: "Buy them cheaper here — 60 cents for three cans." (Meanwhile, Warhol, never one to let pass an opportunity, arranged for a newsie to photograph him signing cans of Campbell's in a local supermarket; the

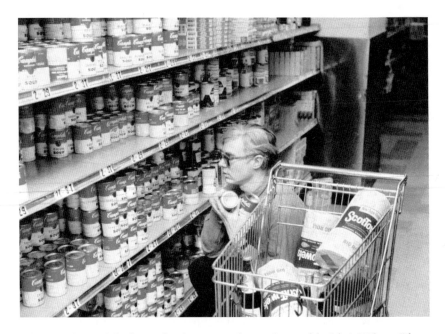

wire services picked up the image and sent it worldwide.) When Blum told Warhol about the limited sales, the artist suggested that the whole set should stay together. Blum agreed to buy all thirty-two paintings for $1,000 ($31.25 each), persuaded the Los Angeles collectors to cancel their purchases, and sent Warhol $100 a month for the next ten months. More than twenty years later, Geldzahler would describe the soup cans as "the *Nude Descending the Staircase* of Pop art . . . an image that became . . . the rallying point for the sympathetic and the bane of the hostile." Soon "Andy was Pop and Pop was Andy." The object's originators, on the other hand, were decidedly underwhelmed. "The Campbell [executives] are a staid, conservative people," Karp later noted. "For three years after Mr. Warhol glorified tomato soup, they said nothing. But recently they gave their retiring president one of Andy's paintings as a going-away gift. And if I may judge by the expression on the old man's face in the newspaper, there is nothing he wanted less."

In New York, Warhol told friends that his Los Angeles show was a sell-out — omitting the details — but at first no local gallery was willing to give him a show. Later that summer, however, Eleanor Ward, owner of the Stable Gallery, was sunning herself in the garden of her Connecticut vaca-

Art imitates art: Warhol confronts his muse at Gristede's

tion house when (as she recalled) a disembodied voice said two electrify-
ing words: "Andy Warhol." Ward had left for the country determined not
to think about who would fill the important November slot from which
she had recently ousted Alex Katz. "I *immediately* went into the house,"
she said and cold-called Warhol. She asked to look at his work, to which
he replied, "Wow!" When she saw the canvases, it was her turn to be
"absolutely stupefied . . . riveted." She saw versions of *Marilyn Monroe* and
Elvis Presley, Liz Taylor, and more Campbell's soup cans. She told Warhol
that November, the best month for galleries, was "by a miracle" available
for his show; his reaction: "Wow!"

Having just found success with Robert Indiana's first show immediate-
ly before Warhol's November 1962 debut, Ward had modest expectations
for the launch of yet another unknown artist. Warhol, though delighted to
get a New York venue, had also set his financial sights fairly low. He had
indeed sold out his thirty-two soup cans in Los Angeles the previous sum-
mer, but Irving Blum's purchase had netted him less than one-tenth of
what he could get for a single commercial drawing. And the reaction in
California had hardly been stellar. A Pasadena exhibit that included his
work *New Painting of Common Objects* had attracted only scorn from the
anti-Pop *Los Angeles Times* reviewer Henry Seldes, while the respected
critic Jules Langsner, reviewing the show in the low-circulation *Art Inter-
national,* confessed to being "uneasy" if not "cantankerously at odds" with
the "shrill acclaim" that some prominent art-world figures were heaping
on Pop. The depictions of common objects demanded attention, he
allowed, but "the initial shock . . . wears off in a matter of seconds."

Yet despite the West Coast demurrers, Warhol's show at the Stable did
reasonably well. Five of the twelve paintings sold, and three were reserved,
at prices ranging from $250 for *Soup* to $1,950 for *Coca Cola: 180 Bottles.*
The University of Nebraska Art Gallery bought *Baseball,* Warhol's first
silk-screen painting, for $1,800. Included in the show were several of
Warhol's first paintings of Marilyn Monroe, among them the *Gold Marilyn*
(bought by Philip Johnson and given to MoMA); a red *Elvis; 129 Die in
Jet (Plane Crash),* a Death and Disaster series painting that Warhol had cre-
ated from a front-page *Daily News* photo; *Close Cover before Striking,* a
matchbook advertising Coca-Cola; and a dance diagram, laid out hori-
zontally on a low platform to mimic the instructional charts the Arthur

Murray Studios used. Michael Fried, a disciple of Clement Greenberg, gave the show a mixed review; he considered the silk-screen technology "brilliant" but worried that Warhol's dependence on celebrity images would wear out. The "vulgar, heart-breaking icons of Marilyn Monroe," he wrote, could well be "unintelligible to [future] generations."

David Bourdon would later describe Warhol standing "timidly on the sidelines" at Henry Geldzahler's postopening bash, "a wallflower at his own party." He seemed flustered by the presence of some Abstract Expressionist devotees. One of the guests was Barbara Rose, who suggested that Warhol was an idiot savant; informed of that diagnosis, Warhol asked, "What's an idiot *souvent?*" Soon after the opening, Geldzahler brought Jasper Johns to Warhol's studio, to disappointing effect. Instead of looking at Warhol's work, Johns studiously flipped through a pile of Polaroids left on a nearby table. More than two decades later, Geldzahler explained that Warhol's "self-consciously anti-intellectual" attitude caused "Jasper's whole Wittgenstein side" to "rear up in horror." By contrast, Rauschenberg had visited Warhol's studio with the Castellis and was intrigued by the silk screens; he quizzed Warhol on details of his technique for making silk screens from photos. The huge works Rauschenberg then created using Warhol's methods were shown at his one-man show at the Jewish Museum the following spring.

Warhol had been crushed by what he saw as Rauschenberg's and Johns's cavalier treatment. He asked Emile de Antonio, a filmmaker and artists' agent who had befriended him in 1960, why those two already-successful artists shunned his quest for friendship. De Antonio said they considered him "too swish." Warhol protested that the post–Abstract Expressionist sensibility was, "of course, a homosexual one," but de Antonio explained that "these two guys wear three-button suits — they were in the Army or Navy, or something," and that they were "nervous because he collected paintings," something that "traditionally . . . just isn't done." Finally, said de Antonio, they considered Warhol a commercial artist, while *they* did commercial work "just to survive. They won't even use their real names. Whereas you've won *prizes!* You're famous for it." De Antonio later believed that telling Warhol about Johns's and Rauschenberg's disdain "made him very ambitious and angry . . . absolutely determined."

In reality, Warhol's dogged ambition was evident decades earlier and

hundreds of miles away, in an immigrant slum beneath the toxic skies of steel-smelting Pittsburgh, where he was born on August 6, 1928. The impoverished Warhola household — the family's actual name — included two older brothers, John and Paul, who went door-to-door around the neighborhood selling homegrown vegetables, while his mother, Julia, peddled artificial flower arrangements in foil-covered coffee cans. Nine-year-old Andy tagged after them during those bleak Depression days, trying to sell little drawings of flowers and butterflies. "At ten, he was hustling rich folks for portrait commissions," the maverick art historian Dave Hickey later wrote in an insightful essay, adding: "He never stopped."

Andy was often home from school, bedridden with a vague illness, sometimes identified as Saint Vitus's dance. It was during some of those cold winter days that Julia treated him to the soup that inspired his later, much-magnified cans. Like a primitive cave painter depicting a whole herd of bison — a visual prayer to make the images come to life and feed a multitude — Warhol obsessively depicted a whole array of Campbell's soups, two hundred of them, on a single canvas. They were created in the Lexington Avenue townhouse, where the widowed Julia dwelled in the basement, often emerging with a bowl of his favorite, Campbell's tomato. (After eighteen years of preparing Andy's soup and urging him to get married, she moved out of the house in the fall of 1970 and moved in with her older son John. She died in November 1972; Warhol, whose many renderings of skulls vividly illustrate his fear of dying, did not attend the funeral.) Warhol's father had died of blood poisoning in 1942, when Andy was fourteen. The boy may or may not have inherited $1,500 to help him attend art school; in high school, he may have been popular among his peers or marginalized as "weird" — one never quite knew what the real story was. What is known is that at the Carnegie Institute of Technology, Warhol demonstrated a nimble talent, not only to complete assignments but also to shock. To the Associated Artists of Pittsburgh's annual show, he submitted a self-portrait, *The Broad Gave Me My Face, but I Can Pick My Own Nose.* "He always appeared to be aspiring to do the right thing as best he could," wrote Hickey, "while inadvertently screwing up and doing something revolutionary."

The attempt to piece together a coherent Warhol history has exasperated an army of biographers, critics, interviewers, academics, and philoso-

phers, as Warhol evaded their questions and displayed contradictory aesthetic directions. Most irritating of all was his stubborn repetition: "Why don't you just make it up?" And, frustrated, they often did. Consulting books he allegedly wrote or cowrote is no less perplexing; the text of *POPism: The Warhol '60s* tells an engaging story, but its very coherence is testimony to the writing talent of coauthor Pat Hackett. Fragile of form, slow of speech, and hardly a cowboy, a movie star, or a gangster, Andy Warhol harbored a boldness born of desperation, a sheer struggle to survive, to live the American dream — as Frank Sinatra might have put it — "his way." To his benefit, Warhol's strivings meshed with the profound changes in American society later conflated into "the sixties."

The joys of living a self-invented life had always been an upper-class privilege, but in the 1960s that entitlement seeped down to engage large segments of the American public. Hippies and flower children, beatniks and Beatles fans, back-to-the-land collectives and militant individualists hastened to claim a permissive corner of the new society under the rubric "lifestyle." The Pop artists seemed to personify the change with their lighthearted colors and entertaining subject matter, but no one represented the age's rampant individualism better than Warhol. As people began calling others by their first names, everyone came to know who was meant by "Andy."

This familiarity, however, did not seep below the artist's carefully contrived surface. Rather, the one-liners endlessly repeated in the media represented not Warhol's genuine beliefs, but just another layer of an artfully designed cloak behind which the man sheltered. Did he *really* believe his prognostic in the catalogue of a 1968 Stockholm exhibition that "in the future, everybody will be world famous for fifteen minutes"? Is there a kernel of truth in the statement (published in his 1975 memoir *The Philosophy of Andy Warhol*), "Being good in business is the most fascinating kind of art"? What really motivated Warhol to pour "an astounding amount of energy and refinement into work of the most perishable nature," as the art historian Carter Ratcliff noted in a 1983 biography? "He presented himself so ambiguously that he gave the unfortunate impression that anybody could do work like this," commented Sally King-Nero, executive editor of the Andy Warhol catalogue raisonné. "In fact, he would physically examine every detail of every item."

In his fine-art persona, Warhol showed the same combination of pain-staking fastidiousness and throwaway insouciance. For his second show at Ferus in September 1963, he sent Irving Blum a 150-foot-long, 70-inch-high canvas scroll containing twenty-three images of Elvis Presley, all meticulously reproduced from the same original photo, along with assort-ed canvas stretcher bars. But when Blum phoned Warhol asking what he was supposed to do with it, the artist snapped, "Figure it out." Also in the package were a dozen 40-inch-square images of Elizabeth Taylor, all based, like the Elvis paintings, on a single publicity still. These were early versions of the hundreds of portraits — of friends, the famous, the wealthy, those alive and dead, as well as the artist himself — that Warhol would transform from Polaroid snapshots into silk-screened artworks and that would help bring him fame and fortune. But that year in Los Angeles, no one wanted any of them. Blum complained that the Elvis images "didn't look enough like art . . . they looked machine-made."

The real Elvis already lay hidden behind a machine-made image. A shy, ambitious poor boy in the cultural backwaters of the interior South, he had made his first tremulous visit to a struggling Memphis recording studio a few weeks after graduating from the local high school in June 1953. Just three years later, on September 9, 1956, Elvis Presley had gyrat-ed suggestively on *The Ed Sullivan Show* while 82.6 percent of the entire television audience watched his electronic image on their TV screens. Several years after that, Elvis was already a pop icon and Hollywood star, "the greatest cultural force in the twentieth century," according to no less an appraiser than Leonard Bernstein. But as his fame increased, the feral power of his persona and performances noticeably diminished.

Here was a model for another poor, shy boy, this one growing up in a northern backwater, aching for recognition. He labored obsessively over the Elvis images, creating striking variations on a banal source, a 1960 stu-dio photo promoting the film *Flaming Star*. The spray-painted silver back-ground — against which, as one critic wrote, Elvis "exud[es] stardom like a supernova near collapse" — hints at the fabled silver screen, while the black silk-screen images show wide variation in the density of black ink. Several also feature superimposed images of Elvis, mimicking his sugges-tive movements onstage, and others show two identical figures side by side. Warhol had clearly devoted long hours to manipulating that single

image. Blum anxiously tracked his progress, suggesting that the next Ferus exhibition "should be the most intense and far-reaching composite of past work, and the Elvis paintings should be shown in my rear gallery." But Warhol insisted that Blum concentrate on his newest creations.

Dennis Hopper had promised Warhol a "Movie Star Party" if he came to the opening on September 30. Such a lure from Hollywood persuaded Warhol to cross the United States in three days, riding with his sidekick Gerard Malanga in a station wagon, with the magic-realist painter Wynn Chamberlain and the poet and actor Taylor Mead sharing the driving. Warhol, who had never been west of Pennsylvania, was enchanted by the American roadside. "The farther west we drove," he wrote, "the more Pop everything looked. . . . We were dazzled. Once you got Pop, you could never see a sign the same way again." Everything he witnessed seemed to validate the art he had created by instinct, adapted from advertising, or copied from the headlines. The optimistic Coke bottles and Campbell's soup cans, the Marilyns and Elvises, counterbalanced the grisly electric chairs, horrifying airplane crashes, and gruesome road accidents. In their contradictions, they were all intimately entwined with the coast-to-coast panorama he was seeing for the first time.

Almost twenty years later, when Warhol had long been rich and famous, he still looked back on that first trip to Hollywood like a wide-eyed vagabond facing an uncertain world. He recalled none of the art on view at a seminal retrospective of 114 Duchamp works at the Pasadena Museum of Art. Nor did he mention the large group of California artists who turned out for the show, including Ed Kienholz, Robert Irwin, Ed Ruscha, and Billy Al Bengston. Nor, finally, did he seem impressed by the Duchamp readymades — the bicycle wheel, the bottle rack, the urinal — that seemed to speak poignantly to his own images of everyday objects. Instead, Warhol focused on having drunk so much of the pink champagne that on the way home he vomited at the side of the road; he noted that "in California . . . you even felt healthy when you puked." And perhaps most of all, he remembered an angry scene at the entrance, sparked by Taylor Mead's appearance at the black-tie affair in a ragged, overlong sweater. When a *Time* magazine photographer pushed past Mead to photograph Warhol with Duchamp, the poet-actor screamed, "How dare you! How dare you!" In those three heated monosyllables, Warhol discerned a

profound social shift, "the idea that anybody had the right to be anywhere and do anything no matter who they were and how they were dressed."

Warhol might not have been thinking of Duchamp's mocking parody of the Mona Lisa, *L.H.O.O.Q.*, when he created his own riposte to the genuine Mona Lisa's pathbreaking presence in Washington and New York in early 1963; but he was certainly conscious of the extensive publicity surrounding every detail of the Renaissance icon's transportation and security, not to mention the more than one million visitors, some of whom lined up for hours in the bitter cold to pay her homage. Warhol used three illustrations from a pamphlet promoting the Met's Mona Lisa exhibition to create *Thirty Are Better than One*, a huge expanse of linen (110 x 94½ inches) silk-screened with thirty replicas of the same mysteriously smiling face.

In less than three years, the wan, inarticulate kid from the meanest Pittsburgh streets managed to convince a decisive segment of the art world that such silk screens were art of a new order. Collectors and museums snapped them up, graduate students in art history delved deeply into their meaning, and other artists built whole careers on emulating — or mocking — these paper icons. For years, Warhol had played with mass-producing images: rubber erasers carved in the shape of leaves and flowers, fruits and suns, butterflies and strawberries, stars and bowties, a veritable universe of the everyday. By 1962, however, he was creating huge canvases packed with rows of Coca-Cola bottles or dollar bills — tedious repetitions, in a sense, but the transfer of photographs to silk screen yielded variations in execution that encouraged Warhol to exploit these new pictorial possibilities. "They revel in their repetitive, yet individual variations," wrote the director of the Andy Warhol Museum. "Each is simultaneously the same while remaining distinctly unique." "Andy wanted to keep the human element out of his art," reflected Gerard Malanga, "and to avoid it he had to resort to silkscreens, stencils, and other kinds of automatic reproduction. But still the Art would always manage to find a way of creeping in. A smudge here, a bad silkscreening there, an unintended cropping. Andy was always antismudge. To smudge is human."

Warhol, the silent watcher of popular media who had fashioned a brilliant commercial career while no one in the New York art world was looking, had also developed an uncanny feel for the spirit of the times.

THE POP REVOLUTION

During his early years in New York, there had been occasional outbursts, harbingers of the blatant youth culture to come. One was Larry Rivers's mocking portrayal of a central event in American history, George Washington crossing the Delaware River during the Revolutionary War. In Emanuel Leutze's depiction, it typified the bombastic, heroic style of 1851. Rivers's version, painted in 1953 and now at MoMA, was a slapdash, cinematic takeoff: the hero in a solitary pose surrounded by scenes of utter confusion. Two years later, Rivers again roiled the abstract art world with *Double Portrait of Berdie*, his plump mother-in-law standing and seated in the nude, an unvarnished depiction of sagging, elderly flesh. Discussing his work much later, Rivers told the art writer Robert Hughes, "I wanted to do something the New York art world would consider disgusting, dead, and absurd." He was attacked as a rebel in the reigning Abstract Expressionist environment, but, writes Hughes, "other painters, as yet unheard of, got the message." Among these painters were Roy Lichtenstein, who at that time began painting cowboys and Indians; Jasper Johns, who two years later painted a flag; and, unnoticed by any of them, Andy Warhol, who told an interviewer many years later: "I just loved Larry Rivers's stuff and I used to go and try to buy some of it and it was always too expensive."

To the irony implicit in Rivers's rebellious works, Warhol brought an ambiguous hero-worship. Considering how many versions he created of the same pedestrian images of Marilyn, Elvis, Liz Taylor, and other celebrities, a thoughtful observer must wonder what significance Warhol saw in these people. One answer is that they rode to prominence (some call it notoriety) in gilded chariots — television and movies — from modest, if not hardscrabble, backgrounds. Another answer surely lies in the pathos of that ride. Elvis Presley virtually invented the persona of the sexually potent rock star, only to sink into self-parody and self-indulgence as the teeny-bopper industry recast and neutered him. Norma Jeane Baker emerged from a childhood in foster homes and orphanages, followed by a short-lived marriage at the age of sixteen to an aircraft-factory worker. She drifted into modeling and posed nude for a highly collectible calendar photo before heading to Hollywood, where she changed her name to Marilyn Monroe. For more than a decade, she found occasional bit parts but lingered on the fringe, "the archetypal forlorn starlet," wrote film biographer

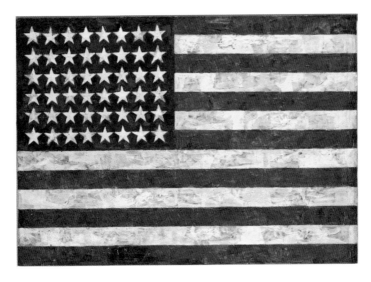

EARLY AMERICANA:

Larry Rivers, *Washington Crossing the Delaware* (1953)

Jasper Johns, *Flag* (1954–55)

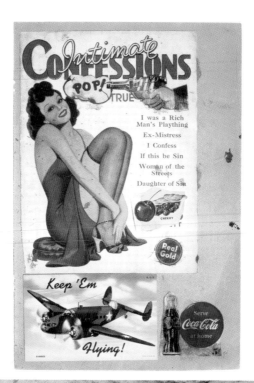

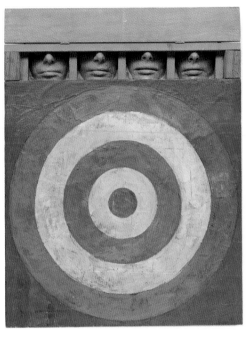

facing page:

EARLY BRITANNIA:

Eduardo Paolozzi, *I Was a Rich Man's Plaything* (1947)

Richard Hamilton, *Just What Is It that Makes Today's Homes So Different, So Appealing?* (1956)

above:

Jasper Johns, *Target with Four Faces* (1955)

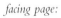
right:

Robert Rauschenberg, *Bed* (1955)

facing page:

COMICS ORIGINS:

Roy Lichtenstein, *Look Mickey* (1961)

Andy Warhol, *Popeye* (1961)

above:

DEATH AND AMERICANS:

Roy Lichtenstein, *Whaam!* (1963)

Andy Warhol, *Red Disaster* (1963)

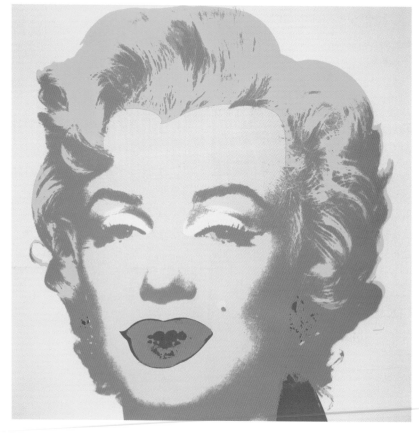

facing page:

TWO VISIONS OF AN AMERICAN ICON:
Richard Hamilton, *My Marilyn* (1966)
Andy Warhol, *Marilyn* (1967)

this page:

MERRY PRANKSTER:
Claes Oldenburg, *Soft Pay-Telephone* (1963)
Claes Oldenburg, *Lipstick, Ascending, on Caterpillar Tracks* (1969) at Yale

following page:

TWO VISIONS OF THE AMERICAN DREAM:
Robert Indiana, *American Dream* (1971)
James Rosenquist, *F-111* (1964–65) at MoMA

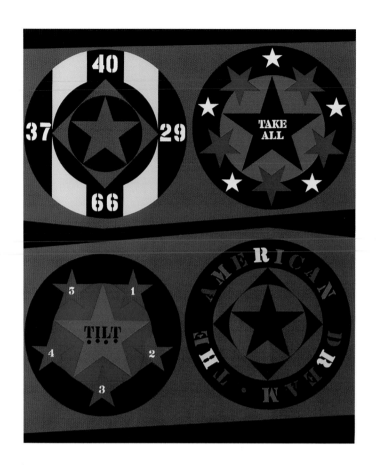

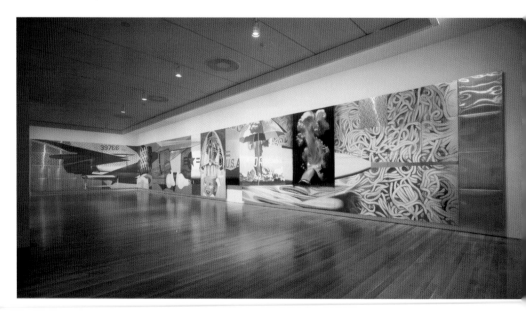

David Thomson. For about nine months during 1954, she was married to Joe DiMaggio; he was far more famous as a baseball star than she as an actress. Only when her studio began marketing her as a "slightly ditzy blonde exuding a breathless sexuality" did Monroe attract public attention. One of these images mesmerized Andy Warhol in 1962, immediately after her suicide on August 5.

During August, September, and early October of 1962, Warhol produced thirty-seven paintings based on the same eight-by-ten glossy black-and-white publicity still. The first was a now-iconic painting in which the star's face floats in a sea of gold, her smile as enigmatic as the Mona Lisa's. The portrait resembles the images of saints assembled in a grid on the iconostasis in Eastern Orthodox churches, like the Byzantine Christian church where the Warhola family heard Slavonic Mass every Sunday in Pittsburgh. "Her painted mask is reproduced endlessly until it is no longer possible to say where the mask ends and the woman begins," wrote John Rublowsky and Ken Heyman in one of the earliest books on Pop Art. "It is blatant and subtle, naïve and sophisticated, gaudy and beautiful. . . . It is much like the man who created it."

When Warhol was making his first *Marilyn*, Nathan Gluck had been his assistant for three years, first working in the Lexington Avenue townhouse and then in a nearby former firehouse. He had mastered Warhol's original blotted-line technique and completed many of his commercial jobs. "Andy had to hustle all the time," he explained. Gluck often suggested subjects for the witty flyers and cards Warhol sent to art directors as he sought commissions. The assistant also carved soap erasers into makeshift stamps to add color to the black-and-white books Warhol had printed in batches of 160, and he numbered the books for distribution as gifts to art directors and to sell at small galleries. Warhol understood the value of low numbers in artists' prints. Gluck said: "Andy told me that when I got to number seventeen, I should start over." On the *Marilyns*, Gluck warned Warhol that the various color screens had to be precisely aligned so that the register would be perfect. "No," muttered Andy, "I don't want it perfect."

This was a defining moment, as the assistant, trained in commercial art at Cooper Union and Pratt Institute, sought to apply his education to a new task. But Warhol deliberately shifted the color screens to achieve a

disorienting vibration. As Robert Rosenblum has noted, this approach perfectly suited the "machine-made quantities of our time, where the tawdry imperfections of smudged printer's ink or off-register coloring have exactly the ring of commonplace truth we recognize from the newspapers and cheap magazines that disseminated [Monroe's] fame."

Warhol used the same twenty-by-sixteen-inch silk screens for a dozen paintings with varied color backgrounds (or "flavors"), eight of which were exhibited at the first Stable Gallery show. Nor was this the end of Warhol's obsession with Monroe's image. Emily and Burton Tremaine bought *Marilyn Diptych*, two joined panels with twenty-five images in color and twenty-five in monochrome, directly from Warhol's studio. Warhol showed the panels separately, but Emily suggested they be attached, to which the artist replied, "Gee Whiz, yes." Emily thought she had achieved "a very complex and moving statement about Marilyn" and considered herself "a collaborator"! The Tremaines loaned the diptych for the Stable exhibition; in gratitude, Warhol dedicated and gave them one of two tondi, a black Marilyn on a hand-painted gold circle.

The early reaction to the success of Andy Warhol's first one-man show in a leading New York gallery ranged from Clement Greenberg's embittered disdain for "slapstick art" to Thomas Hess's slam, in *Art News*, of its "cutie pie wit and engaging decorativeness." The dealers and curators who claimed that it was "the beginning of a new renascence," he wrote, were damaging other artists, as it "hinders them from finding their own subject matter." Strongly dissenting many years later, Dave Hickey insists that even if Warhol had retired after 1962, "his position in the pantheon of Western art would be secure." Hickey suggests that "the blasphemous aspect" of the soup cans and the *Marilyns* "derives from the crisp analogy they draw between our appetite for 'fine art' and our appetite for food, sex, and glamour." In his introduction to *Andy Warhol "Giant" Size*, a behemoth of a book thirteen by seventeen inches large, 624 pages long, and weighing nearly twenty pounds, he describes "Andy's real quarrel" with his predecessors: that his paintings present "a visible distinction between the picture of the object we desire (and can never possess) and the iconic presence of the painting we prefer (and can always acquire)." Warhol's own comment on the *Marilyns* was delayed, succinct, and telling. "People look the most kissable when they're not

wearing makeup," he wrote. "Marilyn's lips weren't kissable, but they were very photogenic."

Warhol was included in group exhibitions of Pop Art throughout 1963, as American museums came to recognize that a new movement had arrived. At the Guggenheim, Lawrence Alloway assembled works for an exhibition titled "Six Painters and the Object," which traveled cross-country from the Rose Art Museum at Brandeis University in Waltham, Massachusetts, to the Los Angeles County Museum, with various stops along the way. Other Pop Art exhibitions were held in Houston, Washington, Kansas City, Oakland, Buffalo, and Cincinnati. While most of these exhibitions featured many *Marilyns* and soup cans, they did not include the dramatic, sometimes frightening, works that Warhol had created earlier, the electric chairs and airplane disasters, nor the more recent silk screens based on photographs of race riots and burning cars.

Meanwhile, sophisticated Europeans were getting acquainted with Warhol via exhibitions at Ileana Sonnabend's Paris gallery. Sonnabend had visited Warhol's studio in September 1962 and picked six inoffensive paintings and six drawings, which she exhibited in a group show with several Castelli artists. Warhol then insisted on showing his series of car accidents and plane collisions, which Sonnabend displayed under the title "Death and Americans" in January 1964. That year, works consigned to Sonnabend were also loaned to exhibitions throughout Europe at the Moderna Museet in Stockholm, the Stedelijk Museum in Amsterdam, a salon in Paris's Musée d'Art Moderne, and museums in Ghent, The Hague, Vienna, Berlin, and Brussels.

By then, Warhol was preoccupied with his next art project, something he called Box Sculptures. Over some eighteen months, he produced an estimated 368 different sculptures on a single eccentric aesthetic theme: shipping containers for such supermarket staples as Brillo scouring pads, Campbell's soup and tomato juice, Mott's apple juice, Del Monte peach halves, Kellogg's Corn Flakes, and Heinz tomato ketchup. The variations in details, sizes, and numbers are still troubling the meticulous editors of the Warhol catalogue raisonné. Warhol signed some when they were created and others after they had been purchased by collectors; still others remained unsigned. Since all of the originals were common items of commerce, some replicas could have been fakes, and all of them caused

storms of ridicule and rage. Critics could not help noticing the irony of scrupulously replicating an object so banal that its presence in a trash bin was usually overlooked and of daring to exhibit quantities of it at venues dedicated to fine art. The original version cost 15¢ to make and was available free to anyone seeking a cardboard box behind a supermarket. The replica was constructed of plywood by a cabinetmaker, then painstakingly stenciled by the artist or an assistant. Stacked in a gallery, it cost $200 for the small version and twice that for a larger one.

Except for a few boxes that were sold from Warhol's studio, the first public exhibition opened to a record crowd at the Stable Gallery on April 21, 1964. The boxes were piled so high inside that a line formed at the entrance, snaking down Seventy-fourth Street. The gallerist Joan Washburn attended with James Harvey, a contemporary artist who supported himself in commercial design and had created the original Brillo box logo. "Jim was shocked," she recalled, "but he was also amused, as we all were." Eleanor Ward was not amused. She was dismayed from the moment she learned what Warhol was creating for the show, and, considering that some four hundred boxes were on display, she at first grumbled that too few were sold at the opening. But before the show closed, "enough cartons had been sold to gladden a grocer's heart," wrote Grace Glueck. One unidentified buyer "plunked down $6,000, for twenty of the regular size."

The postexhibition party was the first of many trendy events at an elderly loft building on East Forty-seventh Street that Warhol had christened the Factory. Every surface of the space was covered in aluminum foil, a tribute to Warhol's fascination with silver that stretched from the background of the Elvis paintings to his craving for the silver screen, from the astronauts' silver space suits to the color of the capsules in which they rode into outer space beginning in 1962, and even to the wig Warhol habitually wore — a platinum mop. A Pinkerton guard stood at the door to turn back potential crashers seeking to mingle with the "in" Pop crowd — Roy Lichtenstein, Claes Oldenburg, Tom Wesselmann, James Rosenquist, and Henry Geldzahler — and some of the lost society youths, transvestites, drug takers, and exhibitionists who would later transform the Factory into a glittering, frenetic, and sometimes sadistic and orgiastic venue. But this night, the party was hosted by Ethel and Robert Scull, who had brought in Fun Fair, a Coney Island caterer, to serve hot dogs

and beer. "To me, Andy Warhol was the most exciting thing imaginable," Robert Scull later said. "I conveyed this through the means that people understand the most — of putting my name on the bottom of a check and paying for it."

Critical reactions to the Brillo boxes began with Eleanor Ward's violent dislike for the vulgar display in her gallery, and it continued with reviewers such as Sidney Tillim, who cogitated for almost six months before deciding that the boxes "repudiate any art quality whatsoever" and convey an orgy of "aggressive passivity." Canadian customs inspectors voiced their own critique in 1965, when they refused to admit boxes intended for exhibition at a Toronto gallery unless the owner, Jerrold Morris, paid duty for them as merchandise. Dr. Charles Comfort, director of the National Gallery of Canada, agreed with the customs verdict, saying that viewing photographs of the boxes convinced him "they were not sculpture."

To Arthur C. Danto, Columbia University philosopher turned art critic, the boxes were not just a playful send-up of traditional definitions of art, but also the symbols of a dramatic turning point in the history of aesthetics. He thought long and hard over the boxes' implications and expressed his views over more than forty years. In December 1964 he presented a paper, "The Artworld," at the annual meeting of the American Philosophical Association. In it, he argued that the boxes represented yet another extension of a theory of what constitutes art that had already been "seriously revised" by the acceptance of Impressionism in the late nineteenth century. Afterward, not only were the violent distortions of the Cubists admitted to museums, but such objects as masks, weapons, and figures of tribal gods were moved from anthropological museums to the most prestigious, elegant showplaces of the fine arts. Furthermore, he wondered, "If one may make a facsimile of a human being out of bronze, why not a facsimile of a Brillo carton out of plywood?"

Twenty years later, Danto still sounded perturbed as he described the reception during the midsixties for his radical views from the aging, largely Abstract Expressionist members of the Club. The artists who had come to dominate the art scene during the 1950s gave him "a violent repudiation"; few seemed to realize, wrote Danto, that their "backs were against the wall." He was faced by "howling and voluble men and women who

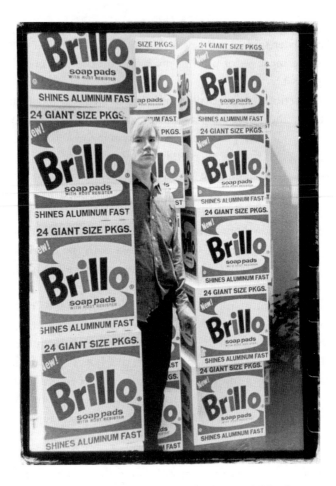

did not want to hear what I had to say." Understandably, they resented his message — a diagnosis refined over the decades — that Pop Art, followed rapidly by Minimalism, Conceptualism, neo-Expressionism, and other short-lived movements, signaled a new paradigm. After the Brillo boxes came "a period of post-historical art," he said, but "constant self-revolutionization of art is now past." He suggested that the past "wild effervescence of the art world" may have been "a terminal fermentation."

In 1989, writing in *The Nation*, where he followed a long line of distinguished art critics, including Pop's archenemy Clement Greenberg, Danto suggested that all innovative twentieth-century artists had proclaimed theories justifying what they were doing, only to be overtaken by

the next group spouting its own new theory. The Abstract Expressionists also believed they knew what art was, but "Pop violated every component of their theory and somehow remained art." In 1992 Danto furthered his argument that art did not come to an end with the Brillo boxes; what ended was "a certain narrative" in which "making art" would carry forward the tradition of fresh discoveries and "new breakthroughs." The implication was that modernism had ended with Abstract Expressionism and its offshoot, Color Field painting. He placed the new art firmly within 1960s social changes based on "utopian politics," which were erasing boundaries between genders and classes. "Worlds and ways of life heretofore thought irredeemable by a cultivated taste" were now aestheticized, he wrote, "a transfiguration of the commonplace." Postmodernism had arrived, and Arthur Danto drew its first map.

In a mirror image of Warhol's reiterations of Marilyn, Elvis, and Campbell's soup, Danto continued to refine his theory, consulting the art philosopher's perennial aides-de-camp, Descartes, Kant, and Heidegger — all thinkers who had believed that "works of art were always identifiable as such." While the Brillo boxes were "a most unlikely messenger of philosophical depth," Danto argued, they represented the end of distinctions "between music and noise . . . dance and movement . . . literature and mere writing." Hence, "art can be anything that artists and patrons want it to be." The politics of 1964 seemed to reinforce this inclusive change in the cultural climate: the civil rights movement exploded across the South; the feminist movement was galvanized by Betty Friedan's *The Feminine Mystique*, published the previous year; and the Beatles, already famous in Europe, stepped off an airplane in New York into a howling mob of lovesick teenagers.

Dave Hickey offered a more mundane, but perhaps equally insightful, take on the meaning of the Brillo boxes. At a lecture on contemporary art in 1995, he described how Warhol's most famous professor at Carnegie Institute of Technology, the abstractionist Balcomb Greene, often faulted the socially conscious artists of the 1930s for presenting "the soapbox speaking instead of the man." Hickey argued that Warhol's boxes of Brillo soap pads were an ironic, topical twist on Professor Greene's remarks, "a profoundly knowing way of acknowledging the values of the culture while simultaneously dissenting." On the issue of beauty in art, which the

Brillo boxes also challenged, both Hickey and Danto seemed abashed that the millennial standard — beauty — has disappeared from discussions of contemporary art. When Hickey, asked in 1990 about the defining aesthetic issue in the decade ahead, replied "Beauty," his audience greeted that word with "total uncomprehending silence."

Whether beautiful art or not, the boxes had produced a notable side effect: Ivan Karp and Henry Geldzahler, perhaps with some considerable help from Ileana Sonnabend's success selling Warhol in Europe, had finally persuaded Leo Castelli to give Warhol a show. Since the boxes were primarily sculptures, the dealer claimed, Warhol's new work was sufficiently different from Roy Lichtenstein's to avoid a conflict. But the works Warhol began creating for the Castelli show soon after the Brillo box exhibition closed were not sculptures or portraits of famous people, but rather paintings of subjects that had inspired artists for at least two thousand years: flowers. If the friends who had persuaded Castelli to show Warhol from late November to mid-December — art-season prime time — were taken aback, they held their piece. The images that Warhol began creating in June 1964 were based on illustrations in an article about color processing in that month's issue of *Modern Photography*. Warhol massively enlarged the magazine illustrations, then cropped them to remove extraneous background. He ordered silk screens of various sizes, eventually ranging from five to eighty-two inches square, and produced them in bulk at the aptly named Factory over several years, just as if they were furniture or clothing. However, each example showed unique touches, background foliage variously detailed, the flowers hand-painted to overlap the background differently, the white flowers not just exposed canvas, but carefully rendered in white acrylic paint.

Despite Eleanor Ward's disgust with the Brillo boxes, she became furious when she learned from an intermediary that Warhol had signed on with Castelli. She was convinced that her prestige and loyal collectors had "made Warhol," and she tried to get the artist's friend David Bourdon to persuade him to come back. Castelli, she claimed, was bringing in Warhol only "to make Rauschenberg and Johns look more important by comparison. . . . He wouldn't promote Andy with the same zeal as he did his 'old masters.'"

Nonetheless, the Castelli opening received widespread media atten-

tion. It even attracted the skeptical editor of *Art News*, Thomas Hess, who reviewed the artist more than the art. "Underneath his turtleneck disguises — white wig, black glasses, deprecating shrugs in frugging bashes," Hess discerned "a diamond-sharp mind with a flair for doctrinaire theatrics." Of the audience at the opening, he wrote: "A livelier bunch of swinging humanoids won't be found this side of Vegas." Hess deprecated the little gold "sold" stars pasted beneath most of the works shown, "filling the gallery atmosphere with a glamour smell of cash." David Bourdon reviewed the show for the *Village Voice*, noting that flowers had been a persistent theme in Warhol's career since his door-to-door sales of flower sketches as a young boy. The flowers shown at Castelli's, he wrote, seemed to float in front of the canvas "like cut-out gouaches by Matisse set adrift on Monet's lily-pond."

"Saint Andrew," *Newsweek* magazine's six-page Warhol profile by the early Pop proponent Robert Rosenblum (published without a byline), was more a tour of the Warhol oeuvre and its effect on an exuberant public than a review of the show. At the party following the opening, as Rosenblum described, the smiling 36-year-old artist beatifically repeated "Terrific!" as he watched the guests slowly shimmying "like a mob of dancing bears back-scratching against the trees of a thick forest." The artist standing "in the midst of the Beatle-rocking bedlam [and] dancing only with his pale blue eyes" was "the Peter Pan of the current art scene. . . . He paints the gamy glamour of mass society with the lobotomized glee that characterizes the cooled-off generation." Visiting the Factory before the opening, Rosenblum had observed Warhol happily contemplating "the fields of painted flora." Flowers were "the fashion of the year," the artist told him. "They look like a cheap awning. . . . Terrific!" Rosenblum likened the flowers to the huge Carmen Miranda wedgie he had spied on a table in Warhol's house, or "the giant shoe ad which had won him the Art Directors' Club medal in 1957." Although he was as close to Warhol as anyone, he could only speculate on the flowers as "a kind of happy regression back to the undifferentiated childhood world of giant images and soothing repetition . . . a sort of fetish." But the art historian was also aware of Warhol's adult persona. At the Factory, he had found the artist "kneel[ing] on the floor in green rubber gloves, spreading paint through the screen with a wooden bar — a craftsman absorbed in his work." The

image under the screen was yet another version of the only nonflower painting in the show — Jacqueline Kennedy after her husband's assassination. "Maybe I should have made the whole show Jackie," said the artist. "It's terrific."

Warhol's inventive transformations of visual clichés contrast dramatically with the verbal clichés — "Terrific! Terrific!" — that grate on the reader. The master image manipulator comes across in print as the antithesis of his contemporary Marshall McLuhan. Repeatedly interviewed, the Canadian professor had mesmerized audiences with cascades of scintillating phrases, even as his writings drowned in a sea of empty verbiage. By contrast, the inarticulate artist, pursued by eager interviewers, lapsed into monosyllabic mutterings, then rushed to his studio to produce yet another Marilyn or flower painting, each one minutely different from the others, expressing visually the verbal nuances that eluded him.

Aware of his deficiency, Warhol revered people who knew how to use words. Ivan Karp did, and he clicked with Warhol in 1960. So did Henry Geldzahler, whose verbal facility would best a long-established array of art critics in his eloquent defense of Pop Art. But not every attachment was so favored. Earlier Warhol had fallen in love with a portrait of Frank O'Hara in a bookstore window and pursued the poet, their friendship coming to a cruel end when O'Hara, "in Warhol's own living room, theatrically pointed his finger at Andy and laughed at him." Warhol had also developed a crush on Truman Capote, whose sensational debut, *Other Voices, Other Rooms*, was published in 1948, the year Warhol arrived in New York. The artist began sending the writer almost daily fan mail, all of which went unanswered. Months later, when Warhol summoned the nerve to visit Capote's apartment, the writer listened impatiently to the other man's story and joined in a brief telephone relationship, to which his mother soon put an end: "Stop bothering Truman!" Later, Capote dismissed Warhol as "a sphinx with no secret" and "one of those helpless people that you know nothing's going to happen to . . . just a hopeless born loser, the loneliest, most friendless person I'd ever seen." He nonetheless contributed a blurb to *The Philosophy of Andy Warhol* in the 1970s, praising it as "Acute. Accurate. . . . A constant entertainment and enlightenment."

For Warhol, the memory lingered on; years later he posed for a photograph that mimicked the famously languid pose Capote had adopted

for the dust jacket of his first book. And in 1966, when he received an invitation to Capote's highly exclusive Black and White Ball at the Plaza, he invited Geldzahler, with whom he hadn't spoken in six months, to go with him. "Tallulah Bankhead, among several hundred stars, was standing a few feet away from us," Geldzahler recalled; "awestruck, Andy said, 'Look, we're the only nobodies here.'"

From the day he spotted the campy Carmen Miranda shoe in Warhol's studio, Geldzahler had become Warhol's mentor; for some six years, they spoke at length on the phone several times daily. It was also Geldzahler who had provided Warhol with ideas for paintings like *129 Die in Jet* (1962), which led to the artist's Death and Disaster series, and in 1964 Geldzahler had posed for what may have been Warhol's earliest movie. The artist brought a newly rented eight-millimeter camera to his apartment, where he created a three-minute silent film of Geldzahler smoking a cigar, throwing it into the toilet, brushing his teeth, then flushing the toilet. "He was just trying to see what it looks like through the camera," said Geldzahler. That year, the young curator sat for an early silk-screen portrait and for another, edgier movie, *Henry Geldzahler*, described as a "screen test"; only the subject is seen, and he is trying to keep his composure while an off-screen person attempts to seduce him. The discomfiting homage was indicative of a shift in the two men's relations. "Andy must periodically have felt the lash of Henry's educated and sarcastic tongue," wrote the poet and popular-culture scholar Wayne Koestenbaum. The film portrait was a roundabout payback to "every merciless eminence who thought Warhol a poseur, a hick or a freak."

Indeed, as Warhol became increasingly involved with movies and with the questionable crowd populating the Factory, Geldzahler and other earlier fans drifted away. The place "became a sort of glamorous clubhouse," Geldzahler told the art historian Carter Ratcliff many years later. Too many people were "trying to attract Andy's attention. . . . It was like Louis XIV getting up in the morning. The big question was whom Andy would notice." Marginally talented, many of the hangers-on had developed aggressively unconventional ways to express themselves: cross-dressing, flamboyantly unorthodox sexual practices, unstable hours, blatant drug abuse, and intrusive personality tics. Geldzahler trusted Billy Name, the young fellow who had silverized the Factory, with his apartment while he

flew off to a weekend in Provence. He returned to find "a big fat, naked woman, the self-anointed Duchess, lying on his marble table, with a needle poked into her buttock." Warhol later gave an affectionate nod to the Factory as a collection of "odds-and-ends misfits, somehow misfitting together." But others, such as Ivan Karp, who had been a fixture at the studio and had once viewed the scene "with a great sense of wonder," had grown dismayed at seeing "the positive energy of the Factory degenerate into an orgy of drugs and unsavory characters." "I know a lot of people think it's glamorous over there," Karp had told Warhol, "but to me it's just gloomy."

The last substantial event at the Factory — not counting the chaos that accompanied filmmaking — was the launch in June 1965 of a book about Pop Art by John Rublowsky and Ken Heyman. Its publisher invited some three hundred people. Grace Glueck caught the guests drinking and frugging to the "peak-decibel" music of the Denims, "in a non-air conditioned atmosphere as thick as a can of Campbell's chicken gumbo soup." Among the guests was the Pop Art collector Leon Kraushar, who exclaimed, "This is it! You can't beat the sound, you can't beat the music. People go to Europe and they're crazy. The whole world is here." Not quite; Andy Warhol, the purported host, was rumored to be at another party in an air-conditioned hotel.

Rublowsky lauded Pop as the first true visual manifestation of the American character. "Democratic, expansive, brimming over with confidence and vitality," he wrote. "With the Pop movement, American art becomes truly American for the first time and thus becomes universal." In the book's foreword, Samuel Adams Green, the director of the Institute of Contemporary Art in Philadelphia, described being stunned when "an excited public" and a "once-frowning officialdom" embraced Pop. He compared Pop objects with the nineteenth-century realist novels of Honoré de Balzac, describing them as a record of "our era in which cliché and banality are served up with such delectation that they inspire reverence."

Green might have revised his views about "reverence" a few months later, after the opening of Warhol's first American retrospective at his institute. Hoping to mimic the tone of the Factory, Green had painted the exhibition floor silver and played rock music, but he had not anticipated

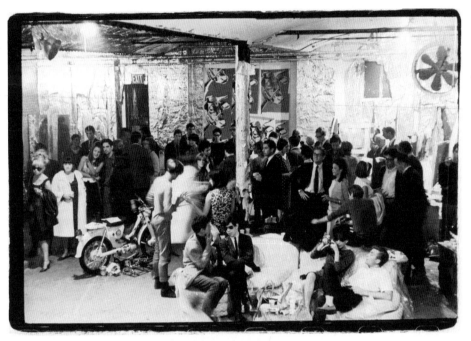

that between two and four thousand hyperactive young fans would cram into a space meant for only seven hundred. Warhol emerged from his limo garbed totally in black, with eight safety pins in the collar of his turtleneck, his face shielded behind wraparound shades. From afar, Leo Castelli observed, "It was just a howling . . . like the Beatles." Two students had already been pushed through the windows in the back room and were hospitalized for serious cuts. Faced with the mob, Green had removed most of the art. He observed the artist pinned against the wall, "white with fear," and ordered security guards to escort him and his entourage upstairs to a small balcony. Down below, the crowd chanted, "We want Andy and Edie [Sedgwick]!" "Andy watched the proceedings with awe" and kept saying, "Look how exciting this all is," Gerard Malanga told Warhol biographer Victor Bockris. But Henry Geldzahler, who had joined the group on the balcony, wanted only to get out. They eventually exited through a hole cut in the roof and down a fire escape to the street, where police cars whisked them away.

Caught up in the whirl of fame, Warhol was at a loss to produce new work for a show at Castelli in April 1966. "Why don't you do landscape?"

The Factory in its silver-lined heyday, August 1965

was Ivan Karp's offhand suggestion. "You know, cows." The result was rolls of wallpaper imprinted with the heads of identical cows, which looked suspiciously like the Borden milk-products logo, Elsie, but were actually taken from an agricultural book illustration of a Jersey cow. The wallpaper was installed in Castelli's back room, and the front room was stocked with helium-filled silver "pillows." Castelli put up with this game mostly because Warhol was continuing to attract so much attention abroad. Since 1964, his work had been shown several times at Ileana Sonnabend's gallery, and also at galleries in Essen, Hamburg, Milan, Turin, and Buenos Aires, as well as museums in Brussels and Stockholm.

By 1966 the silver interior of the Factory was beginning to deteriorate. Nothing much was done to renovate it because the lease on the Forty-seventh Street space was due to expire at the end of 1967, after which the building would be demolished and replaced with a residential high-rise. Warhol and his colleagues finally settled on a location for another Factory, a more businesslike setting that underlined the artist's stated decision to "retire" from painting to concentrate on making films; promoting his rock band, the Velvet Underground; and other enterprises. In the fall of 1967, the Factory moved to the sixth floor of 33 Union Square West, an undistinguished eleven-story structure that featured high ceilings, parquet floors, and tall windows. In a ragged reminder of Union Square's glory days in the 1930s, when May Day was celebrated by New York's large left-wing group, the Communist Party was headquartered on the eighth floor.

With the move, many of the more extreme characters from the Forty-seventh Street Factory dropped out, even though the drug users among them could find plentiful sources in the park across the street. Still, "they didn't feel comfortable with its antiseptic look and Warhol's newfound inaccessibility," wrote Bourdon. The silver age was over; the "old insanity" couldn't go on at the new location. Warhol was relishing his evident fame: the way people recognized him in the street, the way fans crowded around for autographs when he appeared almost nightly with his entourage at Max's Kansas City, the raucous "in" spot just across Union Square — the "Cedar Bar of its era," as Castelli called it.

On June 3, 1968, Warhol arrived at 4:15 P.M. in the lobby of 33 Union Square West. He rode in the elevator with his housemate, Jed Johnson, and Valerie Solanas, an actress who had founded SCUM, the Society for Cut-

ting Up Men. Solanas had once given Warhol a script, *Up Your Ass*, which Warhol considered so obscene that he worried it might be "some kind of [police] entrapment." After the script became lost in the chaos of the old Factory, Solanas started demanding financial compensation. That day, she got off the elevator with Warhol. Soon afterward, he was on the phone when he heard a loud explosion. "I saw Valerie pointing a gun at me," he recalled a decade later. "No! No, Valerie! Don't do it!" he pleaded while trying to crawl under a desk. "She moved in and fired again," wrote Warhol, "and then I felt a horrible, horrible pain, like a cherry bomb exploding inside me."

Clinically dead, Warhol was rushed to Columbus–Mother Cabrini Hospital some five blocks away, where emergency-room staffers quickly decided that his condition was hopeless. Only when they were told who he was did they send him to an operating room. There, surgeons struggled to repair the damage from the single bullet; it had ripped through his left side, punctured his liver, spleen, pancreas, esophagus, one pulmonary artery, and both lungs. After more than six hours, a doctor emerged, calling Andy's chances "fifty-fifty." While the operation was still under way, Solanas approached a traffic cop at Seventh Avenue and Forty-ninth Street and handed him the recently fired .32 automatic. She was taken to the Thirteenth Precinct police station for booking.

The following day's *New York Post* was headlined "ANDY WARHOL FIGHTS FOR LIFE" in the fat capitals reserved for the tabloid's top event; his name was now etched forever on the consciousness of the New York public, even the few to whom he was still unknown. Only another shooting that week, this one fatal, would eclipse the news, when presidential candidate Bobby Kennedy was gunned down in Los Angeles on the fifth, a mere two days after Warhol. The artist was not allowed visitors for some days. But when he phoned David Bourdon at last, his friend and future biographer "collapsed in a fit of choking sobs, and it was [Warhol] who had to comfort me." With typical irony, Warhol lamented: "If only she had done it while the camera was on!"

Chapter 5

ART FOR ALL
1960 – 1970

Andy Warhol's phenomenal success at persuading people to buy multiple images of soup cans, movie stars, and Brillo boxes reflected a thread woven through the American cultural scene for more than a century: that the pursuit of happiness included enjoying art. And if a single work enhanced that goal, then a multitude of the same image brought even more happiness. In the realm of consumer goods, hadn't mass production brought the Model T within reach of millions in the early twentieth century? And in the postwar years, hadn't the same principle provided decent housing, however ticky-tacky, to millions of eager buyers? The interstate highways of the 1950s and the introduction of jet airliners between 1960 and 1970 drastically increased how often people traveled, as it decreased the cost of getting places. In a single decade, the number of passenger miles soared from 30.5 billion to 104 billion. International travel alone boomed from 8.3 billion passenger miles flown in 1960 to 27.5 billion a decade later.

During that period, a similar pattern of marketing artworks to an ever-growing middle-class audience became a mass industry. While newly prosperous Americans like Emily and Burton Tremaine and Ethel and Robert Scull used their fortunes to build expansive collections of paintings and sculpture, entrepreneurs busily explored new ways to bring the pleasures of owning art to a wider cross-section of the public.

Inevitably, they looked to Europe, where in the nineteenth and early twentieth centuries, dealers like Ambroise Vollard and D. H. Kahnweiler had commissioned well-known artists to create works that could be reproduced in limited editions and sold to less pecunious art fanciers. Vollard had persuaded Georges Rouault to devote nine years to producing the monumental series Misery and War and encouraged Marc Chagall

to create etched illustrations for the Bible. The art-book publisher Albert Skira had commissioned Picasso to illustrate Ovid's *Metamorphoses* and Matisse to illustrate Mallarmé's *Poésies*, the first major book project for each artist. The dealer would then hire a printmaking studio to create etched or lithographic plates based on the art and print them in limited series, normally of one hundred, after which the plates would be destroyed — theoretically, at least. These artists' books and prints, published by dealers for the carriage trade, held a sort of middle ground between owning a full-fledged original work and the kind of etchings commonly found in middle-class homes in Europe and America.

Following on this tradition, Tatyana Grosman and her husband, Maurice, having found a supply of Bavarian sandstone and acquired a cheap printing press, established Universal Limited Art Editions (ULAE) in 1957 in West Islip, Long Island. Its first product was a twelve-page book, titled *Stones*, created by Larry Rivers and the poet, critic, and museum curator Frank O'Hara. During the next decade, ULAE published about two hundred lithographs by a constellation of prominent artists, including Helen Frankenthaler, Robert Rauschenberg, Grace Hartigan, Fritz Glarner, Robert Motherwell, Jasper Johns, Lee Bontecou, Jim Dine, Barnett Newman, Marisol, and James Rosenquist. An edition of thirty-five images, sold at $100 each, earned the artist $3,500 for the work of a day or two in a lively studio; prints that sold for $350 would bring in upwards of $12,000. By 1967 nearly fifty museums owned editions, and at Henry Geldzahler's urging, the National Endowment for the Arts gave ULAE a $15,000 grant to experiment with artists' etchings.

Grosman, who was born in 1904 in Yekaterinburg, Russia, cut an exotic figure as she trekked to New York museums lugging bulky portfolios, her soft yet persistent sales pitch conveyed in an endearingly vague and difficult accent. Her timing, on the other hand, was right on the money, as works produced at her increasingly sophisticated studio and her tireless promotion of them intersected with the vibrant growth of public interest in art. The explosion of such prints had a profound impact: only about two hundred people spent at least $10,000 on art during 1973, but some fifty thousand people bought limited editions of objects and prints, a market that annually attracted more than $100 million.

The museums Grosman cultivated did their part. In the early 1960s,

THE POP REVOLUTION

MoMA's influential curator William Lieberman persuaded museum patrons Celeste and Armand Bartos to spend anywhere between $65 and $200 to buy the first print from every ULAE edition for the museum. Within a year or two, many aspiring collectors saw MoMA's exhibitions as an upscale Sears, Roebuck catalogue of what to buy. The museum was the world's leading exhibition space for modern art, a magnet for a fast-growing audience, and a bellwether for novice and even experienced art buyers. Its exhibitions of artists' prints in 1964, 1969, and 1971 validated such works as unique and worth collecting, as it had previously done for photography. The museum's imprimatur encouraged a multitude of art lovers who could not afford paintings to buy prints instead — after all, they were not only decorative but could even become valuable. As artists increasingly began creating giant paintings and sculptures, prints offered a more modest, yet aesthetic and original, alternative.

In Los Angeles, June Wayne, a self-educated artist, had a different vision. She wanted to bring skilled European printmakers to the United States to help artists produce innovative quality prints for a wide audience. Starting with a grant of $165,000 from the Ford Foundation, the Tamarind Workshop became the center for pairing apprentice lithographers with artists who challenged them to create imaginative images. By the time the workshop moved to the University of New Mexico in 1970, its alumni numbered some 160 artists and many skilled lithographers, including Robert Rauschenberg. Art prints became a mass phenomenon, as enthusiasts of modest means could now own works bearing the hand of a famous creator.

Seeing the demand, other print studios sprang up in cities and small towns all over America, many employing printers trained at Tamarind. Ken Tyler, one such Tamarind veteran, soon realized that the modest studio he had started in Los Angeles in 1965 needed business management and more capital; he brought in two art collectors, an accountant, and a manufacturer and formed a corporation, Gemini G.E.L. The new company was a magnet for printers trained at Tamarind or at the many smaller shops it had inspired. Seeking profits for both the artists and the studio, the Gemini managers moved beyond simply colorful images on paper to reliefs and even sculptures, all issued in limited quantities. With each

"editioning challenge," new procedures were invented. For the environmental artist Edward Kienholz, there were cinder-block televisions; for Jonathan Borofsky, aluminum figures; for Robert Graham, porcelains; and for Isamu Noguchi, galvanized steel creations. Many artists had not attempted prints or editions before Gemini supported their efforts, even though the market for the studio's output seemed limitless.

Among the most challenging of the artists working at Gemini was Robert Rauschenberg. Until 1966 Rauschenberg had produced only a modest number of prints at Tatyana Grosman's Universal Limited, though each was more complex than the last in size and intricacy and consequently more expensive. In 1967 he planned a set of eight prints with Gemini, the most ambitious the studio had ever produced. Neither of the two principal suppliers of lithographic paper, Rives and Arches, stocked paper that was six feet long. Gemini used a grant from the National Endowment for the Arts and a consultant from the Crown Zellerbach Paper Company to produce the necessary support for Rauschenberg's *Booster and Seven Studies* portfolio. Castelli sold the set for $2,350, bundled with an essay by the art historian Lucy Lippard, who described the work as Rauschenberg's "gap-toothed smile on life and art." In 1969 NASA commissioned Rauschenberg to commemorate that year's moon landing. The Gemini workshop labored over this project for more than a year before completing the editions of *Sky Garden* and *Waves*, the largest hand-pulled lithographs ever created.

By 1968 Rauschenberg had moved to Broadside Arts, Inc., a company organized by the arts patron Marion Javits (wife of Senator Jacob Javits), the graphic designer Milton Glaser, and Clay Felker (the founding editor of *New York* magazine). There he created *Autobiography*, three massive vertical panels replete with photos, words, and colors, including an almost life-size X-ray of the artist himself, his horoscope, the view of New York from his studio superimposed onto a map of Texas, and other biographical elements. Printed by a billboard lithographer, it added up to an image that was seventeen feet tall and four and a half feet wide. The Whitney Museum exhibited the work in January and also sold a massive edition of two thousand copies, each initialed by the artist; the total proceeds, $300,000, far exceeded the typical price of a Rauschenberg paint-

ing. The *New York Times*'s Hilton Kramer was not amused. This mural graphic was notable as an art-market phenomenon, he wrote tartly, "certain to be widely imitated," but that was its only virtue.

Leo Castelli was skeptical about Rauschenberg's print tsunami; "not sellable" was his blunt verdict. He spoke from experience, having sometimes been forced to give away prints to favored customers. Still, Castelli, for all his acumen, didn't always see the potential in front of him, as demonstrated by Rosa Esman, a pioneer in marketing artists' prints. While summering in the Berkshires, Esman opened a small gallery in Stockbridge, Massachusetts, selling prints loaned by other galleries or museums. The borrowed prints were selling so briskly to summer visitors that in early 1963, she borrowed some money and started Tanglewood Press, named after the nearby music festival. The first portfolio, New York 10,

Rauschenberg with Autobiography, *1967*

came out in 1965 and included signed works by Claes Oldenburg, Helen Frankenthaler, George Segal, Jim Dine, Tom Wesselmann, and Roy Lichtenstein. Each of the one hundred portfolios of ten prints sold for $90. That same year, at Castelli's suggestion, Esman published and marketed a series of portfolios in three different formats; called 11 Pop Artists, it contained prints by Pop's main figures, in an edition of 250 with Arabic numbers, plus 50 with Roman numerals. Despite the large edition and somewhat higher prices, the portfolios sold well. In addition, as the arts editor Elizabeth Baker pointed out, the prints that Castelli's artists made for such studios as Tanglewood, ULAE, and Gemini "considerably broadened the audience for the gallery."

In the early 1960s, the cost of a painting by an established artist was in the four figures, whereas an artist-signed print went for just two figures. However, Esman observed, many of the young people who bought prints would later have the income to buy paintings. In 1969 the Metropolitan Museum of Art asked her to supply original prints for a folding display that could be circulated to New York public schools. She developed The Metropolitan Scene, a group of panels three feet square for displaying original prints by such artists as Helen Frankenthaler, Adolph Gottlieb, George Segal, and Roy Lichtenstein. Each artist donated twenty prints for the museum display and shared the proceeds from the fifty sets. In 1971 Esman opened a gallery in an East Side apartment with an exhibition of drawings long unsold from Castelli's back room. Much to the dealer's surprise, the clientele Esman had built up with print sales bought out the entire show.

As happens frequently in American culture, the booming print business started to exceed even its substantial market, and some critics began wondering how much actual art lay behind the commerce. An artist writing in 1977 blamed "the big printmaking houses" for offering artists seductive rewards. "They're making thirteen prints a year in editions of 100," he said. "They're into commerce. . . . Once you start that, it's hard to retrieve yourself." The print boom had also encouraged some publishers to muddle the distinction between originals and signed reproductions or to manipulate quantities to help jack up prices.

Roy Lichtenstein's experience with Gemini G.E.L. was a case in point.

In 1969 Gemini had offered Lichtenstein one-third of the sales' proceeds, plus round-trip transportation from New York, accommodations, meals, and the use of a car while he was in Los Angeles. By the following year, sales of his prints had surpassed $700,000, while potential royalties on the unsold backlog amounted to $320,000. Gemini, apparently replying to Lichtenstein's concerns about royalties, suggested he continue making new prints, but in smaller editions, to boost the price. But by 1976 Lichtenstein, a "humble, serious man" (said Karp) who approached art the way a dutiful executive approached his paperwork, was worried that the massive inventory of unsold prints would depress prices — "too many pieces of paper around," he wrote — and he insisted on waiting for sales to pick up "before I add more to the pile."

Two related economic events helped feed the mania for prints as the 1960s ended. One was inflation, which had fueled much of the rise in art prices during that decade, giving art collectors the sense — or the illusion — that the works they owned could yield not only aesthetic value but also a generous financial dividend. An item donated to a museum entitled the donor to a hefty tax deduction, based not on the original purchase price but on the current, appreciated value. Concurrently, another income-tax reform reduced the benefits of investing in oil and gas wells, real estate, and movies, further encouraging investors seeking tax shelters to purchase art, including entire editions of prints. At the same time, given the sharp rise in demand, many of these prints were of rather mediocre quality and fared poorly on the open market; their purchasers then claimed losses on the unsold graphics. Faced with such intense competition in the print world, print studios sought ever more innovative ways of luring customers.

Gemini G.E.L., for one, was relying on dazzling technical magic to attract both artists and collectors, producing phenomenally complicated works in overwhelming sizes. For Expo '70 in Osaka, Japan, the graphics studio created a monster *Ice Bag* by Claes Oldenburg, with a base diameter of 18 feet and a height of 7 feet (until an internal motor, rotating and twisting, inflated it to 16 feet). There were also multiples in 4-foot and 12-foot versions. The following year, the ice bag reprised its twenty-minute dance on an outdoor plaza at the Los Angeles County Museum of Art, to the delight of thousands visiting the elaborate exhibition "Art and Tech-

nology." The show brought together some eighty artists, including Oldenburg, Lichtenstein, Warhol, and Rauschenberg, and thirty-seven business sponsors, including IBM, Lockheed, and U.S. Steel.

Claes Oldenburg, the playful, good-humored designer of the dancing ice bag, had creatively managed to elude the disapproval traditional critics so generously ladled upon Pop artists. In 1967, for instance, Barbara Rose detached him from the obvious Pop connection of his painted plaster hamburgers and ice cream cones and his soft sagging toilets and telephones. These jokey contraptions could be set up in various ways, she claimed, setting them apart from more static, "reactionary and academic" Pop works. Harold Rosenberg also shrank from using the word *Pop*, instead labeling Oldenburg "the most inventive American artist of the Post-Abstract Expressionist generation." From the artist's *Giant Soft Drum Set* of 1964, made of stitched and stuffed vinyl, to the 1969 *Shining Saw*, flowing onto the floor in hinged segments, Rosenberg, the onetime radical, sensed in the artist a Chaplinesque "offside mind and deadpan of the comedian-visionary."

Even the *New York Times's* most conservative critics relented in the face of Oldenburg's wit. John Canaday regretted calling the artist "a gagman"; it was meant in a friendly way, he wrote, as the work was "consistently humorous at a very high level." John Russell compared Oldenburg's roughshod plaster confections to Rembrandt's depictions of bodily decay; the artist was simply showing "the physical degeneration of mass-produced objects." Donald Judd, the stern taskmaster of Minimalism, deemed Oldenburg's work "profound." And Max Kozloff, who had called the Pop artists "the new vulgarians," admired how his stuffed vinyl creations responded to the pull of gravity.

The immediate trigger for much of this acclaim in 1969 was not only an Oldenburg retrospective at MoMA, where the artist's younger brother, Richard, was director of publicity, but also the first Oldenburg monument not on paper. This was an imposing sculpture, descriptively titled *Lipstick (Ascending) on Caterpillar Tracks*; made of inexpensive aluminum and plywood, it was erected on Beinecke Plaza at Yale University, where Oldenburg, class of 1951, had spent four lackluster years. Fellow alumni Philip Johnson and John Hersey had paid $6,000 to realize the piece.

In a quick first look, one might see the 24-foot inflatable lipstick as just

a friendly welcome to Yale's first female students. But in the inflamed polit-ical atmosphere of the late 1960s — the widespread campus agitations against the Vietnam War — one did not have to be a rocket scientist to rec-ognize the tall sculpture's reference to the missiles poised to obliterate both parties to the cold war. A side-glance at its phallic thrust might reveal a commentary on the rising tide of feminist consciousness. Barbara Rose called it "the first monument to the second American Revolution," com-paring it to Jacques-Louis David's combative images of the French Revolution's sanculottes. Oldenburg's own take on the piece can be glimpsed in this characteristically noncommittal statement from a 1965 interview: "The last generation believed . . . that the work of art is an ide-alized thing. They thought of themselves . . . as great creators, magicians." Today, however, "the artist wishes to be just an ordinary man," creating art that "can mean many things to many people and yet be only itself." (Owing to vandalism and deterioration, the work, restored in more durable steel, aluminum, and fiberglass and lacking its erectile functionali-ty, was later relocated to Morse College at the far end of the Yale campus.)

There was more of a connection than might be apparent between such objects and the seemingly inexhaustible market for art prints. The

Profound gagman: Oldenburg and Ice Bag

latter's rampant success had spawned the marketing of other art-related products with a strong relationship to the antielitist, democratizing values of the 1960s, though sometimes with only a faint whiff of aesthetic significance. Oldenburg, for instance, had gotten his start in December 1961 by stocking a rented a store on Manhattan's Lower East Side with homemade papier-mâché and plaster replicas of basic foodstuffs and clothing; what the neighborhood kids didn't steal the upscale art crowd snapped up at $50 apiece. A year later, in Philadelphia, Audrey Sobol and Joan Kron founded the Beautiful Bag Company to sell canvas totes with a Pop Art motif, and the Durable Dish Company began marketing china designed by Roy Lichtenstein. The high point of their efforts was a "Happening/ Store/Event" at what they called the Museum of Merchandise. The *Philadelphia Bulletin* dubbed it a "switched-on, tuned-in, op-pop, electronic event," displaying consumer goods designed by artists. The Coca-Cola Company immediately sought an injunction to prevent the sale there of its signature bottles painted silver by Andy Warhol and filled with "Eau d'Andy." Price: $10.

In New York the Bianchini Gallery's "American Supermarket" featured artists' versions of meat, eggs, and other everyday objects, just a block away from Leo Castelli's elegant showroom. On sale were Claes Oldenburg's plaster cakes, cookies, and candies; Tom Wesselmann's giant poster for Butterball turkeys; black and pastel-flecked eggs for $2; and wax bananas and tomatoes, three for $15. Andy Warhol attended the opening, as did Robert Scull, whose famous Jasper Johns bronze beer cans were displayed atop a pyramid of real Ballantine cans. "I just don't want people touching them," said Scull as he grabbed the work off its precarious perch.

Marian Goodman, then a Columbia University graduate student in art history, was so excited by the exhibit that she joined her friend Barbara Kulicke in a new venture, Multiples, Inc. Kulicke was already selling banners designed by such artists as Jack Youngerman and Wayne Thiebaud. Her company, the Betsy Ross Flag Company, was part of a nationwide itch to shove art off its snobbish, elitist pedestal. This applied not only to two-dimensional works; the advent of durable industrial plastics, like Rowlux, allowed print dealers such as Rosa Esman to venture into marketing "editions" of artists' sculptures, and much less laboriously than the production and sale of works by Picasso or Maillol a half-century earlier. As Grace

THE POP REVOLUTION

Glueck described it, the goal was to sell "prints, portfolios, posters, jewelry, sculptures, objects, boxes, banners and so forth produced by well-known artists in carefully supervised, signed and numbered editions."

Such editions gained added prestige after Marcel Duchamp authorized replicas of his readymades in 1964. Building on his first American retrospective exhibition in Pasadena the previous year, the artist allowed the Milan art dealer Arturo Schwarz to hire Italian craftsmen to painstakingly re-create thirteen machine-made objects Duchamp had selected and signed in the early twentieth century, including the iconic bicycle wheel mounted on a stool, the snow shovel, and the urinal titled *Fountain*. Unlike the Pop copies, however, these were not entirely within the common man's reach: at the time, a set sold for $25,000; by 2002, one copy of *Fountain* alone fetched more than $1 million.

Moreover, despite the evident similarities, Duchamp's relationship with Pop Art remained characteristically aloof. He scoffed at the contemporary artists' penchant for joining society and making money. "They have country houses, two cars, three divorces, and five children. An artist has to turn out lots of paintings to pay for all that, hmmm?" he remarked to Grace Glueck — though as John Cage pointed out, some jealousy might also have been involved, as Duchamp "couldn't understand why Rauschenberg and Johns should make so much money and he should not." Duchamp had nonetheless developed a friendly relationship with the champion money-maker of the day, Andy Warhol. In 1966 Warhol shot a hundred feet of Duchamp puffing on a cigar at a gallery benefit. Duchamp liked Warhol's spirit. "He's not just some painter or movie maker," said the elderly artist. "He's a *filmeur* and I like that very much." Affection had its limits, however. Duchamp granted Warhol only four minutes of shooting time, rather than the twenty-four hours the *filmeur* had requested.

The vast number of art prints and multiples from the 1960s and early 1970s continued to enjoy a lively market in galleries and at auctions. Despite a recession in the late 1960s, New York's leading galleries, among them Castelli, Marlborough, Pace, Martha Jackson, and Richard Feigen, kept publishing prints for its well-heeled clientele. In 1971 MoMA's print curator Riva Castleman remarked that she had never seen anything comparable: "Everywhere you turn someone is lassoing an artist to make a

print." The sale of multiples followed a similar trajectory, from an idealistic effort to "take the snobbism out of art collecting," as one early publisher asserted, to institutionalized commercialism and increased exclusivity, as the objects meant to democratize art ended up on the coffee tables of the upwardly mobile middle class.

Still, the popularity of prints and multiples had vastly broadened public interest in art, and periodicals specializing in the topic were quick to follow that new market. The British art magazines *Studio International* and *Art and Artists* began featuring multiples on a regular basis, and *Art in America*, among others, started devoting more space to "Art under $500." Aiding in the effort was the new offset technology, which liberated these periodicals from letterpress printing — the century-old technical straitjacket — and transformed their tiny, blurry black-and-white photoengravings into lavish color spreads.

The three major American art magazines had been shaken by the arrival in New York, in 1967, of a daring upstart from the West Coast. *Artforum* had been founded in June 1962 in San Francisco as a local art magazine featuring diverse, even contradictory, views. Stone-broke in San Francisco three years later, the magazine moved to Los Angeles at the behest of Charles Cowles, an angel with deep pockets and the heir to an Iowa publishing empire. When Cowles moved *Artforum* to New York in 1967, the magazine seemed to have broken all the rules of successful magazine publishing; its square pages forced advertisers to adapt to an offbeat format, and its articles ranged from long, deeply opinionated aesthetic ruminations to nonpartisan quicksilver takes on new art. In its pages, artists found a friendly platform no matter, it seemed, how elliptical their prose. The editor, Phil Leider, was an original; he hated the telephone and confessed that he was "terrified of meeting people, cant [*sic*] stand artists . . . gets physically sick at all social functions, especially art world parties and openings." In 1971 Leo Castelli warmly admired "the sudden influence" of *Artforum*. "Whatever appears in this magazine has importance," he told an interviewer.

Meanwhile, in 1972 a new owner transformed *Artforum*'s rival, the drab, unprofitable *Art News*, into a flourishing yet radically different organ. Milton Esterow left a position at the Culture desk of the *New York Times* to buy the struggling periodical from its absentee owner, *Newsweek*.

THE POP REVOLUTION

Esterow decided to abandon judgmental coverage of art and instead deal with art journalistically, without the "existential gas" that filled other art publications. He intended to apply "good old commonsense journalism to the arts," he said. "No one was interviewing the scholars, the artists, the museum directors, the collectors, all the people involved in the wonderful, mysterious world of art." The magazine went on to capture the largest art magazine circulation in the world, as well as many prizes for its journalism, notably on the nonrestitution of art looted by the Nazis from Jewish collectors.

The diverse new directions at *Artforum* and *ARTnews* (as the title was refashioned) marked a decline in the prestige and authority of such established gurus as Harold Rosenberg and Clement Greenberg. As art magazines could now feature vibrant illustrations of new art, there was less need for minute descriptions; the works shown spoke for themselves. Furthermore, the younger critics, emerging from the country's top universities, were not as interested in guiding the reader's taste as they were in examining the artist's derivation and influences, as well as the aesthetic school in which he or she dwelled. On the one hand, without judgments handed down by sophisticated critics, art careened rudderless in assorted directions. At the same time, the large color illustrations of various kinds of works left readers free to reach their own conclusions. The artist and art critic Peter Plagens noted a diminished interest in how art looked; what counted, he wrote, was "what it says about classism, racism, sexism, homophobia, etc." He also worried about "some 300,000 Master of Fine Arts degree-holders . . . abroad in the land," which to him signaled "the final steps in the academization of the avant-garde."

For his part, Leo Castelli was having doubts that "collecting as it used to be will continue. . . . Conditions have changed enormously," he told an interviewer in 1971. He was still showing, and selling, works by Pop artists, but his gallery had moved into the Minimal and Conceptual universe. Nor was that the only change. In 1969 Ivan Karp had set off on his own, pioneering a gallery funkily named OK Harris Works of Art. (The name, he explained to Grace Glueck, referred to a fictitious character "who wears a zoot suit and a gold chain, the kind of sharpie who might come suddenly to town and deal in art.") Karp opened his new space in the burgeoning art neighborhood in lower Manhattan known as SoHo.

Two years later, Castelli would follow him there, refurbishing a former paper warehouse at 420 West Broadway to create spaces for himself and three other dealers: André Emmerich, John Weber, and Ileana Sonnabend. At a cost of $500,000, the foursome created SoHo's first multigallery complex. Paula Cooper and Max Hutchinson were already building traffic for art galleries in the neighborhood; rents there were only $2 per square foot, compared with $15 on the Upper East Side. Unsure whether the move would succeed, Castelli kept his original Seventy-seventh Street gallery, where his second wife, nicknamed Toiny, presided over Castelli Graphics, as well as a warehouse space at 103 West 108th Street. The latter, a former garage, featured a concrete floor and an elevator that could handle anything heavy and large; it was perfect for displaying the oversize steel sculptures of Minimalist artists such as Richard Serra, Keith Sonnier, and Eva Hesse. Not many art fans ventured to the warehouse, however, because it was in a heavily crime-ridden neighborhood. "People could get a cab to take them there," said Castelli, but when they wanted to leave, "it was impossible to find [one]."

More than a decade before any art galleries migrated there, artists had been finding large spaces and cheap rents south of Houston Street, the last place in Manhattan that offered such benefits. The neighborhood consisted of a warren of streets that had once been a red-light district and was later dominated by factories and warehouses. In the postwar decades, these businesses began moving to facilities in the outer boroughs and the suburbs, where the buildings were newer and the traffic less congested. The artists moved in to fill the vacuum, defying city ordinances that prohibited residence in the commercial zone and building handsome living spaces connected to spacious studios. They also formed vocal political groups to defend their space, and eventually New York City zoning enforcers abandoned their attempts to evict the illegal occupants. "The artists are an extremely vital cultural industry," a young city planner conceded in 1970, as the artists were on the verge of legalizing their living arrangements. Inevitably, real estate values leaped; buildings that had sold for $30,000 ten years earlier were suddenly going for $150,000, and rents doubled and tripled.

Castelli, for one, felt his move downtown had been a wise one. "It's a constant movement on Saturdays down there, a real joy," he remarked in

1973. The Seventy-seventh Street gallery was attracting fewer visitors, and those who came lacked "real enthusiasm." In SoHo, on the other hand, he had discovered "a very clubby kind of atmosphere," including his own favorite Italian restaurant where he lunched almost every day with a colleague, artist, or collector.

To Tom Wolfe, the dealer resembled "the eternal continental diplomat, with a Louis-salon accent that is no longer Italian; rather Continental," his voice "soft, suave, and slightly humid, a cross between Peter Lorre and the First secretary of a French Embassy." In the dozen years since he had opened his gallery, the empire Castelli had built seemed at times to rival the Austro-Hungarian Empire of his youth. When interviewed, he described his business activity as an adjunct to his real passion: supporting deserving artists. But the network he had forged extended not only to lucrative relationships with colleagues in what he called "the provinces" — Los Angeles, Dallas, Minneapolis, Saint Louis, and other urban centers — but also across Western Europe.

Perhaps the most prominent of the European Pop collectors was the German chocolate magnate Peter Ludwig, who took advantage of his country's blazing economy to make wholesale acquisitions. Castelli later said that, by square footage, Ludwig and his wife, Irene, had built up the largest collection of contemporary art in Europe, including the best Rauschenberg collection in the world and at least fifteen Lichtensteins. Ludwig had been inspired by Amsterdam's Stedelijk Museum, which Ileana Sonnabend had aided in developing its fabled collection, and when in New York he would drop by the Castelli Gallery to sample the latest arrivals. But as was his custom, Castelli politely refused to sell directly to Ludwig or to any other European, explaining that "it would invade Ileana's territory." When Ludwig then duly appeared at Ileana's gallery, she informed him that there was a waiting list and that he would be placed at the end of it.

To an interviewer, Castelli described the "rigid rules that I imposed upon myself not to deal with any Europeans . . . because that sort of monopoly that she had for several years did create a market." Castelli, like most European entrepreneurs, had no qualms about monopoly, a form of capitalism that had been common in Europe for centuries. Until the advent of the European Union in November 1989, there were no antitrust

laws on the Continent, and even now regulations against monopolies are only sporadically enforced. In fact, Castelli mused wistfully about persuading the major art magazines to specialize. "What sense does it make," he wondered, "to put the same names in *Arts, Artforum, Art News, Art International, Art in America?*" He suggested that major dealers should confer with the art magazine editors to develop "intelligent solutions to . . . this insane overlapping."

That idea, of course, like Castelli's business practices in general, was anathema not only to the magazines at issue but also to the multitude of analysts, critics, art historians, museum curators, and art groupies trying to understand Pop's success in the marketplace. When it first emerged in the late 1950s, most of the aesthetically minded public believed that art based on popular images was a passing fad, as the critic Clement Greenberg had predicted, something like bob-haired flappers doing the shimmy or college kids swallowing goldfish. But a decade after its emergence, Pop Art seemed feistier than ever, its dealers respected, its artists enthusiastically collected, its explicators teaching at prestigious colleges, and its defenders curating museum exhibitions. Postmodernism was entrenched, it seemed. But the grand panjandrums of modernism were not about to leave the stage without a fight.

Chapter 6

"THE MOLDS ARE BREAKING"

1969 – 1980

Some two thousand art notables had been invited to the October 15, 1969, opening of the Met's first comprehensive survey of postwar American art, innocuously titled "New York Painting and Sculpture, 1940–1970." But when an event typical of the time, a gigantic protest against the Vietnam War, fell on that date, two thousand telegrams announced postponement of the opening to the eighteenth. On that evening, a ragtag-and-diamonds throng far exceeding two thousand turned up at the venerable Beaux Arts landmark occupying four gold-plated blocks of Fifth Avenue. The select, black-tie coterie around the museum's trustees mingled with "tribal swingers dressed as American Indians, frontiersmen, Cossacks, Restoration rakes, gypsies, houris, and creatures of purest fantasy," wrote the art critic Calvin Tomkins. A rock band thumped in one gallery, and a dance band swayed in another. Sculptures were dripping with empty plastic glasses, the residue of six open bars, and the air was thick with marijuana.

The opening party and the exhibition sent a striking message: the raucous culture of the 1960s had arrived at America's most prestigious treasure house of art, and a building redolent of the past would now embrace the turbulent present. On the museum's entire second floor, an exhibition space twice as large as the entire Whitney Museum, 35 galleries displayed 408 works by 43 artists. Much to some prominent critics' dismay, only Henry Geldzahler had selected the artists to be included, choosing them, as he wrote in the catalogue, for "the extent to which their work has commanded critical attention or significantly deflected the course of recent art." Geldzahler noted that the 43 whose works were selected com-

posed a larger group than those considered crucial in any previous period, even the High Renaissance.

In 1967, just two years earlier, the museum had reluctantly devoted a single gallery to contemporary American art. The exhibition marked a sea change not only in the Met's concern for such art, but also in the worldwide impact of Abstract Expressionist works and more recent ones. As Geldzahler was assembling the objects to be shown, he told an interviewer that for the first time in history he had to borrow important contemporary American pieces from collectors in Europe. The exhibition would also be the first in the Met's history to be commercially sponsored. In its first art-related venture, Xerox committed to donating $350,000, then a handsome gift, to cover insurance and shipping costs, as well as related symposia. Geldzahler may have been "tastemaker-by-appointment" to the New York scene, as Grace Glueck had put it in August — going so far as to refer to the upcoming exhibit as "Henry's Show," a nickname that has entered posterity — but some significant critics begged to differ.

Six days before the opening, the *Times*'s senior critic, John Canaday, rushed to call the exhibition "a booboo on a grand scale" and denounced Geldzahler as "the museum's Achilles heel." Hilton Kramer, Canaday's colleague in the *Times*'s art corner, managed another shot across the exhibition's bow the morning before it was launched; he told readers that it lacked "a coherent understanding of the way [New York] art developed." Instead, it relied on artists' reputations and featured "works which happened to strike Mr. Geldzahler's fancy." Kramer followed up the next day with a lengthy assault peppered with an elitist's grievance: the show lacked "intellectual tact" and "intellectual disinterestedness"; it evidenced "little intellectual commerce," and its curator had no "intellectual profile." Perhaps this diatribe was written on deadline, but its author's resort to seven repetitions of the single adjective *intellectual* bespeaks a certain outrage. On the same day, Glueck polled some of the artists whose omission had caused an uproar but found that "dudgeon did not run hysterically high (it's hard to hate Henry)." The sculptor Louise Nevelson was happy that at the age of seventy she was "still controversial," and Tom Wesselmann, the creator of innumerable Great American Nudes, suggested that curators, too, could be reevaluated over time.

THE POP REVOLUTION

More than a decade later, Calvin Tomkins suggested that the *Times* critics may have been particularly chagrined because "they had played so negligible a part in the triumph of postwar American art." At around the same time as the exhibit, John Canaday's replacement at the newspaper, the British critic John Russell, asserted that the show was still being argued about; although it represented only Geldzahler's taste, he wrote, it still provoked "historical fascination." The dispute revolved around not only the show but also the man who had organized it, though even the headstrong Geldzahler didn't operate in a vacuum. In fact, the young curator of contemporary art owed much of his rise at the Met to the museum's new, dynamic, and instantly controversial director, Thomas Hoving, a 35-year-old whirlwind who was determined to blast some of the centennial dust off of the venerable New York institution. "These are revolutionary times," Hoving had declared in 1968, not long after his appointment. "The social order is in flux, and we must be relevant to it."

The son of Walter Hoving, chairman of New York's jewel box, Tiffany, Thomas Pearsall Field Hoving had attended several prestigious prep schools before studying art history at Princeton University, to which he also returned for graduate studies after a stint as a marine. In 1959 he had caught the eye of the Metropolitan's then director, James Rorimer, with a lecture at the Frick Collection on the art of the Middle Ages. Rorimer, who was also a medievalist, hired Hoving as curatorial assistant at the Cloisters, which housed the Met's rich medieval collection. Located in Fort Tryon Park, overlooking the Hudson River at the northernmost tip of Manhattan, the Cloisters consists of French and Spanish monastic buildings imported and reassembled, together with a twelfth-century chapter house and a Gothic and Romanesque chapel. Hoving added the Fuentidueña Chapel, a towering Romanesque fragment he had discovered in a vacant lot in France, and in 1963 acquired the richly carved, two-foot-tall Cross of Bury St. Edmunds, a twelfth-century ivory masterpiece.

In 1965 New York's youthful mayor, John Lindsey, had appointed Hoving commissioner of parks, but when James Rorimer died suddenly fifteen months later, the Met's trustees made him the youngest director in the museum's history. His first show, "In the Presence of Kings," assembled royal objects from all the museum's departments; it attracted so many youngsters that some museum workers called it "In the Presence of

Schoolchildren." Hoving welcomed those crowds, extending museum hours to accommodate more visitors. Occasionally he would appear in a peppermint-striped blazer and straw boater, a metropolitan Music Man, part of what Glueck called his "multimedia extravaganza." Not all of his colleagues were impressed. Richard Randall Jr., director of the staid Walters Art Gallery in Baltimore, described the revived Met as "a great bing-bang show, a buzz bomb," complaining that it was no longer possible to spend a quiet Sunday afternoon with great works of art. And one visiting curator claimed that "the Museum's biggest show . . . is on the second floor behind the door marked Director."

Geldzahler did not lag far behind his boss in attracting notoriety. Ostensibly, the outcry over "Henry's Show" had to do with the artists left out and with Geldzahler's exercise of purely subjective criteria in selecting works. But there was also a lingering subtext: the anxiety among some art critics over what they deemed to be the rise of outspoken homosexuals on the New York cultural scene. For more than a century, the city's laissez-faire anonymity had been a magnet for the gay community, offering privacy and discreet social venues, as well as opportunities for work, no questions asked, in theater, dance, and other arts. In the profound cultural reexamination of the 1960s, laws criminalizing homosexuality came under increasing attack, culminating in an incident in Greenwich Village on June 28, 1969, some four months before the opening of "New York Painting and Sculpture." City police had conducted a routine raid on a Christopher Street bar frequented by gay men, the Stonewall Inn. But instead of enduring arrests and humiliation, patrons and passersby confronted the "vice squad," throwing rocks, bottles, and a firebomb. For two more nights, rioting rocked the neighborhood; in time, news of the event led to widespread recognition that homosexuality was not a crime requiring police intervention.

Critics of "Henry's Show" also seized on Geldzahler's catalogue essay, in which he described his selections as "a marriage of history and the pleasure principle." They took note of his "rotund and effervescent" presence during the opening as he stood at the head of the museum's grand staircase in a blue velvet dinner jacket. He was chatting with Andy Warhol, who cheekily identified himself as "the first Mrs. Geldzahler." The artist, barely recovered from his shooting a year earlier, still had to wear a corset;

his companion, wrote Calvin Tomkins, was a person "of indeterminate sex" wearing "a silver dress and silver-painted sneakers." Critics of this culture dared not speak its name, but John Canaday still could not leave it alone some thirty months later, when he recalled the show as an "all-time flagrant example" of the "stranglehold" that "a tiny group of curators" had on museum exhibitions. Geldzahler's show, he persisted, was "a scandal of historical distortion" perpetrated by certain "slaves to a shared formula." Harold Rosenberg, in *The New Yorker*, evoked Oscar Wilde in describing Geldzahler as "given to costumes suggestive of gone-by periods of middle-class elegance"; and he labeled him a new type, the "Swinging Curator." Such coded messages expressed long-held resentments of homosexual art professionals who were emerging from centuries-long confinement in a "closet."

The very idea of a department of contemporary art at the Met had angered some of the museum's conservative patrons, and Geldzahler's appointment as chief curator had only stoked their rage. A year before the "New York Painting and Sculpture" show, the Met had attracted critical wrath over the installation in one of its galleries of a colossal James Rosenquist mural, *F-111*, on loan from Robert Scull. Without consulting

Mr. and "the first Mrs." Geldzahler, 1965

Geldzahler, Hoving had agreed to show it in an exhibition titled "History Painting — Various Aspects," along with Nicolas Poussin's *Rape of the Sabine Women*, Jacques-Louis David's *The Death of Socrates*, and Emanuel Leutze's iconic *Washington Crossing the Delaware*. Geldzahler furiously resigned over not being consulted but was soon rehired and produced an essay lauding *F-111* in the museum's *Bulletin*. The work is "not only the largest Pop work," he wrote, "it is also the grandest." When *F-111* was first shown at the Castelli Gallery in 1965, its 86-foot expanse covered all four walls. The antiwar statement, by an artist who had acquired his skills painting giant billboards above Times Square, had been traveling for three years to museums in Stockholm, Amsterdam, Switzerland, Denmark, Germany, and São Paolo. The painting was thirteen feet longer than the airplane of its title, a fighter-bomber notorious for its deadly role in Vietnam. That image contrasted poignantly with images of angel food cake, a beach umbrella, and a postcard-pretty girl under a hair dryer. The work's "scale and subject matter," Geldzahler wrote, "is a visual equivalent to the physical extravagance of our economy." Also in the museum's *Bulletin*, Robert Scull revealed that he had been on vacation when the painting was shown at Castelli's. He had rushed to the gallery the day after the show closed and watched in dismay as painted panels from *F-111* were being maneuvered down the stairway. Castelli had sold forty-one of its fifty-one segments to separate buyers; however, the dealer had stipulated that if he found a buyer for the whole work, the sales would be rescinded. It is difficult to know what pleased Robert Scull more: to have his words about the painting published in the museum's sober publication — "a milestone in the visual literature of what is perhaps art's greatest theme: the struggle between life and death" — or to have bought the entire set away from his rival collectors for $45,000.

Not everyone was so enthused, particularly outside the institution's walls. Sidney Tillim, writing in *Artforum*, deemed the Met's vaunted trophy "part farce, part high drama, evoking as it does the crisis of high art in our time," and claimed that even "the advanced crowd" had greeted it with "gasps of horror": "They felt shame, the shame of an avant-garde chicken coming home to roost in a way they had neither imagined nor desired. No one imagined the apotheosis of modernism in this form. . . . Pop art at the Met?' Sire, this is no longer the revolution, it is the Terror." For his part,

Canaday, who had developed the influential "Metropolitan Seminars in Art" for the museum before joining the *Times*, found *F-111* "pretentious and juvenile in conception" and Rosenquist's painting style "triumphantly awful." Showing it at all was "a lapse from policy difficult to stomach."

Part of the dismay might have stemmed from what critics such as Tillim and Canaday saw as a throwaway aesthetic, not only in Rosenquist's technique but even in his lifestyle. It didn't help that, around this time, the artist had hired the fashion designer Horst to make him a suit of brown Kraft paper. Wearing it, said Rosenquist, made him "sort of feel like a paper bag. Something that might end up in the garbage tomorrow. I mean sometimes it's like a neon sign keeps flashing at me and it's saying, 'JAMES ROSENQUIST, IT'S ALL OVER!' I mean you're through! Dead. Finished." (More famously, the period also saw the advent of a paper dress, decorated with Warhol soup cans and meant to be discarded after one wearing.)

But there were more deep-seated anxieties at work as well. Canaday was one of many critics and intellectuals who were ambushed in the late 1960s by new attitudes about the role of criticism, not only in art, but also in literature and other creative disciplines. The educated public had grown dramatically and was determined to exercise its own taste, rather than passively embrace a critic's verdict. As early as 1954, a note of anxiety had hovered over a gathering of contributors and editors at *Partisan Review*, the nation's leading non-Communist leftist intellectual journal. In the symposium "Our Country and Our Culture," the twenty-four participants worried that a growing group of writers no longer saw themselves as rebels and exiles; few any longer cared to bring the avant-garde values of an aging European modernism to an American context. Clement Greenberg reemphasized the intense downward draft on culture exerted by Hollywood movies, Coca-Cola, comic strips, *Time*, *Life*, advertising, and mass journalism; the mortal threat popular culture posed for high art was far greater than it had been when *Partisan Review* published Greenberg's forceful essay "Avant-Garde and Kitsch" in 1939. Though not personally on friendly terms, Rosenberg and Greenberg took pride in having guided a cohort of new postwar art lovers through the difficulties and perplexities of appreciating modernism, especially Abstract Expressionism. Not a single symposium participant suggested that mass culture

was anything other than a wicked Pied Piper leading a helpless public to cultural doom.

As the 1960s were ending, traditional high culture seemed to be under siege by an even more pernicious threat: a counterculture that glorified drugs, unbridled hedonism, and license to "do your own thing." In 1972 Rosenberg mournfully described the ominous situation at another *Partisan Review* symposium, "Art, Culture, and Conservatism." He observed that the cultural revolution of the past hundred years had dwindled. Unlike the avant-garde challenges of the past, he charged, "social and aesthetic far-outness" had become just "a public relations technique." Some of the worst writers, thinkers, and artists were making the most money, he said. As so often happens to aging radicals, Rosenberg, the erstwhile intellectual sniper from the left cultural margin, had achieved a remarkably soft landing: a double tenure at the University of Chicago, as a professor on the Committee on Social Thought and in the Department of Art. His principal activity, however, seemed to be commuting to New York to fulfill his duties as art critic for *The New Yorker* and preparing the text of these and other writings for books published by the University of Chicago Press.

Rosenberg's trajectory was shared by an entire segment of the American intelligentsia. Born in New York soon after the First World War, this small but outspoken coterie had published its cutting-edge articles in obscure little magazines and survived on a patchwork of part-time jobs. Ironically, it was also New York, during the 1960s and into the 1970s, that witnessed its dissolution and dismay. Political radicals firmly focused on the European avant-garde, the editors of *Partisan Review* started out in the 1930s believing that their mission was to support the non-Communist Left and to make sense of modernism in all the arts — from the recondite pages of James Joyce and Marcel Proust to the advanced canvases of Picasso, Matisse, and, in the 1950s, the Abstract Expressionists. Lionel Trilling, as a student and then a professor at Columbia University, associated himself closely with this enterprise. His appointment to the literature faculty in 1939 had been a political and social landmark in New York; he was the first Jew ever to be admitted to that sanctum of literary grandees, but only at the insistence of Columbia's reforming president, Nicholas Murray Butler. Trilling's first scholarly work, a study of the Victorian lit-

erary critic Matthew Arnold, was hardly a breakthrough for cutting-edge modernism, but it firmly placed the young professor among the Euro-centric literary scholars in America.

Trilling's career path, like Rosenberg's, typified the drift of the pre-dominantly Jewish New York intellectuals into the secure but insulated environment of academe. In 1957 Philip Rahv, *Partisan Review*'s fiercely independent coeditor, had accepted a professorship at Brandeis University in Massachusetts, and in 1963 the magazine found shelter at Rutgers University in New Jersey (and later at Boston University). The lively and sometimes raucous discussions among the New York intellectuals were largely displaced and gentrified during the 1960s, much as the artists and writers in bohemia's erstwhile outpost, Greenwich Village, had been over-run by a rising middle class that could afford the rents.

An advertisement in late 1967 for a new magazine, *Avant-Garde*, seemed to crystallize the boisterous, icon-bashing confrontation with tra-ditional culture that enlivened, even as it undermined, the discourse about serious art. Under the suggestive headline "A Proposition," the advertise-ment proclaimed that "the mad mod scene is about to witness the birth of a fantastic new magazine destined for greatness." Among the articles promised for just a $3.95 annual subscription were "The Dead-Serious Movement to Run Allen Ginsberg for Congress" and "The Writing on the Wall — the Emergence of Graffiti as a Medium of Social Protest." The new publication would be "wildly hedonistic," reporting on "every aspect of the ebullient life style now emerging in America . . . with no put-ons and no inhibitions."

Such blatant attacks on the cultural establishment sowed disquiet and even panic among the scholars and critics whose careers had focused on modernism. Already, substantial segments of the public had fled from con-tact with those mandarins still devoted to unraveling modernist complex-ity, still explaining why it was important for a cultivated individual to nav-igate the word soup of *Finnegans Wake* or pay serious attention to the poetry of Ezra Pound, to understand Jackson Pollock's drips or de Kooning's slashes. Some called it a cultural revolution, but its pattern more closely resembled a cultural reformation. In the sixteenth century, the Protestant reformers had affirmed each individual's right to commune directly with God without clerics' intervention; in the latter part of the

twentieth, individuals were encouraged to commune directly with art, without critical mediation. The euphoria in the art world was palpable: art exhibitions sold out before the openings; museums rushed to show works by new artists and organized retrospectives for those whose careers were just beginning. Contemporary fiction dwelled more on the here and now and less on the then and gone, as readers snapped up the racy novels of John Updike and Philip Roth or (albeit in lesser numbers) the unorthodox fictions of John Barth, Donald Barthelme, and Richard Brautigan.

In 1961 Trilling had written a triumphant essay about his success at introducing the study of twentieth-century literature at Columbia, work that his colleagues had considered "shockingly personal" and that raised previously frowned-upon questions about whether "we are content with our marriages, with our family lives, with our professional lives, with our friends." But by the mid-1960s, society itself was asking the same questions without resort to challenging readings. Even as Trilling wrote anxiously about the fading of modernism in 1965, a large segment of the educated public was liberating itself — or believed it was liberating itself — without the guidance of Joyce, Proust, or Kafka, not to mention Trilling and Rosenberg.

Even *Partisan Review*, which had published many of the earlier, culture-defining writings by such former guides, was turning to new intellectual voices willing to build bridges across the chasm between high culture and the popular culture that the older modernists deemed heresy. In 1964 the review published "Notes on Camp," an essay by a 31-year-old writer named Susan Sontag. For most readers, the use of the word *camp* was puzzling; in the essay's context, it hardly suggested a child's summer experience in the country or military lodgings. Rather, it meant "a mode of aestheticism," as Sontag wrote, that was esoteric, that loved artifice and exaggeration, and that was also "something of a private code . . . among small urban cliques." Beauty had little to do with "the way of camp," which could apply to objects, music, literature, buildings, even people. Tiffany lamps could be considered camp, as could the ballet *Swan Lake*, old *Flash Gordon* comics, and such female finery from the 1920s as feather boas and beaded dresses. The best examples of "the most typical and fully developed camp style" were objects that looked like something else — "light fixtures that resemble plants" or Hector Guimard's entrances to the Paris metro,

cast-iron canopies shaped like orchid stalks. "Camp is art that proposes itself seriously," wrote Sontag, "but cannot be taken seriously because it is 'too much.'"

Sontag was describing in scholarly terms the kind of sensational culture epitomized by the flamboyant goings-on at Andy Warhol's Factory: in a setting clad in ersatz silver, its freewheeling inhabitants played out unending fantasy scripts before the movie camera's artificial glass eye. Vying for attention, especially from the talented ringmaster Andy, the cast paraded fake glamour and fetchingly bizarre eroticism. As Sontag put it, "The haunting androgynous vacancy behind the perfect beauty of Greta Garbo" was "the most refined form of sexual pleasure . . . going against the grain of one's sex." Arthur C. Danto credited her with spotlighting the camp aesthetic as "essentially a gay revolution through Warhol and others." Sontag "gave people a vocabulary," wrote Danto, "for talking . . . and thinking about it."

Unlike most of the *Partisan Review* crowd, who sprang from poor immigrant families, Sontag presented herself as an exotic import. She was born in New York City and was raised by her mother in Tucson and Los Angeles after her father, a fur trader, died in 1938. Upon graduating from North Hollywood High School, she arrived at the University of California at Berkeley in 1949 at the age of fifteen, a precocious, opinionated, and impulsive free spirit. Six months later, she decamped to the University of Chicago to study philosophy and literature, and ten days after attending the sociologist Philip Rieff's class on Kafka, Sontag and the professor were married. They moved to Boston in 1951, where Sontag took a master's in philosophy at Harvard and where her son, David, was born in 1952. Five years later, she left her husband and son for a fellowship at St Anne's College, Oxford. Disillusioned by the university's entrenched sexism, she moved to Paris, joining the American expatriates orbiting the avant-garde quarterly *Paris Review*. There, she exercised her talent for attracting prominent older men, forming relationships that opened doors for her subsequent career as a sharp-tongued intellectual gadfly, what the writer Eric Homberger called "the Dark Lady of American intellectual life." By the end of the decade, she was back in New York with, as she later said, "$70, two suitcases, and a seven-year-old," as well as a recent divorce. She pieced together part-time teaching and editorial jobs and parlayed a

friendship with the publisher Roger Straus into a lifelong publishing rela-
tionship with the firm he had co-founded, Farrar, Straus and Giroux.

Forty years after the fact, Sontag's *New York Times* obituary described
the publication of "Notes on Camp" as "a shot across the bow of the New
York critical establishment." It would not be her last fusillade at the aging
guardians of high culture. In 1965 she took her own advice of ranging the
cultural spectrum with an article as challenging in its content as it was
unexpected in its venue. It was in *Mademoiselle*, amid fashion and beauty
tips for young career women, that Sontag published "One Culture and
the New Sensibility." She argued that abstract art echoed the complexity
and expansive scope of modern science. Perhaps with Robert Rauschen-
berg in mind, she noted that "painters no longer feel themselves confined
to canvas and paint, but employ hair, photographs, wax, sand, bicycle tires,
their own toothbrushes, and socks." For readers largely interested in hair-
styles and lip colors, Sontag laid out a dense philosophical meditation on
how contemporary culture was "defiantly pluralistic," challenging many
accepted cultural borders — "not just the one between the 'scientific' and
the 'literary-artistic,' or the one between 'art' and 'non-art,'" but also tra-
ditional distinctions between "form and content, the frivolous and the

Susan Sontag and Jasper Johns at a New York loft party, 1966

serious, and (a favorite of literary intellectuals) 'high' and 'low' culture."

An imposing raven-haired virago, Sontag plowed through the turbulent midsixties like a virtual Rototiller, ridding the culture of ancient debris. Reviving contacts she had made in Paris, she flashed her views in the pages of a new weekly, *The New York Review of Books,* founded in 1963 during a punishing six-month newspaper strike. Sometimes she generalized wildly: "What I like about Manhattan is that it's full of foreigners. . . . The rest is just drive-through." And sometimes she had to backpedal from an impulsive action, such as her trip to Hanoi in 1968 while the Vietnam War was raging, or her offhand remark that "the white race is the cancer of human history." Her judgment sometimes faltered, as when she had to reconsider her praise of Leni Riefenstahl's Nazi propaganda films. But such was her restless curiosity that by 1966 she had published twenty-six essays on subjects as eternal as the death of tragedy and as relevant to the moment as the article titled "Happenings: An Art of Radical Juxtaposition."

More than many of her contemporaries, Sontag zigzagged nimbly through the cultural minefield, to the disarray of the old-boy network of critics who did not take kindly to this noisy challenger. Irving Howe called her "a publicist able to make brilliant quilts from grandmother's patches." However, many of those patches endured: "The ultimate camp statement: 'It's good because it's awful.'" "Illness is the night side of life." "What pornography is ultimately about isn't sex but death."

Nor was Sontag alone in presenting fresh critical perceptions to the cultural scene. The literary critic Leslie Fiedler, who took credit for inventing the term *postmodernism,* denounced the nation's leading literary critics for promoting a two-tier cultural scheme. He condemned as "a scandal . . . the notion of one art for the cultured . . . and another sub-art for the uncultured," calling it "the last survival . . . of an invidious distinction proper only to a class-structured community." The age of Proust and Joyce was over, he declared. From his perch at the University of Montana in Bozeman, Fiedler proclaimed that the critic's authority in the postmodern world was not founded on his research skills or textual analysis but "on his ability to find words and rhythms and images appropriate to his ecstatic vision of, say, the plays of Euripides or the opening verse of Genesis."

Fiedler's challenge from the Wild West may have seemed like a distant

trumpet, but soon audacious marauders were undermining the ivory tower itself. Just a year after Lionel Trilling of Columbia had glowingly endorsed "Ideopolis," a superuniversity envisioned by Clark Kerr, president of the University of California, the regents summarily fired Kerr for failing to control the riotous students on the Berkeley campus. Two years later, Columbia University was shut down as students ransacked classrooms and offices in five university buildings. They trashed professors' books and papers before police arrived and arrested 628; classes were suspended on May 5 for the rest of the school year. So shaken was the Columbia historian Richard Hofstadter, whose *Anti-Intellectualism in American Life* had won the 1963 Pulitzer Prize, that he diagnosed "a crisis point in the history of American education and probably that of the Western World."

The turmoil marked the end of modernism as a viable framework for understanding new works of art, literature, or music. In his 1970 essay collection, *Decline of the New*, Irving Howe, editor of the proudly socialist review *Dissent*, lamented that "we have now entered a period of overwhelming cultural sleaziness." Perhaps replying to Sontag's version of camp, he charged: "The new sensibility is impatient with ideas, it wants instead works . . . as absolute as the sun, as unarguable as orgasm, and as delicious as a lollipop." Yet his description of modernism as "uncompromisingly a minority culture" conflicted glaringly with his power-to-the-people political views.

Needless to say, the arrival of Postmodernism, the fidgety new paradigm, presented its own conflicts. Even as Henry Geldzahler assembled his famous 1969 exhibit at the Met, he realized that the Pop Art movement he had defended so eloquently in 1962 was already losing steam. In the catalogue for his controversial show, he saw Pop as only an interesting "episode [that] left its mark on the decade . . . but not a major movement which continues to spawn new artists." The modernist gospel that had dominated the thinking about art for almost a century was shattered, but no one could agree on its replacement. Postmodernism consisted of a "progressive loss of idealism and anti-idealism," the artist and art critic Brian O'Doherty glumly reported in 1971. It was the last resort of an art "surfeited with paradox . . . and deprived of confidence." Flailing vaguely, this deeply pessimistic view of the art scene presented yet another par-

adox: it was published in *Art in America*, alongside four articles about Andy Warhol and sixty pages of colorful advertising.

On February 25, 1970, a forecast of increasing clouds and impending frost perhaps symbolized the looming breakup of New York's art establishment, as the cream of the city's art world gathered for the funeral of Mark Rothko. At the age of sixty-six, the artist had taken a fatal dose of antidepressants before slashing his arms with a razor. As Henry's Show had shaken the guardians of the modernist aesthetic, so Rothko's gory suicide underscored the woeful eclipse of Abstract Expressionism. Still, the various sides in the upcoming clash of art styles came together for the funeral. Among the mourners were MoMA curator William Rubin, who had been an adviser to the artist; Henry Geldzahler; and a flock of art writers that included Dore Ashton, Thomas B. Hess, Irving Sandler, Elaine de Kooning, and Brian O'Doherty. All were veterans of many an art opening, so the funeral, despite the somber context, was a convivial occasion. Also present were representatives from the art world's more affluent provinces, such as Robert Scull; John de Menil and his wife, Dominique, heiress to the Schlumberger fortune, who had commissioned Rothko to create a chapel in Houston; and the textile merchant and collector Ben Heller, who a year later would sell Jackson Pollock's *Blue Poles* to an Australian museum for the unheard-of sum of $2 million.

Few of those present at the funeral cared to comment about how the traditionally low-key wheeling and dealing in art had grown significantly more shrill and less decorous during the previous decade. To Scull, a Rothko painting represented a chip in a high-stakes game that mimicked his earlier speculations with New York taxi permits. Indeed, it was such speculations that had financed his massive art-buying spree. "I make my living from a taxicab business and a real estate business," Scull told an interviewer. "I'm a product of the . . . undulations of change in money markets, from one group of men to another."

By 1965 the Sculls owned far more works than could be shoehorned into their spacious Fifth Avenue apartment. The rest were stored at a warehouse on East 107th Street, except for 140 items that were on loan to museum and gallery exhibitions all over the world. The pileup had already nudged Scull toward an auction of thirteen Abstract Expressionist paintings. The auction yielded mixed results, but one thing that became

clear was that loaning works to museums helped enhance the gavel price. Willem de Kooning's *Police Gazette*, the artwork most frequently lent to museums, won a record $37,000, more than twenty times the $1,820 a similar work fetched just three years earlier. The total proceeds, some $165,000, went into a family foundation Scull had set up a few days before the sale to support young, unknown artists, whose work, presumably, he could then buy at a special discount. Sometimes Scull bought up artworks in wholesale lots, as when he paid Castelli half-price for all twenty paintings in a Jasper Johns show in 1959. The dealer had deemed that greedy move "vulgar," but more mass acquisitions followed.

Vulgar or not, in April 1969 the Sculls were basking in the spotlight of a tribute at the exclusive Georgetown Club in Washington, DC, to benefit the tradition-oriented Corcoran Gallery of Art. The president of the gallery's Friends group suggested that the couple "would add class with a capital C to the Corcoran." Ethel wore an Adolfo pant suit, and Bob appeared in an Edwardian-cut tuxedo with a wide velvet tie. He explained that his wife had thrown out all his clothes and "bought me this sort of thing."

The following year, Scull again tried an auction, sending two Abstract Expressionist paintings and four Pop works to the block, among fifty Abstract Expressionist works auctioned at Parke-Bernet that November. He explained to Grace Glueck that "we decided to let these few things out into the world because they're history, darling, and I'm not involved with history." The auction house promised that the sale would topple the record of $60,000 paid six months earlier for a Pop work, Warhol's *Campbell's Soup Can with Peeling Label*, though it was not to be. Nonetheless, Sotheby's turnover had doubled between the 1965–66 and 1969–70 auction seasons, from $31 million to almost $60 million; Parke-Bernet, which had been acquired by Sotheby's in 1964, reported a sales increase from $23.5 million to $38.5 million; and the take at Christie's during the same years jumped from $20.3 million to $48 million. Even the smaller auction houses reported gains of 300 percent.

Given those figures, Scull did what any bright businessman would do: he carefully prepared for an auction of fifty of his best-known works at Sotheby's in October 1973, and even paid a documentary filmmaker $60,000 to record the happening. Ethel Scull did her part to publicize

the event. In February 1973, after a two-year hiatus due to a back injury she suffered while vacationing in Barbados, she threw one of her legendary salons. "I'm so desperate to come back to a life of usefulness," she told the *New York Times* society reporter in attendance. During the party, the hostess "flitted among her guests," including Henry Geldzahler, Betty Friedan, George Segal, and Thomas Hoving. At several points during the evening, the self-styled "Spike" withdrew to rest on a chaise in the bedroom. "It's like Madame Recamier," she declared, while showing off her black-and-white Adolfo caftan.

The auction eight months later would be the first in the United States devoted exclusively to contemporary art. It attracted an upscale crowd in evening dress to Sotheby's auction gallery at Madison Avenue and Seventy-ninth Street. But it also attracted a raucous chorus of self-appointed activists, the residue of the turbulent sixties, when self-expression was not only a right but a duty. At the entrance, a group of enraged cab drivers loudly chanted that Scull was exploiting them; the signs they carried thrust home the point: "Robbing Cabbies Is His Living. Buying Art Is His Game." Nearby, the Art Workers' Coalition presented a tableau of deprivation: some actors dressed as "beautiful people" and other actors clad in rags, representing artists. Irate feminists clustered nearby, shouting

Scenes at an auction: Robert and Ethel Scull watch their profits go up, up up . . .

bitterly that only one woman artist, Lee Bontecou, was included in the sale. The proceeds, $2.2 million, vastly exceeded typical art sales of that time, highlighting an idea still dormant in the minds of most art buyers: that the fun and status of investing in art could also turn a profit. Rauschenberg's *Double Feature*, which Scull had bought for $2,500 in 1959, was sold for $90,000, and the artist's *Thaw*, bought for $900 in 1958, went for $85,000. Jasper Johns's *Double White Map*, for which Scull had paid $10,000 in 1965, was sold to the Italian industrialist Gianni Agnelli for $240,000.

Outside Sotheby's, Robert Rauschenberg furiously accosted Scull, shouting, "I've been working my ass off for you to make that profit." The collector coolly replied, "How about you? You're going to sell now, too. We've been working for each other." On the film he had commissioned, Scull gruffly nailed down what the auction revealed: that art was no longer "such a fine, tony, cultured thing. . . . Suddenly people are bidding wildly like it was a commodity." As to the auctioneer, "That's art without the floss of culture. Over there, it's hard cold money and business. . . . [There's no] talking about the aesthetics . . . they just talk about the money."

Rauschenberg had not exactly been living on bread and water. In October 1972, for instance, he'd hosted a formal dinner in his multistory

. . . as protestors on the sidewalk decry the rampant capitalism inside

SoHo mansion for Princess Christina of Sweden. The occasion was the forthcoming exhibition of a large collection of American paintings at the Moderna Museet in Stockholm. Rauschenberg had passed up a suit made entirely of neckties in favor of a white shirt, black tie, and knockoff American Indian jacket with fringes at the shoulders and sleeves. His "wavy, shoulder-length coiffure," wrote the *New York Times* social reporter, was held back by a bobby pin over each ear. The neckline of the princess' dress "plunged daringly," but she forwent her tiara. Among the 309 guests were Larry Rivers, Roy Lichtenstein, Andy Warhol, James Rosenquist, and Henry Geldzahler, who sat beside the princess at dinner. The menu included fresh salmon flown in from Sweden, chicken with dill from a Greenwich Village restaurant, and fruit and cheese, all served on paper plates; the vintage Muscadet wine flowed into plastic cups. Also in attendance was Robert Scull, who called the whole thing "great. Just think of it as a picnic al fresco."

Still, the artist devoted considerable time after the Scull auction to campaigning for legislation to give artists royalties when collectors sold their works for a profit. That effort mostly failed, although the auction results did what Scull had promised: the price of Rauschenberg's work rose dramatically. But the shocking events of that evening at Sotheby's persuaded many art-world figures that their milieu had drastically changed. An intimate gathering of genteel colleagues had been transformed into a high-power industry. Grace Borgenicht, who had operated a gallery in New York since 1951, told an economist researching the art market some three decades later that before the Scull sale, "there wasn't this hype, promotion, art scene, superstars, and media." Many other dealers said money didn't interest them much. Leo Castelli's daughter, Nina Sundell, said she'd never heard anything about money until the 1980s, and her father painted a somewhat bucolic picture of his early years as a dealer, saying that money was "needed, but it was never a consideration. I never considered the gallery as a business." Barbara Rose furiously described the auction as the end of the art world's innocence and warned artists of the betrayal they could expect from patrons like Scull. The outraged voices came years too late, with the sudden recognition that a complex market had developed around objects of aesthetic delight. It encompassed people with various, sometimes conflicting, motivations, from artists and gallery owners to

museum curators and administrators, historians, publishers, and critics. Almost two decades later, Andy Warhol's biographer Bob Colacello recalled that long-ago evening in 1973 when, for the first time, "the public at large, not just dealers and collectors, attended and followed an auction of contemporary art."

Reviewing the 1973–74 season, the art critic Peter Schjeldahl attributed the trend toward commercialism to "the unforeseen and overwhelming triumph of American art," even as "the serious artist [was] in the same lonely fix as ever." In the early 1970s, many art-world observers blamed "a runaway bull market euphoria" for steeply escalating prices, not only for paintings and sculptures but also for prints and multiples. In that revolution of rising expectations, those at the center were blamed for the bubble. The accusers, reported Schjeldahl, argued that "this crazy so-called 'art' stuff couldn't possibly be doing so well unless somebody was pulling the strings." Hilton Kramer ventured closer than most art critics to identifing who that "somebody" was. Reviewing a one-man show of Francis Bacon's paintings, he deemed the artist's work "little more than a form of theatrical illustration." He argued that "the world where Bacon's paintings are seen and bought and judged and talked about is avowedly homosexual," that it trafficked "in images of sexual violence and personal sadism." For organizing the show and writing an admiring catalogue essay, he blamed Henry Geldzahler, "the Diaghilev — or was it the Barnum? — of Pop art." Others set their sights on dealers such as Leo Castelli or high-profile collectors like Robert Scull.

By then, the flamboyant Sculls had descended into a noisy, public bickering match that would feed tabloid headlines for more than a decade. In early 1975, Robert stormed out of the couple's Fifth Avenue apartment after Ethel claimed he was taking all the credit for their immense art collection; he had even omitted her name from the auction catalogue. She should have said something at the time, she later admitted, but told the reporter from *People*, "I was too well bred." Almost all the art, now valued at $3.5 million, was in storage; the only exception was Andy Warhol's 1963 landmark *Ethel Scull 36 Times*, which had been on loan at the Met. "The only thing I miss are the paintings," she said. "The walls ache and ache." However, she had obtained an injunction to prevent her estranged husband from selling more than one-third of the collection and

retained a maroon limousine to carry her to her physical therapist and her psychiatrist. The $850 weekly alimony she received in July 1975, she said, "was not enough for a sea urchin to live on."

In 1976 the sociologist Daniel Bell sadly observed that the era's democratizing tide had tarnished genius itself, that the public had become "so culturally voracious that the avant-garde . . . is in the public domain." Bell was the quintessential postwar intellectual: he wrote as though he had read everything that affected society, past or present; he knew the Greeks and Romans, quoted liberally from the Bible, engaged with Rousseau and Marx, Fourier and Durkheim, and was familiar with great writers from Shakespeare to Bellow, Dante to Nabokov. He had also seen the great plays, heard the great classical music, contemplated modernism in art, and written engagingly about his experiences and conclusions. His career had blossomed during the 1950s as he shuttled between journalism and academe, a lucid liberal pen during a quiescent time. In 1960 Bell's collection of essays from the previous decade, *The End of Ideology*, found a large, appreciative audience. He concluded that the ideologies that had animated intellectual debate earlier in the twentieth century — communism, socialism, fascism — had run their course and that the future belonged to individual freedom. However, the freedom that Bell had admired so convincingly in 1960 now caused him intense alarm. In *The Cultural Contradictions of Capitalism*, published in 1976, Bell deplored the deterioration of culture during the previous decade. He was aghast at the widespread contempt for socially beneficial rules and at how that disdain had boiled over into contempt for rules of good taste, proper behavior, and sexual and social morality. The new sensibility, the counterculture, "masqueraded as an attack on the 'technocratic society,'" he wrote, "but was an attack on reason itself." In the arts, the serious critic had been pushed aside; he or she could fruitlessly denounce what passed for high art or "resign himself to being the doorman at the discotheque."

A preponderance of the New York artists interviewed by a trio of art critics in 1977 also deplored the commercialized art scene. Norman Bluhm saw the artist losing control of his work, "selling himself to the dealer," who "creates the Hollywood atmosphere, the limelight effect . . . this destructive merchandising of art." Roy Lichtenstein said that New York had been important for him when he was still teaching at Rutgers

but conceded that the New York hustle was "awful." Vito Acconci, who had gained notoriety for *Seedbed*, a 1971 performance at Ileana Sonnabend's New York gallery in which he masturbated under a tilted platform for days on end, asserted that "doing art in New York means doing 'public art.' . . . Art is not complete until it enters publicity channels," he said. "Publicness . . . is an inherent quality of the work itself."

Clearly, it seemed that no art, however "avant" or offensive, would attract serious resistance or condemnation. The typical tension between radical, shocking new art and a shocked middle-class public had been erased, wrote Bell. The vanguard had become institutionalized, a contradiction in terms meaning that nothing could be really new. Instead of enhancing the sophistication of mass culture, the democratizing revolution of the 1960s had introduced graphic depictions of violence in such films as *Bonnie and Clyde*, which lacked the catharsis so essential to classical tragedy. The boundary between art and life, he argued, had been blurred into a vague murk labeled "lifestyle." Deeply troubled by this cultural plunge, Bell pointed a furious finger at the prophet of hedonism, Marshall McLuhan. Slogans like "the medium is the message," he wrote, "are litanies to assuage a person's anxieties . . . they are Turkish baths of the mind."

Yet many observers were beginning to find their way through that overheated, foggy domain. After years of testy disparagement of Pop and other successors of his favorite Action painters, Harold Rosenberg made his peace with the end of traditional art criticism. The discipline had been "swallowed up in a sea of image-making without boundaries," he wrote. Separate cultures — high, middle, and low — had blended into "one indefinable agglomeration," a pulsing, shimmering array from which each individual would construct his or her cultural dwelling. Henry Geldzahler had arrived at a similar conclusion. Addressing graduates at the New York School for Visual Arts in 1976, he described stockbrokers emulating the traditional artist's boho way of life, while "there are successful artists who live and look like stockbrokers. The molds are breaking and it is better so."

Chapter 7
DEATH & TRANSFIGURATION
1970 – 1987

As Andy Warhol was recovering from his near-fatal shooting in June 1968, the fuzzy image of the deviant artist-filmmaker surrounded by even more deviant personalities began to change. The new Warhol persona was just as synthetic and opaque as the earlier one had been, but it seemed better suited to the cultural atmosphere of the early 1970s, with its reaction against the rampant hedonism and drug-taking sloppiness of the preceding decade. And as went Warhol's personality, so went the Factory.

The architect of this transformation was Fred Hughes, an elegant young Texan who had met Warhol in 1967 at a benefit for the Merce Cunningham Dance Company. Sponsored by the Houston art patrons Dominique and John de Menil, the event was a picnic at the architect Philip Johnson's renowned Glass House in New Canaan, Connecticut. Years later, Warhol recalled how impressed he was at seeing Johnson's underground art museum, but Henry Geldzahler's introduction of Warhol to Hughes turned out to be much more significant. The Texan, who was in New York as an assistant to the de Menils, began dropping in at the Factory. For Warhol, clothes made the man; the artist was impressed when Hughes arrived for the first time "wearing a flared double-vent dark blue suit, blue shirt, and light blue bow tie." Warhol responded to Hughes's appreciation of his work with "the sounds you make when you're embarrassed, but saying thank you."

At first, Hughes would spend his days at the Menil Foundation and then head downtown to the Factory, where his unpaid job was to sweep the floors. Sometimes he arrived dressed for a big evening, Warhol recalled, and would clean the Factory in a custom-tailored dinner jacket. Soon Hughes moved out of the plush de Menil townhouse and settled into "a

bare essentials room" at the Henry Hudson Hotel on faraway West Fifty-seventh Street. Apparently seeking to impress Warhol, he tried to join the artist and his entourage at Warhol's nightly haunt, Max's Kansas City, in evening dress and a ten-gallon hat. When owner Mickey Ruskin blocked him at the door, saying, "We don't know you," Hughes (as he later confided to Warhol) was so mortified that he sped uptown to the exclusive El Morocco Nightclub, where he was warmly welcomed.

In any event, this state of affairs was short-lived. Within months of arriving at the Factory, Hughes hung up his broom, acquired a spacious, businesslike office, and began constructing the formidable Warhol moneymaking machine. The two men had much in common: both were devout Catholics and would eventually have an audience with Pope John Paul II; both had emerged from modest backgrounds and had worked hard to achieve security; and both relished the privileges that came with money, especially the ability to acquire beautiful things.

One late afternoon in the winter of 1969, the two appeared outside Lewis Robinson's five-story antiques emporium on Broadway at Twelfth Street, in the heart of New York's downtown antique district, and not far from the Factory's new address. Robinson was ready to close for the day when he spotted "two strange guys in ratty Army surplus overcoats," he recalled, begging to be let in. Reluctantly, he unlocked the front door and spent the next two hours hearing them say: "I'll take this. I'll take that." It was only when he looked at the check for $9,000, an impressive sum in those days, that he noticed the signature. Robinson, who billed himself as "Antique Dealer to the Stars," was delighted to add Warhol and Hughes to his impressive list of celebrity clients, alongside Tallulah Bankhead, Faye Dunaway, Don Ameche, and Barbra Streisand.

On a trip to Paris that same year, Warhol and Hughes also visited the salesroom of Jean Puiforcat, a leading Art Deco silversmith. They paid little more than scrap value for the array of handmade silverware in dusty, neglected showcases; the salespeople, having no feel for the "camp" sensibility, considered the work merely passé. As part of the same spree, the two men furnished a paneled executive office in his studio at 860 Broadway with a massive oval table in Macassar ebony veneer and twelve matching chairs by Emile-Jacques Ruhlmann, France's leading furniture designer of the early twentieth century. Still, Warhol later denied that he had been on

a shopping trip to Paris, and he minimized the importance of the furniture as "just stuff we used for a movie," things on which he and his staff ate "our little lunch from Brownies . . . out of paper boxes with people like Bernardo Bertolucci."

Hughes suavely altered the Factory's atmosphere. Although he was fifteen years younger than Warhol, he took on the role of the father Warhol had lost at the age of fourteen. Hughes also enjoyed a talent for profitable self-invention, beginning with his dandified behavior at the age of eight. According to his brother, Tommy, their shared bedroom in a small Texas town "could have been in *Architectural Digest*," with its collection of stuffed hawks, human-hair wreaths, a tiger rug, a beaver top hat, and some pre-Columbian fertility goddesses. Like Warhol, Hughes was cavalier in describing his background, sometimes presenting himself as the son of an army air force officer whose family owned a profitable steel mill in Indiana. He got to know friends of the de Menils while attending St. Thomas High School in Houston, sometimes swimming in the family's pool. During his freshman year at St. Thomas College, Hughes impressed the de Menil family with his sophisticated tastes in art; he dropped out of college to pursue that interest as an employee, acquiring the nickname "Le Dauphin."

When Warhol was shot in 1968, Hughes took charge of a chaotic scene and, by rushing the artist to the nearest hospital, probably saved his life. That traumatic event sealed a unique, lifelong business partnership, pairing Andy, the clever artist with a flair for getting his name in the newspapers, with Fred, whose marketing finesse, social skills, and fiscal ingenuity would create a financial empire of stunning diversity. But more than a partnership, the Warhol-Hughes team also provided the most genuine friendship either man had ever developed. Hughes persuaded Warhol to return to painting, which the artist had ostensibly abandoned in 1965. To sweeten the pill, he arranged for the de Menils to give Warhol $20,000 for marketing his underground films while they also commissioned portraits of Dominique and of her protégé, Jermayne MacAgy, chair of the art department at St. Thomas College, Hughes's former school.

After the shooting, Hughes systematically went about airing out the Factory's tawdry atmosphere, setting up a reception process to scrutinize unknown visitors, and creating a more professional environment. Gone

was the "semi-hippie chaos" that Geldzahler had experienced. The new Factory was "a very different region of the mind indeed," wrote Stephen Koch, a film scholar and frequent visitor to the old silver-clad premises on East Forty-seventh Street, which he nostalgically called "the dead center of the Zeitgeist." By contrast, Koch saw the new factory as "large, sleek business quarters in an office building on Union Square West," as indeed it was.

Hughes also quietly persuaded Warhol to launch *Interview*, a monthly publication featuring international celebrities. The idea was to attract upscale readers who would purchase the elegant products advertised in the magazine. Through Hughes's connection with the de Menils, Warhol was introduced to (as Henry Geldzahler wrote) "a worldly international crowd that found him titillating" and who would later vie with each other for the privilege of sitting for a Warhol portrait. Finally, Hughes had a hand in Warhol's art sales. Even though the artist was technically represented in New York by Leo Castelli and in Europe by Ileana Sonnabend, potential clients began to buy directly from the studio and from other European dealers.

In 1970 the venturesome Pasadena Museum of Art held the first Warhol retrospective, a carefully edited assemblage curated by the art critic John Coplans that omitted, possibly at Hughes's behest, all of Warhol's commercial art as well as his trial-balloon paintings before 1962. The exhibition underscored Warhol's connections with Marcel Duchamp, whose readymades, an earlier challenge to traditional definitions of art, had been exhibited in the same venue seven years earlier. But unlike the Duchamp retrospective, which went no farther than Pasadena, the Warhol exhibit traveled for two years: to the Museum of Contemporary Art in Chicago; the Stedelijk Museum in Eindhoven, the Netherlands; the Musée d'Art Moderne in Paris; and the Tate in London, where it broke attendance records, possibly because the artist himself attended with a small entourage of his "superstars." The retrospective finally arrived at New York's Whitney Museum of American Art in May 1971; Philip Johnson's partner, David Whitney, who hung the show, featured the cow wallpaper in the background, which somehow made the soup cans and Brillo boxes, the Jackies and Marilyns, the car crashes and electric chairs, take on a more sensational aura than they had in the other museums.

Reviewing the exhibit at the Whitney, Barbara Rose called Warhol

"the Zeitgeist incarnate" and bitterly observed that the images he created "will be the permanent record of America in the sixties: mechanical, vulgar, violent, commercial, deadly and destructive." The *Times*'s John Canaday noncommittally described Warhol's work as "better than he has ever looked before." Like other reviewers, he overlooked Marcel Duchamp's earlier cheeky takes on such mundane objects as a urinal and a snow shovel and declared Warhol to be "the world's coolest manipulator of borrowed material to induce disturbing responses in viewers less cool than himself." A few days after the opening, art-world insiders were shocked to hear that Warhol's six-foot *Soup Can with Torn Label (Vegetable Beef)* sold at Parke-Bernet for $60,000, a record for a work by a living American artist. But such was the art-buying public's voraciousness that the record was surpassed just a few months later, when Lichtenstein's giant brushstroke, the five-year-old *Big Painting No. 6*, sold for $75,000.

By that point, as today, it was difficult to gauge the true value of contemporary works of art. Once, newspaper and magazine reviews of art shows had indicated prices and dealers were more forthcoming about sales, but by the early 1970s art trading had retreated behind a discreet, virtually impenetrable screen. Special arrangements by dealers were the subject of gossip and rumor, but auction results were the only reliable sources for hard data about what sums important artworks were fetching. The auction world was also evolving: what for centuries had been a specialized trade catering to gallerists and a handful of wealthy collectors had become a raucous, often crowded bazaar, a drama starring speculators, connoisseurs, poseurs, and well-heeled amateurs. Moreover, the results were scrutinized not only by the buyers and sellers but also the producers themselves. The day after the controversial Scull auction in 1973, Warhol rummaged through his old canvases, pulled out his first soup-can painting, and asked Bob Colacello, the editor of *Interview*, to find a buyer for it for $100,000. "It's a nothing painting," said Warhol, "but it's the first."

Such was the success of the Warhol "brand" that in 1974, taking advantage of a real estate slump in New York, the artist paid $280,000 in cash for an elegant six-story town house at 57 East Sixty-sixth Street. The house was located by Jed Johnson, a young decorator who had become the artist's companion. Moving from the building on upper Lexington Avenue took months, as Johnson and Warhol sifted through the art, fur-

niture, and artifacts that had accumulated during the artist's fourteen years there. To the chagrin of many later observers, they tore up Warhol's early commercial drawings and loaded them into plastic trash bags, leaving these in front of other houses so no one could see what Warhol was discarding. It was the first time, Johnson told David Bourdon, that he had seen Andy throw anything away.

The new house offered a much larger and grander setting for an artist at the pinnacle of his career. Built in 1911, it had been occupied for decades, according to Warhol, "by somebody's WASP granny." Hughes arranged for what little refurbishing it needed to restore the house's traditional old-money look. So the wall-to-wall carpet went, the underlying wood floors were refinished and covered by a few authentic rugs, and walls were repainted in original colors. The only concession to modernity was a new air conditioning system.

A kind of real estate musical chairs followed Warhol's move to Sixty-sixth Street; Fred Hughes rented Warhol's former Lexington Avenue town house, and a young man named Vincent Fremont, whom Warhol had met five years earlier, moved into Hughes's old apartment on East Sixteenth Street. Fremont, a nineteen-year-old Californian, had dropped by the Factory with some friends one day in August 1969. "We looked like a rock band," Fremont recalled. The son of two artists, he was born in San Diego and raised in Los Angeles. On this first visit to New York, he was impressed by "the brilliance of Warhol's vision" and determined to become part of it. Andy greeted him and his friends, accepting the Mexican face masks they had brought as gifts. By 1971, Fremont was living in New York and working for Warhol full-time. As he recalled it, he started "at the bottom": unlocking the studio every morning, sweeping the floors, answering the phone, and running film cans up to the lab.

Though one of what Warhol dubbed "the kids," Fremont demonstrated a talent for stabilizing the artist; like Hughes, he could play the father to the aging art star. When Warhol fretted over his wrinkles, Fremont recalled his mother's similar worries, and once a year he flew her to New York so she could share her wisdom about antiaging tonics and lotions with Andy. Within a few years, he was writing checks for Andy Warhol Enterprises, and in 1974 he was named vice president of the company. Until Warhol's death in 1987, he faithfully opened the Factory at nine

every morning and locked up every evening at seven. Today he presides over two spacious rooms at 1 Union Square West, where the ceiling-high shelves are crammed with Warhol-related books and papers.

The sober new Factory was attracting other diligent recruits as well, also eager to labor as volunteers, at least for a while. Pat Hackett, a Columbia University student who thought it would be "fun," had arrived in September 1968, just three months after Warhol's shooting. "When I mentioned that I could type, Andy couldn't wait for me to start." Warhol put Hackett in a little room with stacks of tapes that he wanted transcribed. As a joke, she recalled, he would occasionally shout out, like the boss in a 1930s comedy: "Take a letter!" Hackett was also charged with getting Andy's lunch every day from Brownie's, a kosher health-food restaurant around the corner on East Sixteenth Street. Some six months later, Hackett told Warhol's sidekick Jed Johnson that she had to find a paying job but hesitated to approach Warhol for money. She was on a subway platform waiting for a train when Johnson came rushing down the stairs. "Wait!" he shouted after her. "I just talked to Andy and he said he'd start paying you."

For Bob Colacello, who arrived in 1970, Hackett symbolized "the transformation of the Factory from an all-night party to an all-day office." After graduating from Georgetown University School of Foreign Service, Colacello was at loose ends back home in Brooklyn, when he was asked to write reviews for *Interview*. His father was furious that, after an expensive education, his son would work for "that *creep* Andy Warhol." But Colacello went on to become editor of the magazine, staying until 1983. Warhol "looked like a calm, neat, beautiful ghost," Colacello later wrote. "It wasn't easy working for a ghost, especially one who wanted to be calm, neat, and beautiful, and wasn't." But Colacello also recognized "the fear, pain, and sadness that were always [in Warhol's eyes], no matter how much Andy tried to silkscreen them out," and "because I knew it was there . . . I stayed." Pat Hackett also thrived. Listed as assistant editor in the first few tentative issues of *Interview*, she then coauthored with Warhol the 1980 best seller *POPism: The Warhol '60s* and the gossipy, oversize *Andy Warhol's Party Book*, published by Crown in 1988. In 1989 she edited another best seller, *The Warhol Diaries*.

Fred Hughes was the quiet, industrious catalyst for these triumphs.

Between 1969 and Warhol's death in 1987, the Warhol business added licensing and reissues of earlier graphic successes such as the Elvises, Marilyns, Liz Taylors, and Jackies, plus a never-ending array of silk-screen prints in editions ranging from fifteen to three hundred or more, and with subjects in sixty-five categories, from Alexander the Great to zebras. Of course, Warhol had been making silk-screen paintings since the early 1960s, but the proliferation of images from the 1970s is striking. Auction records from November 2007 indicate that 297 *Campbell's Soups*, 587 *Flowers*, and 696 *Marilyns* had been sold at auction up to that time. The avalanche began in 1969 with prints of twenty different kinds of Campbell's soup. In 1973, when Warhol was working on two movies in Rome, *Andy Warhol's Frankenstein* and *Andy Warhol's Dracula*, new editions of his earlier prints were published by a local gallery. The following year, at a show at the Musée Galliera in Paris, the background wallpaper consisted of images of Mao, later sold off in 40½ x 29½-inch pieces by a new Warhol entity, Factory Additions.

Such mass production seemed to cross the invisible line between art and commerce. Unlike the medieval alchemists who failed to turn base metal into gold, the poor boy from Pittsburgh found a royal road to riches: using a silk-screen process or even a garden-variety Xerox to transform a banal image, like the publicity photos of Marilyn Monroe or Elvis, into a multitude of salable works of art.

Indeed, Warhol kept a virtual army of silk-screen printers around New York busy creating large editions of well-known images and adding works that rang familiar bells in viewers' imaginations. In November 1968 he offered a portfolio of eleven images related to the assassination of John F. Kennedy, together with three reproductions of that day's tragic Teletype text and a screen-printed cloth cover; each set in the edition of 200 was packed inside a Plexiglas box. The same year, Factory Additions published a portfolio of ten versions of Campbell's soup cans in an edition of 250. And the following year, the same publisher produced Campbell's Soup II, a repeat with different flavors. In 1972 Warhol created a striking new portfolio based on a bland portrait of Mao Tse-tung that had appeared opposite the title page in tens of millions of copies of the *Little Red Book*, the sayings of the Chinese supreme leader condensed for the masses like Campbell's tomato soup. Using that illustration, Warhol created a portfo-

lio of ten versions of *Mao*, blown up to thirty-six inches square; the various colors of the face and backgrounds convey a surprisingly diverse personality, from the colorless visage of a kindly leader to the image — well before many of the details had become known — of a vicious brute indifferent to the fate of the millions who perished in the Great Leap Forward and the Cultural Revolution.

Although Fred Hughes had been largely instrumental in furthering this printmaking frenzy, he was often embarrassed by Warhol's crass descriptions of his art and tried to mitigate such offhand but much-repeated quips as "good business is the best art . . . the step that comes after Art." Interviewed in 1980 by Jeffrey Deitch, a collectors' adviser and the founder of two galleries, Hughes insisted that Warhol's remarks were just "throwaway phrases." Deitch concluded that "after all these years, Hughes could be just as good at playing dumb as his boss." In his 1980 article "The Warhol Product," Deitch suggested that Warhol's enterprises had accurately redefined the role of the artist in the late twentieth century: "Art, too, is a business in the context of American culture." As if to underscore the point, Warhol embarked on a new extravaganza in early 1982 with a deluge of dollar paintings, which he introduced through an exhibition at the Castelli Gallery, as well as portfolios of dollar bill prints. The motif should have come as no surprise to those who remembered the artist's many depictions of U.S. currency, like the *200 Dollar Bills* he painted in 1962, or his judgment that "American money is very well designed."

More than the work of any artist of his time, Warhol's creations are closely intertwined with their monetary value. The artist himself, who often emphasized his determination to "bring home the bacon," ventured wherever that desirable commodity might reside. In the 1970s it was the celebrity realm. The aristocrats of the past had hired such prominent masters as Titian, Velázquez, and Gainsborough to paint flattering likenesses of them garbed in satins and furs. Andy Warhol was the late twentieth century's artist of choice for the international celebrities of film, theater, rock music, and fashion, as well as for those who were famous simply for being famous. Unlike the regal sitters of the past, who posed for long hours and days in the artist's studio, these clients were pleased to drop by for a quick Polaroid snapshot session that Warhol would transform into a surprisingly meaningful portrait.

He was particularly adept at depicting people he had known for years and who had been instrumental in shaping his career. Four rakishly smiling versions of his Swiss dealer Bruno Bischofberger appeared in 1969. Irving Blum, who first shocked Los Angeles with the soup cans in 1962, gazed askance in 1970 from a sharp blue field. Ileana Sonnabend, who had done so much to foster Warhol's European career, materialized in 1973 from a frothy pink-and-blue background, her chubby fingers caressing an unlined face, her black eyes alert, as if encountering the next big thing. Ivan Karp, whose discovery of Warhol initiated his fame as a fine artist, puffed nervously on a cigar in 1974, as if ready to explode with the next wisecrack. In 1975 Leo Castelli, the innovative art dealer, was portrayed as a sober Central European banker in a natty suit. Henry Geldzahler, who for years had dealt with the artist's twice-daily phone intimacies, emerged in 1979 as a sharp-eyed, bearded presence in a black fedora, a wine red bow tie, and a blue boutonniere. Other sitters from the 1970s and '80s include the boxing champ Muhammad Ali and the fashion designer Diane von Furstenberg, the actresses Brooke Hayward and Ingrid Bergman, the singer Michael Jackson, and the dancer Rudolf Nureyev. These celebrities, as much as Gainsborough's dukes and duchesses, could count on a flattering image, their wrinkles and blemishes magically erased. And yet somehow, like the bland, smug, menacing Mao, their personalities were revealed.

David Bourdon astutely summed up the attraction of these portraits when he wrote that Warhol

> transformed his subjects into glamorous apparitions, presenting their faces as he thought they wanted to be seen and remembered. By filtering his sitters' good features through his silkscreens and exaggerating their vivacity, he enabled them to gain entrée to a more mythic and rarefied level of existence. The possession of great wealth and power might do for everyday life, but the commissioning of a portrait by Warhol was a sure indication that the sitter intended to secure posthumous fame as well. Warhol's portraits were not so much realistic documents of contemporary faces as they were designer icons awaiting future devotions.

But while Warhol's silk-screened portraits seemed to throw new light on the rich and powerful, he zealously guarded the shadows around his

own image. Bob Colacello attributed it to an almost childish form of game playing: "For Warhol, the art of deception, the fun of fooling people, mystifying, hiding, lying — camouflaging, if you will — was a compulsion, a strategy, and a camp." Warhol (whose opinion is not necessarily any more reliable) put a slightly darker spin on it while maintaining the childhood association: "I learned when I was little that whenever I got aggressive and tried to tell someone what to do, nothing happened — I just couldn't carry it off. I learned that you actually have more power when you shut up, because at least that way people will start maybe to doubt themselves." In a media-driven age, when masses of people were clamoring for appearances, interviews, and their proverbial fifteen minutes of attention, Warhol's silence was the hook on which he hung his own pursuit of fame and the unassailable talent with which the word-shy artist outwitted the most articulate journalists.

Even those who thought they knew Warhol intimately were tempted to interpret his character in the light of their own backgrounds. Henry Geldzahler, the product of a well-to-do home, was struck by Warhol's "aching poverty early on, which hit him like a ton of bricks." Warhol didn't trust money in the bank, Geldzahler told an interviewer in 1978. "He judges success by how much money is coming in each year because underneath is always the image of total starvation and poverty and being evicted. . . . That's the armature of his view of the world." Noticing how Warhol had inserted himself into the celebrity-obsessed high society of the seventies, Peter Schjeldahl dubbed him the "arriviste's arriviste" — a label as telling and as incomplete as any other applied to this "disembodied genius of the people."

During nightly appearances at affluent dinner tables and charity events, Warhol diligently marketed his portrait business, pursuing what he jokingly called his future "victims." With prices at about $25,000 dollars apiece, the roughly one thousand portraits he sold brought in a good $25 million. But more than this, as Robert Rosenblum noted, Warhol revived the moribund art of portraiture in the United States "practically single-handedly." In the catalogue for an exhibit of Warhol's portraits at the Whitney Museum in 1979, the director Tom Armstrong turned to the terminology of nineteenth-century portraiture to describe Warhol as "the limner of our times." The portraits convey an age that values "tinsel and

glitter," he wrote. "The lip gloss of today is the sheen of tomorrow." By contrast, Hilton Kramer called the show "vulgar. It reeks of commercialism and its contribution to art is nil." Whitney openings were usually free to museum members, but the many portrait subjects who attended the opening were delighted to pay $50 a head for the "art experience," as the canny art marketer Jeffrey Deitch described it. The exhibition, he wrote, was "one of the hottest items around," provided by "one of the foremost figures in the art experience industry."

In addition to the lucrative portraits, Warhol and Hughes created print portfolios on behalf of various fund-raising efforts: for the Democratic National Committee in 1976, an anxious Jimmy Carter with an orange patch over his face, followed by a toothy Carter to commemorate his inauguration; for the Brooklyn Bridge Centennial Commission in 1983, an especially fetching composition featuring positive and negative images of the bridge in an edition of 200. The following year, Warhol produced a portrait of Grace Kelly in an edition of 225 to benefit the Institute of Contemporary Art in Philadelphia, Kelly's hometown. In 1972, for the previous presidential election, Warhol had created a campaign poster that raised $40,000 for George McGovern; it depicted a sinister, green-tinted version of McGovern's opponent, Richard Nixon. (After Nixon's election, the IRS returned the favor by auditing Warhol's tax returns every single year.)

In 1980 Warhol began issuing editions of prints featuring famous men and women of the past. That year, the Jewish Museum exhibited his first portfolio, Ten Portraits of Jews of the 20th Century, based on stock photos of Franz Kafka, Gertrude Stein, Albert Einstein, the philosopher Martin Buber, Supreme Court justice Louis Brandeis, George Gershwin, Sigmund Freud, Sarah Bernhardt, the Marx Brothers, and former Israeli prime minister Golda Meir. Somehow Warhol managed to infuse liveliness and dignity into each portrait, gently removing frowns and wrinkles even from the venerable Meir's weather-beaten face.

Considering Warhol's vast output of prints during the 1970s and 1980s, one might conclude that the artist was toiling day and night. But in fact, his routine was exceedingly leisurely. What he described as his "rut" began every morning with a phone call to Pat Hackett, in which he described the previous evening's circuit of celebrity events that included wooing

promising prospects for portrait commissions. After a few more phone calls, he showered, dressed, and took his dachshunds, Archie and Amos, into the elevator to descend from his third-floor bedroom to the kitchen in the basement. There, his two Filipino housekeepers, Nena and Aurora Bugarin, gave him breakfast, just as his mother, Julia, had fed him when she lived there. Then the artist would head out for several hours of shopping. He toured Madison Avenue galleries, auction houses, the jewelry district around West Forty-seventh Street, and Greenwich Village antique shops. Between 1 and 3 P.M., he arrived at the office, ordered lunch, perused his mail, and selected items to add to the day's "Time Capsule," a ten-by-eighteen-by-fourteen-inch cardboard box. For an hour or two, he would chat with people at the office, then read the newspapers, leaf through magazines, take a few calls, and talk business with Fred Hughes or Vincent Fremont, before disappearing into his studio to draw, paint, or paste images. Between 6 and 7 P.M., he took a cab uptown to dress for the evening, sometimes to attend multiple dinners and parties. A quip of the time had it that "Andy would come to the opening of an envelope if he knew the press was going to be there." But however late he stayed out, reported Hackett, "he was always ready for the Diary again early the next morning."

Another occasional preoccupation was *Interview*, which Warhol dutifully handed out during his peregrinations, trying to persuade shopkeepers to advertise. The magazine had started in 1969 as a low-budget, updated movie fanzine, a forum in which to publish uncensored interviews with stars, preferably conducted by other stars. But when someone was described in the first issue as a "drag queen," a lawyer phoned, charging that the characterization was libelous. Warhol, Hughes, Paul Morrissey, Jed Johnson, Gerard Malanga, Hackett, and, as Hackett recalled, "whoever happened to walk in the door" spent the next six hours going through every single copy of the offending issue to cross out the word *drag* with black felt-tip pens, with Morrissey grumbling, "This is like doing penance — 'I will never call him a drag queen again. I will never call him a drag queen again . . .'" Less than five years after that rocky start, the magazine had become "an uptown monthly." Leo Castelli displayed it in his gallery, declaring it a work of art. The designer Halston kept every copy and devoted an entire window at his boutique to *Interview*, saying, "I know all

the people in it." If anything, the magazine became too popular. According to Vincent Fremont, the staff was constantly getting into difficulties because Warhol promised the cover to too many people.

Fred Hughes, who was listed on the *Interview* masthead as executive vice president, explained to a *Newsweek* reporter that its mission was to be "a chic underground paper" and "to revive the avant-garde without being too self-conscious about it." The fashion-industry newspaper *Women's Wear Daily* was the original model for the magazine, but it had gradually evolved "a format and style so superficial, so utterly concerned with the nuts and trivia of life," as the *Wall Street Journal* grumbled in 1975, "that it makes *WWD* look like *Commentary*." *Interview's* editor, Bob Colacello, described the audience he was trying to reach: "Not necessarily people who earn a lot of money, but people who spend a lot of money. . . . The trend in our society is toward self-indulgence and we encourage that."

The Warhol empire was indeed riding an inordinate wave of prosperity. Between 1960 and 1970, after-tax disposable income among Americans doubled to $695 billion, and it would triple in the following decade. In 1970 less than 1 percent of households were considered high-income — defined as earning more than $50,000; ten years later, 4.1 percent had reached that level. Of special interest to the art world was the growth of the college-educated population, from 7.7 percent in 1960 to 17 percent twenty years later, and of the consequent growth in the number of art books published annually, from 470 to 1,437 in the same period. As disposable income swelled, so did spending on what might be called luxuries. Adjusted for inflation, expenditures for recreation between 1970 and 1990 grew from $91.8 billion to $256 billion; purchases of jewelry and watches, from $8.4 billion to $25 billion; and patronage of restaurants and bars, from $105 billion to $163 billion. The number of Americans traveling abroad rose from just over 5 million in 1970 to 43.5 million two decades later.

A new class of wealth was emerging in the United States, and like all wealthy populations throughout history, it pampered itself with the tangible evidence of its arrival at the top: expensive clothes, trophy houses, gourmet meals, luxury travel, and works of art. Typical of this new class were Frederick and Marcia Weisman, a Los Angeles couple who amassed an enormous collection of postwar American art. Frederick was born in

1912 to Russian immigrants in Minneapolis and was brought by his mother to Los Angeles in 1919. After purchasing a small produce business, he met Meyer Simon, the founder of Val-Vita vegetable cannery, and his son, Norton. In 1938 Weisman married Norton's sister, a graduate of Mills College and already a collector of posters and prints. In 1943 Weisman became president of Val-Vita, when Norton merged the company with the tomato-processing concern Hunt Foods. Afterward, Norton Simon prospered in multiple business investments and amassed Old Master and nineteenth-century masterpieces, now on display at the art museum in Pasadena that bears his name. Frederick Weisman also pursued winning business deals, such as riding the first wave of Japanese cars marketed in the United States by distributing Toyotas nationwide.

Like Norton, the Weismans also began collecting art, in their case contemporary. In 1968 they commissioned a dual portrait from David Hockney, showing it with some of their art. The Web site of the Art Institute of Chicago, which now owns the work, says it depicts a couple who had "come to epitomize American art collectors. With his business suit, rigid pose, and clenched fist, Fred Weisman's profile seems as stony as the William Turnbull sculpture before him." Some distance away, Marcia peers out frontally, the couple looking "oblivious to each other and to their art." (Perhaps dissatisfied with Hockney's dour depiction, the Weismans commissioned separate portraits from Andy Warhol in 1975.)

When the Weismans divorced in 1979, they split up their extensive collection. Fred Wiseman's foundation built an art museum designed by Frank Gehry on the University of Minnesota campus in Minneapolis and another on the Malibu campus of Pepperdine University; he also donated artworks to museums across the United States. Marcia Weisman was a leading founder in 1980 of the Museum of Contemporary Art in Los Angeles; she gave MOCA parts of her collection and donated works to the Los Angeles County Museum of Art and the National Gallery of Art in Washington, DC. A year before her death in 1991, she gave LACMA possibly the most important work in her collection, Jasper Johns's *Map*. This behavior was not atypical of the times. Active in art museums but resentful that the institutions they helped support often refused to accommodate exhibits of their holdings, a number of contemporary art collectors instead helped found new museums devoted exclusively to such

works, in cities like Chicago, New York, Philadelphia, Cincinnati, Saint Louis, Los Angeles, and San Francisco — which generally, and not surprisingly, proved less resistant to displaying their patrons' collections.

At the end of 1986, Warhol was suffering from recurrent abdominal pain. He had paid little attention to his first gallbladder attack in 1972 and continued to relish the fatty foods that trigger the typical excruciating discomfort: foie gras, chocolate sundaes, butter cookies, and chicken sandwiches with extra mayonnaise. He had probably inherited the gallbladder problem from his father, who died of intestinal complications at the age of fifty-four, but he was terrified of doctors and hospitals ever since the 1968 shooting, the five-hour operation that followed, and the two months' stay afterward. He was so superstitious about any hospital atmosphere that whenever he attended an auction at Sotheby's on York Avenue, he would cross the street to avoid walking in front of New York Hospital nearby.

Instead, he saw a chiropractor-nutritionist and a man he called "the crystal doctor," whose therapy consisted of waving chunks of amethyst and quartz over the patient's body. At the Factory, Warhol displayed a giant rock crystal almost two feet tall and two feet wide. Doctor Denton Cox, whom Warhol had stopped seeing for annual checkups two years earlier, was among thirty guests at the artist's Valentine's Day dinner on February 12; that night the erstwhile patient told the doctor, "I've been bad. I've been eating chocolate and butter." The following day, Friday, February 13, he cut short an exercise session with his personal trainer, and on Saturday he saw the dermatologist, who gave him collagen antiwrinkle injections; she advised him to see Dr. Cox about the pain. Warhol spent most of the weekend in bed but couldn't resist a modeling gig in a celebrity fashion show on the following Tuesday. The last live photograph of Andy Warhol shows him on the runway with the jazz musician Miles Davis. "His eyes were alight with the thrill of stardom," wrote Bob Colacello, "but his lips were tense and taut."

Over the next few days, Warhol saw several doctors, who told him that his inflamed gallbladder could burst at any time and urged him to have immediate surgery. On Friday, February 20, 1987, he checked into New York Hospital as Bob Robert, giving Fred Hughes as his next of

kin, and that evening spoke on the phone with Vincent Fremont. The next morning he underwent the three-hour operation, then, after three more hours in Recovery, was returned to his room. Later that day, Dr. Cox reported the patient was doing so well — he had been up and sitting in a chair several times — that he could probably go home earlier than planned. Fremont visited Warhol in the afternoon, only to find him asleep, and decided to return the next day with Fred Hughes. In the evening, a private-duty nurse, Min Cho, arrived; she sat in Warhol's room all night. Early the next morning, the hospital called Hughes with the shocking news that Warhol was dead.

Some uncertainty still lingers around the cause of his death, but according to several reliable sources, including David Bourdon and Fremont, a combination of inadequate supervision and inexperience caused the patient to become overhydrated with intravenous fluids, leading to insufficient blood oxygen. By the time Warhol's nurse noticed that he had turned blue, at 5:45 A.M. on Sunday morning, rigor mortis had already begun setting in, and attempts to revive him were futile. Doctors pronounced him dead at 6:31.

Hughes moved swiftly to secure the property he had worked so diligently to develop. The day after the artist's death, he asked an attorney, Ed Hayes, to meet him at Warhol's town house, a place he had seldom entered since helping Warhol upgrade the building in 1974. In the kitchen, Hughes and Hayes found the two elegant Filipino maids, Nena and Aurora, to whom Warhol made his last phone call from the hospital after the operation. They also found every room, and even the stairways, cluttered with bags and packages Andy acquired during years of daily shopping sprees. As a hoarder, Warhol was outdone only by Pablo Picasso, wrote the latter's biographer John Richardson. The grand dining room and the elegant drawing room on the first floor were furnished with massive antiques, but the furniture's looming presence was hidden among shopping bags and boxes overflowing with important documents and photographs, as well as bygone theater programs, handbills, and menus from Chinese restaurants. A drawer in one of the Federal chests in the bedroom was crammed with wigs, and dark green boxes containing more hairpieces were stacked next to the fireplace. Nearby, a basket overflowed with toys for Warhol's dogs, the two miniature dachshunds that were the

only live creatures to share the artist's large Sheraton bed. Every flat surface was covered with jewelry, watches, money, and trinkets, Hayes observed, and even the canopy over the bed sagged with the cash and jewelry Warhol had tossed up there. Hayes was shocked to see clothes, books, magazines, and cowboy boots strewn over the floor or on chairs. The large-screen color television set was positioned so that Warhol could watch it from his bed. In the end, Richardson noted, "Andy let his 'collections' take over, and withdrew to the cozy kitchen or the sedate bedroom." People of great wealth often accumulated goods — J. P. Morgan, founder of the Metropolitan Museum of Art, was a shopaholic — but they also had palaces, castles, country estates, and villas in which to scatter their possessions. The dreams of wealth and acquisition that animated young Andy's desperately needy years became a reality, however chaotic, as he transformed most of the house's twenty-three rooms and basement into a makeshift storehouse. Among the valuable items was an extensive archive, some 8,625 cubic feet of material including six hundred Time Capsules and more than ten thousand hours of audio- and videotapes.

While Hughes and Hayes dealt with mundane postmortem necessities, a great wave of fond recollections and mournful elegies swept through the milieu Warhol had inhabited for so many years. Many of his early associates had already died, some of them before their time: the British society photographer Cecil Beaton in 1980, Truman Capote in 1984, Mario Amaya, author of one of the first books about Pop Art, in 1986. The fast-talking, vulgar taxi king and supercollector Robert Scull succumbed on New Year's Day 1986, possibly to diabetes or recreational drug use and perhaps due to the bitterness of his divorce from Ethel, the subject of an early, innovative portrait by Warhol.

Warhol's brothers accompanied Andy's body to Pittsburgh, where the artist was interred quietly in Saint John the Baptist Byzantine Cemetery, next to the graves of his parents; the picture of record shows a can of Campbell's tomato soup and a box of Crayola crayons poised precariously on the granite headstone. The spirit of Warhol stayed in New York when more than two thousand people jammed into Saint Patrick's Cathedral on April 1, 1987, for a memorial mass. The Reverend Anthony Dalla Villa described the artist as "a simple, humble, modest person, a child of God who in his own life cherished others." Perhaps he was aware of

Warhol's daily devotions at the Church of Saint Vincent Ferrer or his service every Thanksgiving, Christmas, and Easter caring for the homeless at Church of the Heavenly Rest in Manhattan. Doubtless, not many who attended the Mass connected the cathedral's location at Fiftieth Street and Fifth Avenue with the elegant Bonwit Teller department store six blocks away, where Warhol had displayed his earliest paintings in 1961 as part of the window dressing he created. At the Mass, Yoko Ono described Warhol's mentoring of her son after the assassination of his father, John Lennon, in December 1980. The actor Nicholas Love read Warhol's take on death: "It would be very glamorous to be reincarnated as a great big ring on Liz Taylor's finger." Lou Reed, who had catapulted to fame as front man of the Warhol-backed Velvet Underground, was overheard saying, "It's hard to believe Andy's not going to be around. I was hoping he'd turn up and say, 'April Fool!'" The eulogy by John Richardson emphasized the artist's religious devotions and his pride in financing a nephew's studies for the priesthood. As always when Andy Warhol was around, if only in spirit, one photographer or another recorded almost all of the mourners entering or leaving Saint Patrick's Cathedral. *Andy Warhol: The Day the Factory Died* was painstakingly assembled by Christophe von Hohenberg and the cultural historian Charlie Scheips and published in 2006. It is bound in a flexible black cover and features a ribbon page-marker, like a hymnal.

Andy Warhol hardly sank into oblivion after his death. In the spring of 1988, Sotheby's held what *Time* called "the most extensive estate sale in history, and one of the glitziest." After months of sorting and organizing, the auctioneer's staff had produced a five-volume catalogue that sold for $95 (now it fetches nearly $1,000 in the used-book market). The viewing of 10,000 items in 2,526 lots began on April 16, and the auction itself lasted from April 23 to May 3, raising $25.3 million, nearly twice what Sotheby's expected. The 175 cookie jars auctioned on the second day, April 24, attracted hundreds of people from as far away as Paris, Florida, and Nova Scotia; frantic bidders, among those who could squeeze into the salesroom, paid a total of $247,830 for items estimated to sell for a tiny fraction of that amount. Gedalio Grinberg, board chairman of the North American Watch Company, which was working on a Warhol watch, was the biggest bidder, happily paying $198,605 for items that Sotheby's

expected to bring in $7,000. "I got something fabulous," he crowed. While Warhol's penchant for collecting downscale items like cookie jars, Bakelite bracelets, and Russel Wright pottery caught the public's attention, only specialists noted his taste for the best of twentieth-century design: the thirty-three pieces of furniture by Emile-Jacques Ruhlmann, the sleek Puiforcat coffee and tea services, Lalique frosted glass vases and perfume bottles, Tiffany lamps, and silver tableware by Joseph Hoffmann — evidence of the artist's appreciation for both the finer things and his over-the-top "camp" sensibility.

Warhol's mainstream investments yielded another kind of appreciation: blue-chip shares of Boeing, IBM, and General Motors; tax-free bonds issued by the New York Power Authority and Port Authority of New York; more than $4.5 million in life insurance; and bank and retirement accounts in the millions. His real estate holdings included two Manhattan town houses; a compound of five buildings on nineteen acres in Montauk, Long Island; the Factory on Union Square; several rental properties on the Lower East Side; and a forty-acre parcel of land near Aspen, Colorado. In nearly every respect, in fact, the estate proved to be far greater than Fred Hughes and Ed Hayes had anticipated. The exceedingly simple will left Hughes, as executor, $250,000, with (at Hughes's discretion) up to the same amount each for Warhol's two brothers. Hayes agreed to handle the estate's legal affairs for 2.5 percent of its value at closing, which was then estimated at $10 to $15 million and which by that reckoning would have netted him about the same amount as Hughes. But the two had not counted on the real estate, equities, and bank accounts, nor on the massive proceeds of the Sotheby's auction, a huge trove of Warhol paintings discovered in the Factory's basement, and such less liquid properties as *Interview*, whose circulation was approaching 200,000, film rights to Tama Janowitz's best-selling short story collection, *Slaves of New York*, and various other publications. Moreover, New York Hospital, after much litigation and without admitting any negligence, paid the estate another $3 million, all of which, minus legal fees, was split between Warhol's two brothers. By then, the tentative value of the estate had risen to $297 million. To further complicate matters, the Warhol name was sold to an Atlanta licensing firm, the same firm that had marketed $4 billion worth of Cabbage Patch dolls and that now expected to attach the artist's name to bedding,

cosmetics, perfumes, jewelry, and a calendar. Within nineteen months, Hughes and Hayes were disagreeing on virtually everything except for one stunning figure: the estate was worth about $600 million.

And still the machine churned on. The year 1988 alone saw, among other things, the sale of Warhol's diary to Warner Books for $1.2 million, edited by the artist's confidante, Pat Hackett, who received 40 percent of the royalties; showings of Warhol's films at the Whitney Museum; a contract between David Bourdon and the renowned art-book publisher Harry Abrams for a major Warhol biography; publication of *Pre-Pop Warhol, 1949–61* by Jesse Kornbluth and a weighty art-historical analysis, *Andy Warhol: The Early Work*, by Rainer Crone; and arrangements for the definitive Warhol retrospective at the Museum of Modern Art, organized by senior curator Kynaston McShine and scheduled to open in February 1989.

This exhibition, displaying 460 works over two floors of the museum, provided the most comprehensive assemblage of Warholiana up to that time. Its catalogue brought together tributes from many directions, from Robert Rosenblum's scholarly assessment to the experimental writer William Burroughs's statement that Warhol had "shattered the whole existing hierarchy of 'artistic' images . . . a soup tin seen with a clear eye can be portentous as a comet." Four days before the opening, some four thousand celebrities — from the socially prominent to the ubiquitous pariahs — mingled at a MoMA reception. Henry Geldzahler, who had been Pop Art's lone defender at the same museum's symposium almost three decades earlier, considered the show "as important for the Modern as it is for Andy. . . . They were a little late in claiming him," he said, suggesting that Warhol "had his own personal relationship with the public, something that makes museums nervous." Geldzahler put his finger on how the museum's mission had changed since it reluctantly accepted Philip Johnson's gift of the *Gold Marilyn* in 1962. Where once-magisterial art critics anointed artists who met their exacting standards, by the 1980s most critics had relinquished such categorical judgments in favor of friendly explanations of influences on the artist and descriptions of the work; the unspoken assumption was that simply writing about an artist was endorsement enough. Still, given the vast expansion of the art world, someone had to decide which art and artist should receive a gallery or

museum exhibition. That job fell gradually to art dealers and museum curators, vastly enhancing their power beyond the task of simply arranging shows.

The catalogue for MoMA's Warhol retrospective illustrated the museum's new role. Much more ambitious than the typical catalogue of an earlier day, which simply listed the works shown with a brief descriptive text, MoMA's ran to almost five hundred pages and brought together a multitude of little-known illustrations and informal recollections. In addition to 460 color plates of works in the exhibition, the catalogue was profusely illustrated with photos and artworks showing Warhol as a three-year-old with his mother, a recumbent Warhol aping Truman Capote's signature pose, and a dark, tragic 1986 portrait by Robert Mapplethorpe. The individual items shown came from strikingly diverse sources: 29 museums, including 14 in Europe; 36 individuals, including 7 major collectors; 12 galleries; and almost 100 works loaned by the Warhol estate, including 17 versions of *Mao*.

He was so well known, so visible, so ubiquitous, everyone had a take on Andy Warhol. His shooting in 1968 had triggered front-page headlines all over the world. The prices of his Marilyns and soup cans ran the gamut from stratospheric sums for "originals" to $5 for knockoff posters. Yet despite the reams of words tapped out by art scholars and gossip columnists alike, no one arrived at the essence of this ghostly, dramatic figure. When the television hosts called, he dutifully appeared and responded to their aggressive probing with good-humored, totally unrevealing monosyllables. At first, leading art critics industriously shredded his work, but the clamor to buy a Warhol kept inflating the prices. Certain people were sure that an impostor was creating all those Warhol works; after all, how could he do it when he was spending night after raucous night at Max's Kansas City or Studio 54, in between showing up at the ritziest New York parties?

For the Catholic magazine *Commonweal*, he was "a non artist . . . part of an avant-garde Blessed Trinity: John Cage [the father], Andy Warhol [the son], and Jackson Pollock [the Holy Ghost]." "For twenty-five years, [Warhol] functioned in the art world as the indispensable irritant," wrote John Russell, "the ubiquitous nuisance by which all others redefined themselves." And the eminent British Marxist historian Eric Hobsbawm

pronounced Warhol the culmination of "a real world flooding every wak-
ing hour with a chaos of sounds, images, symbols [which] put art as a spe-
cial activity out of business."

This observation seemed especially ironic in that Warhol had not only
built a spectacular business on his artistic talent, but had revealed that
"business was the best art." That statement appeared in *The Philosophy of
Andy Warhol*, an entertaining but characteristically unrevealing autobiog-
raphy published in 1975. It starkly highlighted the transformation of the
1960s' freewheeling, amphetamine-soaked Factory into a carefully orches-
trated enterprise. As the artist noted, in 1968 only a few people were part
of Andy Warhol Enterprises, "free-lancers . . . 'superstars' . . . or whatever
you can call all the people who are very talented, but whose talents are
hard to define and almost impossible to market." Asked about how he ran
his office, Warhol replied that he did not run it: "It runs me." And as for
the rest, the glamour and the parties and the photos and the well-known
quips, it was just the "same old shy act."

Every life contains its ironies, but those surrounding Warhol are par-
ticularly poignant. He was a man who dreaded being interviewed and,
when cornered, relied on the monosyllabic mumble and the vague shrug,
yet he financed a publication that trafficked in the intimate disclosures of
celebrities. He was a public figure who was so shy that he sometimes dis-
patched a stand-in to a public appearance. He was devoutly religious yet
created some exceedingly pornographic films. Although he was personal-
ly abstemious, he presided over orgiastic goings-on at the silver Factory
of the early 1960s. Reviewing MoMA's 1989 retrospective, the art histo-
rian Michael Brenson believed that Warhol's widespread appeal arose in a
rootless and newly wealthy class emerging from "the great blank space of
American culture" since the Second World War. Twenty years later, the
appeal continues unabated, and the avalanche of exhibitions and cata-
logues proceeds.

Andy Warhol's legacy comprises far more than a captivating rags-to-
riches biography, a vast output of original art, and a well-endowed foun-
dation that protects, finances, and encourages American art in every cor-
ner of the United States. His works continue to sell at phenomenal prices;
his name pops up on Google almost two million times, far more than that
of any other American artist. But more than bequeathing its maker (and

his heirs) wealth and fame, Warhol's art ushered in the multitude of aesthetic styles current today. His most impressive legacy is surely the resounding visual "Yes" with which his soup cans, electric chairs, and Brillo boxes responded to the question anxiously raised by his critics in the early 1960s: "Is it art?" Along with, and arguably even more than, the other artists and writers who helped define what we now call the "Pop aesthetic" — the Johnses and Rauschenbergs, Alloways and Hamiltons, Lichtensteins and Indianas, Oldenburgs and Rosenquists — Andy Warhol opened the door to the flood of competing images that populate the art world today. There is no longer a ruling style, and there are hardly any more imperious pundits to anoint it. Diversity rules and everyone is his own art critic, at least for fifteen minutes.

PUBLISHER'S AFTERWORD

This book was to contain a concluding chapter, bringing the story from Warhol's death — the effective end of the Pop era, as the author saw it — up to the present day, as a summation and commentary on the enduring revolution that Pop wrought. Sadly, Alice Marquis passed away after a sudden illness in June 2009, having delivered the bulk of the text but before she'd had time to write this last segment. The manuscript has been prepared for publication keeping Alice's wishes firmly in sight, buttressed by the familiarity born of a ten-year collaboration between author and editor that had resulted in two previous books.

The text as Alice submitted it provides a varied and engaging portrait of a singularly exciting period in our history. Even so, and despite the many exchanges the author and I had about this project in the nearly four years since its inception, the present, published version might have lacked some of its richness were it not for the generosity of Alice's son, John Blankfort, who made it possible for me to consult his mother's library and extensive research papers in La Jolla after her death. These documents — books, note cards, articles, and other raw materials — have proven indispensable to the completion of this book as (I trust) Alice would have wanted it, and I am grateful to John for putting them at my disposal.

One missing element that Alice would particularly have regretted is the acknowledgments. A generous scholar, she was sincerely grateful to the individuals who gave of their time, insights, recollections, and support as she worked to produce *The Pop Revolution*. In the absence of a written list, I ask that all those — friends and interviewees, colleagues and correspondents — who contributed to the writing of this book know that they are deeply thanked.

That said, there was a part of the planned acknowledgments that I did

find among Alice's notes, which seems to express both her enduring pleasure in research and the feeling among those who knew her. Dated February 2006, it reads: "There's a terrific thrill in 'debriefing' the veterans of so many exciting happenings in the New York art world. These participants in the rise and fall and resurrection of so many art stars are as eager to tell how it was as I am to write it down. They appear to be stunned by how quickly it all passed."

NOTES

Chapter 1: Heralds of Change

3 "THE AMERICAN DREAM": Margaret Drabble, ed., *The Oxford Companion to English Literature*, 5th ed. (New York: Oxford University Press, 1985), 75.

4 "A LONG, LONG BENDER": Lee Hall, *Elaine and Bill: Portrait of a Marriage* (New York: Cooper Square Press, 2000), 176.

5 "STARTED THE BALL ROLLING": For this and the following paragraphs: Leo Castelli interviews by Paul Cummings, May 14, 1969–June 8, 1973, Oral History program, Smithsonian Archives of American Art (hereafter AAA). Additional information: Deborah Gimelson, "It's a Wonderful Life," *ARTnews*, Summer 1994, 170–71; Roberta Smith, "Ileana Sonnabend Dies; Art World Figure Was 92," *New York Times*, Oct. 24, 2007; Elizabeth C. Baker, "Leo Castelli, 1907–1999," *Art in America*, Nov. 1999, 33; Barbaralee Diamonstein, *Inside the Art World: Conversations with Barbaralee Diamonstein* (New York: Rizzoli, 1994), 19; Howard Devree, "Modern Roundup: Europeans and Americans in Current Shows," *New York Times*, Oct. 29, 1950.

10 "VERY REGRETFULLY": Leo Castelli interviews by Paul Cummings; Calvin Tomkins, *Off the Wall: A Portrait of Robert Rauschenberg* (New York: Picador, 1980), 56–57.

10 "DO OR SAY NEXT": Hall, *Elaine and Bill*, 135–36.

10 "HAD ALREADY BLOOMED": Tomkins, *Off the Wall*, 128.

10 "ENTIRELY BOHEMIAN": Leo Castelli interviews by Paul Cummings.

11 "MOSTLY CHASTE AND PURE": S[tuart]P[reston], "Art: Latest Showplace," *New York Times*, Feb. 16, 1957; press release, Leo Castelli Gallery, Feb.–Mar. 1957, and Castelli Gallery invitation, Feb. 1957, both Art and Architecture Division, New York Public Library (hereafter NYPL).

11 "EXTREME INDIVIDUALITY": Dore Ashton, "Art: A Local Anthology," *New York Times*, May 8, 1957.

11 "BUT NEW MOVEMENTS": Suzi Gablik, "Protagonists of Pop," *Studio International*, July–Aug. 1969, 10; Diamonstein, *Inside the Art World*, 19–20; Barbaralee Diamonstein, "Pop Art, Money, and the Present Scene: An Interview with Roy Lichtenstein and Leo Castelli," *Partisan Review* 45, no. 1 (1978), 82.

12 "MADISON AVENUE PROMOTION": Leo Castelli interviews by Paul Cummings.

12 "COMFORTABLE SOFA": Meryle Secrest, "Leo Castelli: Dealing in Myths," *ARTnews*, Summer 1982, 67.

12 "SIT THERE FOR HOURS": Leo Castelli interviews by Paul Cummings.

12 "HE HAD AN AURA": Author interview with Amy Newman, New York, Feb. 23, 2006.

13 "GREAT DEALERS IN PARIS": Author interview with Robert Rosenblum, New York, June 19, 2006; Suzi Gablik, *Conversations before the End of Time* (London: Thames & Hudson, 1995), 453–54.

13 "THEY TRUST MY JUDGMENT": Diamonstein, *Inside the Art World*, 22–23.

13 "LIKE A METEOR": Tomkins, *Off the Wall*, 131–33.

13 "ARTISTS TO FEED": Leo Castelli interviews by Paul Cummings; Steven M. L. Aronson, "Architectural Digest Visits Leo Castelli," *Architectural Digest*, Oct. 1995.

14 "WORTH OF PAINTINGS": Tomkins, *Off the Wall*, 128–29; Leo Castelli interviews by Paul Cummings; Grace Glueck, "Leo Castelli Takes Stock of 30 Years Selling Art," *New York Times*, Feb. 5, 1987; Diamonstein, *Inside the Art World*, 117.

14 "VIRTUOSO BRUSHWORK": Tomkins, *Off the Wall*, 126–27.

14 "PHYSICALITY OF THE PAINT": Marco Livingstone, *Pop Art: A Continuing History* (New York: Thames & Hudson, 2000), 18–19.

15 "PLAYED-OUT ABSTRACT EXPRESSIONISM": Peter Schjeldahl, "String Theory," *New Yorker*, May 30, 2005, 96–97; Tomkins, *Off the Wall*, 99–100; Matthew Baigell, *Dictionary of American Art* (New York: Harper & Row, 1982), 186.

17 "NOTHING LIKE JASPER JOHNS": Tomkins, *Off the Wall*, 133; Barbara Haskell, *Blam! The Explosion of Pop, Minimalism and Performance* (New York: W. W. Norton/Whitney Museum of American Art, 1984), 16–17.

17 "NEVER LEAVES YOU": Diamonstein, *Inside the Art World*, 196–97; Tomkins, *Off the Wall*, 13–14.

18 "AS BEING AN ARTIST": Tomkins, *Off the Wall*, 16–18; for the following paragraphs, see 28, 31–33, 72–76.

18 "RETURNED TO ROME": Robert Rauschenberg, "Autobiography," in *Off the Wall*, 303.

20 "TOUCH THAT CRAP": Tomkins, *Off the Wall*, 101–3, 120.

20 "ALL THE TIME": Leo Castelli interviews by Paul Cummings; Gimelson, "It's a Wonderful Life," 172.

21 "HAD IT TO OURSELVES": Author interview with Charles Hinman, New York, Mar. 28, 2007; Stephanie Barron, "Giving Art History the Slip," *Art in America*, Mar./Apr. 1974, 80–81; Joachim Pissarro, "Signs into Art," in *Robert Indiana*, ed. Charles Miers and Ellen Cohen (New York: Rizzoli, 2006), 63; William Katz, "Between Painting and Sculpture: A Dialogue with Charles Hinman," in *Charles Hinman: Current Works*, exh. cat. (Syracuse: Everson Museum of Art, 1980).

22 186,000 TO 496,000: William Lerner, ed., *Historical Statistics of the United States* (Washington, DC: U.S. Department of Commerce, 1976), 295–97, 383–84.

23 "THE REALM OF FREEDOM": Brink Lindsey, *The Age of Abundance: How Prosperity Transformed American Politics and Culture* (New York: HarperBusiness, 2007), 1; John Steele Gordon, *An Empire of Wealth: The Epic History of American Economic Power* (New York: Harper Perennial, 2004), 363–64, 366–67, 370.

23 SEEN IN NEW YORK: Martha Jackson Gallery, *American and European Drawings Exhibition*, exh. cat., May 8–June 14, 1957, NYPL.

THE POP REVOLUTION

23 "PROVINCE OF PARIS": Thomas B. Hess, "U.S. Painting: Some Recent Directions," *Art News Annual*, 1956, 86–87.

24 "LONDON AND SHUDDERED": Jasia Reichart, "Pop Art and After," *Art International*, Feb. 1963, reprinted in *Pop Art: A Critical History*, ed. Steven Henry Madoff (Berkeley: University of California Press, 1997), 14; see also, introduction, xvii.

24 "BY THE AD-MAN": Alison and Peter Smithson, "But Today We Collected Ads," *Ark*, Nov. 1956, reprinted in Madoff, *Pop Art*, 3–4; Leslie Richard, *Pop Art: A New Generation of Style* (London: Tiger Books International, 1997), 117.

25 "FINE ART OF THE DAY": J. G. Ballard, *Miracles of Life: Shanghai to Shepperton* (London: Fourth Estate, 2008), 187–88.

25 "MEANS OF COMMUNICATION": Lawrence Alloway, "Popular Culture and Pop Art," *Studio International*, July/Aug. 1969, 17–21.

25 "OTHER BRITISH ARTISTS": Livingstone, *Pop Art*, 33 (and the following quote); David Mellor, *The Sixties Art Scene in London*, exh. cat. (London: Phaidon, 1993), 11. Read retorted by bitterly denouncing Pop as "anti-art . . . completely lacking in style"; Herbert Read, "The Disintegration of Form in Art," *Studio International*, Apr. 1965, 144–45.

27 "LEAVES MODERN FINE ART": Lawrence Alloway, "The Arts and the Mass Media," *Architectural Design and Construction*, Feb. 1958, reprinted in Madoff, *Pop Art*, 7–9.

27 "WAS GOING TO READ": Author interview with Ivan Karp, New York, Feb. 21, 2006; Ivan Karp interview by Paul Cummings, Mar. 12, 1969, AAA.

28 "AS I DID": Ivan Karp interview by Paul Cummings.

28 "TWO OR THREE COLLECTORS": Ibid.; Hansa Gallery invitation, 1954, pamphlet file, Art and Architecture Division, NYPL.

29 "OF BEAUTIFUL GIRLS": Ivan Karp and Leo Castelli interviews by Paul Cummings.

29 "IN A SCHOLARLY WAY": Ivan Karp interview by Paul Cummings; author interview with Ivan Karp.

30 "FASCINATION AND AMAZEMENT": Ivan Karp interview by Paul Cummings; Smith, "Ileana Sonnabend Dies"; Gimelson, "It's a Wonderful Life," 172.

30 "ECLECTIC BUNCH INDEED": Elizabeth C. Baker, "Leo Castelli, 1907–1999," *Art in America*, Nov. 1999, 31; undated announcement by Galerie 22, Leo Castelli Papers, Group III, AAA; Diamonstein, *Inside the Art World*, 20.

31 "WEARING SUITS, AND GAY": Author interview with Peter Plagens, New York, Nov. 6, 2007; "Art Shows Here May Set Record," *New York Times*, Jan. 4, 1959.

Chapter 2: The Arts Take Center Stage

33 "SHAPE THE WORLD": Daniel J. Boorstin, *The Image: A Guide to Pseudo-Events in America* (1961; repr., New York: Atheneum, 1987), 4–5.

33 "OF HUMAN SOLIDARITY": Marshall McLuhan, *The Mechanical Bride: Folklore of Industrial Man* (1951; repr., Boston: Beacon Press, 1967), 3–4.

33 "ORACLE OF THE AGE": Lewis H. Lapham, "The Eternal Now," in Marshall McLuhan, *Understanding Media* (Cambridge, MA: MIT Press, 1994), x.

34 "WITH A HEART CONDITION": Marshall McLuhan, *The Gutenberg Galaxy: The Making of Typographic Man* (New York: Signet, 1967); Glenn Willmott, *McLuhan, or Modernism in Reverse* (Toronto: University of Toronto Press, 1996), 135–37.

34 "TRIBAL DRUMS": Tom Wolfe, "What If He Is Right?" in *The Pump-House Gang* (New York: Farrar, Straus and Giroux, 1968), 133–70; first published in *New York*.

34 "DOESN'T NEED TO READ": John Wilson, "The Late Hugh Kenner's Theory of Everything," *Boston Globe*, Dec. 7, 2003; Andrew Ross, *No Respect: Intellectuals and Popular Culture* (New York: Routledge, 1988), 114; Willmott, *McLuhan*, 137.

35 "BERSERK OF THE SIXTIES": Will Blythe, "South toward Home," *New York Times Book Review*, Mar. 26, 2006, 16; Brink Lyndsey, *The Age of Abundance* (New York: Harper Business, 2007), 129.

36 "HERE THEY ARE": Ivan Karp interview by Paul Cummings, Mar. 12, 1969, Smithsonian Archives of American Art (hereafter AAA), and for the following paragraph. Douglass was the women's college of Rutgers University.

36 "A VERY LARGE DEGREE": Leo Castelli interviews by Paul Cummings, May 14, 1969–June 8, 1973, AAA.

36 "HE'S GREAT": John Rublowsky, *Pop Art: Images of the American Dream* (London: Thomas Nelson, 1965), 45.

36 "WOULD DO WITH ART": Barbaralee Diamonstein, *Inside the Art World: Conversations with Barbaralee Diamonstein* (New York: Rizzoli, 1994), 162; Grace Glueck, "A Pop Artist's Fascination with the First Americans," *New York Times*, Dec. 23, 2005; Ivan Karp interview by Paul Cummings.

37 "AS GOOD AS THAT": Calvin Tomkins, *Off the Wall: A Portrait of Robert Rauschenberg* (New York: Picador, 1980), 157–58.

37 "VERY UNPLEASANT MOMENTS": Ivan Karp interview by Paul Cummings.

37 "OLD-FASHIONED IN ITS FLATNESS": Lawrence Alloway, *American Pop Art* (New York: Macmillan, 1974), 7.

38 "OWN TASTE, SOMETIMES": "Everything Clear Now?" *Newsweek*, Feb. 26, 1962, 87; Diamonstein, *Inside the Art World*, 162.

38 "ONE-TWO PUNCH": Author interview with Ivan Karp, New York, Feb. 21, 2006.

38 "IN WHAT HE SAYS": Skip Myslenski, "Transformation of Everyday," *Rochester Times-Union*, Apr. 1968, Roll N68-33, Leo Castelli Gallery Papers, AAA.

38 "A TERRIFIC EYE": Author interview with Ivan Karp, New York, Nov. 10, 2005.

38 POP PAINTINGS AND SCULPTURES: Suzi Gablik, "Protagonists of Pop," *Studio International*, July/Aug. 1969, 11.

38 "IS THE EXPLANATION": Robert C. Scull, "Re *The F-111*: A Collector's Notes," *Metropolitan Museum of Art Bulletin*, Mar. 1968, reprinted in *Pop Art: A Critical History*, ed. Steven Henry Madoff (Berkeley: University of California Press, 1997), 256.

39 "BLOCK AND TACKLE": "Saved," *New Yorker*, Jan. 20, 1962, 20.

40 SIGNED UP AT CASTELLI'S: "Anonymous Art," *New Yorker*, Nov. 14, 1964, 47–50; "The Man from AARS," *Newsweek*, May 31, 1965, 75; author interview with Ivan Karp, New York, Feb. 1, 2007; Ivan Karp interview by Paul Cummings.

THE POP REVOLUTION

40 "WHY NOT USE IT":"From Machine-Age Rubbish, Startling New Creations," *Life*, Nov. 24, 1961, 62–72.

40 "NEW YORK ART WORLD": Paul Berg, "About Face from the Abstract," *St. Louis Post-Dispatch Pictures Magazine*, Dec. 31, 1961, cover and 10–11.

41 "ITS PLACE IN HISTORY": Robert K. Sanford, "Which Way Is Modern Art Going? Hold Your Breath and Watch the Soup Cans," *Kansas City Star*, Oct. 21, 1962, in Leo Castelli Gallery Papers, Group II, Roll N68-50; Catalogue for Fine Arts Festival, Kansas State University, May 8–14, 1962, in Leo Castelli Gallery Papers, Group IV, Roll N68-59.

41 "OF A CENTURY AGO": Alfred Frankenstein, "This World," *San Francisco Chronicle*, Jan. 6, 1963, clipping in Leo Castelli Gallery Papers, Group II, Roll N68-50; "Pop Posters Prove Sellout at Museum of Art," *Philadelphia Inquirer*, Dec. 3, 1964, Leo Castelli Gallery Papers, Group II, Roll N68-50.

41 "TO BE PAINTED GRAY": Author interview with Ivan Karp, Feb. 21, 2006.

41 PRICES HAD TRIPLED: Elizabeth C. Baker, "Leo Castelli, 1907–1999," *Art in America*, Nov. 1999, 31; Peggy Polk, "Ex-Ohioan a Leader in Pop Art," *Cleveland Press*, Apr. 2, 1964, Leo Castelli Gallery Papers, Group II, Roll N68-50.

42 "IN PARIS AFTER THAT": Deborah Gimelson, "It's a Wonderful Life," *ARTnews*, Summer 1994, 170–72; Program, Castelli Gallery Papers, Group II, Roll N68-57, and Ulf Linde, "4 Americanare," *Dagens Nyheter*, Mar. 17, 1962, Roll N68-33, AAA.

42 "INTO A VISUAL DILEMMA": Winifred Gaul, "Die Welt der Slogans unter den Phrasen," *Die Welt*, Jan. 18, 1963, and Robert Rosenblum, "Les Oeuvres récentes de Jasper Johns," *XXème Siècle*, no. 8 (1962), unpaged clipping, both Castelli Gallery Papers, Group II, Roll N68-33; "Americans in Paris," *Newsweek*, Jan. 6, 1964, 60.

43 "VIGOROUS WORKS OF ART": Sidney Janis, "The Theme of the Exhibition," catalogue for "The New Realists," Oct. 31–Nov. 30, 1962, reprinted in Madoff, *Pop Art*, 39–40; Sidney Janis Gallery invitation for "The New Realists" opening, Oct. 31, 1962, pamphlet file, Art and Architecture Division, New York Public Library.

43 "WE WILL BURY YOU": Thomas B. Hess, "New Realists," *Art News*, Dec. 1962, 12–13.

43 "PIONEER IN THROWAWAY ART": Brian O'Doherty, "Art: Avant-Garde Revolt," *New York Times*, reprinted in Madoff, *Pop Art*, 41.

43 "DEFINITELY CHANGED": Tony Scherman, "When Pop Turned the Art World Upside Down," *American Heritage*, Feb. 2001, http://www.americanheritage.com/articles/magazine/ah/2001/1/2001_1_68.shtml.

43 "THAN WAS AMERICA": "Americans in Paris," *Newsweek*, Jan. 6, 1964, 60; Rosenblum, "Oeuvres récentes de Jasper Johns"; and Gaul, "Die Welt der Slogans."

44 "SINCE THE ARMORY SHOW": John Coplans, "Pop Art USA," *Artforum*, Oct. 1963, 27–30, reprinted in Madoff, *Pop Art*, 98.

44 "PAINTING RED ON RED": Quoted in Barbara Haskell, *Blam! The Explosion of Pop, Minimalism and Performance, 1958–64* (New York: W. W. Norton/Whitney Museum of American Art, 1984), 28–29.

44 "OF ISOLATED GLORY": "The Smiling Workman," *Time*, Feb. 2, 1962, 44.

44 "A MICKEY MOUSE TIE": Allison Stabile, "The Art of Living Well," memorial speech for Allan Stone, Morgan Library and Museum, New York, Feb. 5, 2007; Wayne Thiebaud interview by Susan Larsen, May 17, 2001, AAA; "The Slice-of-Cake School," *Time*, May 11, 1962, 52.

45 IMMEDIATELY BOUGHT IT: David Bourdon, *Warhol* (New York: Abrams, 1989), 102–3, 109.

45 "SEVENTEENTH-CENTURY HOLLAND": Edward Lucie-Smith, "Saying No," *New Statesman*, Jan. 26, 1962, 137.

46 "AND FINANCIAL SUPPORT": William C. Seitz, *Art in the Age of Aquarius* (Washington, DC: Smithsonian Institution Press, 1992), 21; first published in *Vogue*, Sept. 1963.

46 "OF PRIVILEGED ITEMS": Lawrence Alloway, "Pop Art: The Words," in *Topics in American Art since 1945* (New York: W. W. Norton, 1975), 120; first published in *Auction*, Feb. 1962.

46 "USUALLY DELIGHTFUL RESULTS": G. R. Swenson, "The New American Sign Painting," *Art News*, Sept. 1962, 62.

46 "MUCH MORE ADVENTUROUS": Peter Joseph, *Good Times: An Oral History of America in the 1960s* (New York: Charterhouse, 1972), 36.

46 "FOREMOST AMERICAN PAINTER": Alastair Reid, "The World of Z," *Vogue*, Jan. 1962, 87–88, clipping in Castelli Gallery Papers, Group II, Roll N68-333.

47 "PHILOSOPHY OF PLENTY": "Commanding Painter," *Time*, May 22, 1964, 72.

47 "SPELLBINDING PAINTINGS": Charles Miers and Ellen Cohen, eds., *Robert Indiana* (New York: Rizzoli, 2006), 271–73.

47 "DARED TO OPPOSE HER": Bourdon, *Warhol*, 131–32; Robert Indiana biographical notes, Dec. 3, 1962, and Jan. 4 and Apr. 19, 1963, Papers of the Stable Gallery, Roll 5821/815-19, AAA; comment, Papers of the Stable Gallery, Roll 5822/15 and 34–35, and Rolf G. Nelson, director of Dilexi Galleries, to Eleanor Ward, Dec. 5, 1962, Papers of the Stable Gallery, Roll 5822/62.

47 "BUSINESS SIDE OF ART": Author interview with Paul Gardner, Feb. 5, 2007; Paul Gardner to the author, Jan. 26, 2007.

48 "BLEW ITS OWN FUSE": "Commanding Painter," 72; John Richardson to Eleanor Ward, Apr. 23, 1963; James Michener to Ward, Apr. 25, 1963; Loan Paper to Dunn International Exhibitions, June 5, 1963, all Papers of the Stable Gallery, Roll 5822/63–96; Records for 1964 exhibition, Papers of Stable Gallery, Roll 5822/141–46.

48 "MY DIALOGUE": G. R. Swenson, "Reviews and Previews," *Art News*, Summer 1964, 13–14; "Commanding Painter," 72.

49 "NEARSIGHTED CURATORS": G. R. Swenson, "The Horizons of Robert Indiana," *Art News*, May 1966, 61; Eleanor Ward to Rolf Nelson, Apr. 30, 1965; Ward memo to Robert Indiana, Papers of the Stable Gallery, Roll 5822/192, 199–205; contract between Stable Gallery and Galerie Schmela, Dec. 15, 1965; Alfred Schmela to Ward, Dec. 17, 1965, Papers of the Stable Gallery, Roll 5822/240–41.

49 "OF CULTURAL CONVERSATION": Paul Gardner, "'Eye on New York' Views Pop Art," *New York Times*, Mar. 18, 1964; Paul Gardner, "Channel 13 Plans Study of Pop Art,"

THE POP REVOLUTION

New York Times, Mar. 16, 1964; Wendy Weitman, *Pop Impressions: Europe/USA: Prints and Multiples from the Museum of Modern Art* (New York: MoMA, 1999), 9.

50 "FRIENDLY CRITICS OR CURATORS": Tomkins, *Off the Wall*, 162–63.

50 "THUS BECOMES UNIVERSAL": Rublowsky, *Pop Art*, 3–4, 7.

51 "SHEEP THROUGH GALLERIES": Mario Amaya, *Pop Art . . . and After* (New York: Viking Press, 1965), 15.

51 "ART WORLD GALAS": Tomkins, *Off the Wall*, 208; Alan R. Solomon, "Robert Rauschenberg," catalogue essay for the exhibition at the Jewish Museum, March to May 1963, reprinted in Madoff, *Pop Art*, 24; Brian O'Doherty, "Robert Rauschenberg," *New York Times*, Apr. 28, 1963.

51 "GREAT DEAL OF AUTHORITY": Leo Castelli interviews by Paul Cummings; Tomkins, *Off the Wall*, 206.

51 "EFFECT ON A PAINTER": Solomon, "Robert Rauschenberg," 24; O'Doherty, "Robert Rauschenberg."

52 "YES AND NO": "Pop Goes the Easel," *Newsweek*, Apr. 1, 1963, 80; Barbara Rose, *American Art since 1900: A Critical History* (New York: Praeger, 1967); lectures by Guggenheim Museum staff, carbon copies of typescripts, Leo Castelli Gallery Papers, Roll N68-33, AAA.

52 "TO THE THIRD POWER": Barbara Rose, "Pop Art at the Guggenheim," *Art International*, May 1963, 20.

52 "LOST ITS DEFINITION": Neville Wallis, "Art of the Possible," *Spectator*, Feb. 14, 1964; Hubert Nicholson, "'Pop' Art Draws Out-of-Ordinary Crowds," *Baltimore Sun*, Mar. 7, 1964, in Leo Castelli Gallery Papers, Group III, Roll N68-57.

52 "VERY QUIET ABOUT IT": Frederick Laws, *Daily Herald*, Feb. 5, 1964, Leo Castelli Gallery Papers, Group III, Roll N68-57.

52 SINCE JACKSON POLLOCK: Grace Glueck, "Art Notes: Going, Going Up!" *New York Times*, Feb. 16, 1964; Tomkins, *Off the Wall*, 191.

53 "DONE FOR AMERICANS": Calvin Tomkins, "The Big Show in Venice," *Harper's Magazine*, Apr. 1965, 99–100.

53 "CONTEMPORARY JUNK HEAP": Sam Hunter, "New Directions in American Painting," catalogue essay for the exhibit at Poses Institute of Fine Arts, Brandeis University, 1963, reprinted in *The New Art*, ed. Gregory Battcock (New York: E. P. Dutton, 1966), 63.

54 PEGGY GUGGENHEIM'S PALACE: Les Krantz, *The New York Art Review* (Chicago: American References, 1988), 108; Tomkins, *Off the Wall*, 2–3; Tomkins, "Big Show in Venice," 99.

54 "AN ALSO-RAN CONTEXT": Tomkins, "Big Show in Venice," 101–3.

54 "QUASI-CRIMINAL ACTIVITY": Alexander Eliot, "All Roads Lead to Where?" *Art in America*, no. 6 (1964), 127.

55 "COMMERCE AND TRASH": "Carnival in Venice," *Newsweek*, July 6, 1964, 74; Tomkins, *Off the Wall*, 6.

55 "LITTLE TO REPORT": Tullia Zevi, "The Biennale: How Evil Is Pop Art?" *New Republic*, Sept. 19, 1964, 32–33.

56 "PLAGUE IN THE CITY": Gene Baro, "The Venice Biennale," *Arts Magazine*, Sept. 1964, 33–34.

57 "SOMETHING AFTER ALL": Tomkins, *Off the Wall*, 10–11; "Carnival in Venice," 75.

58 "SIRLOINS OF BEEF": Zevi, " Biennale," 33–34; editorials in *Figaro*, June 22, 1964, and *Monde*, June 21–22, 1964; Raymond Cogniat, "Curieuse agressivité des Etats-Unis," *Figaro*, June 23, 1964; Pierre Mazars, "Venise: Les grandes manoeuvres du 'Pop Art,'" *Figaro Littéraire*, July 1, 1964; Pierre Cabanne, "L'Amérique proclame la fin de l'École de Paris et lance le 'Pop' Art pour coloniser l'Europe," *Arts*, June 24, 1964.

58 "THAN MEETS THE EYE": Rosalind Constable, "Pop in Venice: He Is Saying, 'Look at It,'" *Life*, July 10, 1964, 68; "Europe Explodes as American Takes Prize: Art Pops In," ibid., 65.

58 "THE WHOLE ART WORLD": Leo Castelli interviews by Paul Cummings; clippings for 1964 in Castelli Gallery papers, Group III, Roll N68-57.

58 "A FAMOUS PAINTER": Barbaralee Diamonstein, "Pop Art, Money, and the Present Scene: An Interview with Roy Lichtenstein and Leo Castelli," *Partisan Review* 45, no. 1 (1978), 7–8.

58 "THE STAGE WAS SET": Grace Glueck, "Leo Castelli Takes Stock of 30 Years Selling Art," *New York Times*, Feb. 5, 1987.

59 BY LOCAL COLLECTORS: Ivan Karp interview by Paul Cummings.

59 "ENCIRCLING THE MUSEUM": Robert Hughes, *American Visions: The Epic History of American Art* (New York: Knopf, 1997), 521.

Chapter 3: But Is It Art?

60 "A WORK OF ART": John Canaday, "Pop Art Sells On and On — Why?" *New York Times Magazine*, May 31, 1964, 7.

61 HOSTILITY AS "PALPABLE": Author interview with Ivan Karp, New York, Nov. 10, 2005; Geoffrey Wagner, "Has Pop Art Reached Bottom?" *Connoisseur*, Aug. 1964, 255; William Seitz, "The Rise and Dissolution of the Avant-Garde," *Vogue*, Sept. 1, 1963, 231.

61 "QUALITATIVE JUDGMENT": John House, *Impressionism: Paint and Politics* (New Haven: Yale University Press, 2004), 207.

62 "REASON OR NECESSITY": Ibid., 11–12.

62 "VOCABULARY OF MASS PRODUCTION": Robert Rosenblum, "Pop Art and Non-Pop Art," *Art and Literature*, Summer 1964, reprinted in *Pop Art Redefined*, ed. John Russell and Suzi Gablik (New York: Praeger, 1969), 53–54; Sara Doris, *Pop Art and the Contest over American Culture* (New York: Cambridge University Press, 2007), 4–5; House, *Impressionism*, 209.

63 "UNEDUCATED AMERICAN BOYS": Author interview with Robert Rosenblum, New York, June 19, 2006.

THE POP REVOLUTION

63 "PUBLIC EYE FOR ART": Grace Glueck, "50,000 Paintings Plus," *New York Times*, Jan. 12, 1964.

64 "ALL THE CRAZIES": Author interview with Grace Glueck, New York, Feb. 8, 2007.

64 "DECIDEDLY DERRIÈRE-GARDE": Grace Glueck, "Art Notes: Fledgling," *New York Times*, Feb. 9, 1964; author interview with Ivan Karp, New York, Mar. 28, 2007; Nan Robertson, *The Girls in the Balcony: Women, Men, and the New York Times* (New York: Random House, 1992), 139–40.

65 "OF LITTLE MAGAZINES": Grace Glueck, "The Bowery: Arty and Avant-Garde," *New York Times*, Apr. 24, 1965.

65 "ITS SERIOUS PURPOSE": Robertson, *Girls in the Balcony*, 132–35.

66 A WISE INVESTMENT: Gerald Reitlinger, *The Economics of Taste* (New York: Holt, Rinehart & Winston, 1961), 377–78, 237.

66 "OF WHAT ART IS": "You Bought It, Now Live with It," *Life*, July 16, 1965, 56; Harry Abrams interview by Paul Cummings, Mar. 14, 1972, Smithsonian Archives of American Art (hereafter AAA); William K. Zinsser, *Pop Goes America* (New York: Harper & Row, 1966), 17–18.

67 "IBM STOCK EITHER": Zinsser, *Pop Goes America*, 25–26; "You Bought It, Now Live with It"; "Leon Kraushar, 54, Pop Art Collector" (obituary), *New York Times*, Sept. 13, 1967.

67 "WANTS TO BUY IT": Leo Castelli interviews by Paul Cummings, May 14, 1969–June 8, 1973, AAA.

68 "THE RIGHT PAINTINGS": Ibid.

68 "THE DINNER TABLE": Annette Kuhn, "Post-war Collecting: The Emergence of Phase III," *Art in America*, Sept.–Oct. 1977, 110–13.

68 "RECOGNIZE IT IMMEDIATELY": Zinsser, *Pop Goes America*, 10–11, 21.

69 ACQUIRE THE NEW: Barbara Rose, "Art Talent Scouts," *Art in America*, no. 4 (1964), 19.

69 "AT GREATER COST": Richard Brown Baker, "Two in the First Row," *Art in America*, no. 5 (1963), 91; Zinsser, *Pop Goes America*, 22.

69 "CANVAS BY ROY LICHTENSTEIN": Johanna Garfield, "Getting There First: Reflections of a Collector," *New York Times*, Oct. 25, 1998.

70 "AT THE SAME TIME": Baker, "Two in the First Row," 91; "New Talent, USA," *Art in America*, no. 1 (1962), 23; Richard Brown Baker, introduction to *The Last Twenty Years in Contemporary Painting: Selections from the Collection of Richard Brown Baker*, exh. cat. (Rochester, MI: University Art Gallery, Oakland University, Feb. 20–Mar. 17, 1967), unpaged; Alice Goldfarb Marquis, *The Art Biz: The Covert World of Collectors, Dealers, Auction Houses, Museums and Critics* (Chicago: Contemporary, 1991), 171–73; author interview with Richard Brown Baker, New York, Sept. 20, 1989; Roberta Smith, "Richard Brown Baker, Collector and Donor of Contemporary Art Dies at 89," *New York Times*, Jan. 27, 2002.

70 "THOUGHT I WAS CRAZY": Jane Kramer, "Profiles: The Man Who Is Happening Now," *New Yorker*, Nov. 26, 1966, 95; Zinsser, *Pop Goes America*, 11–12; Doris, *Pop Art*, 65–106; "At Home with Henry," *Time*, Feb. 21, 1964; Steven M. L. Aronson, "*Architec-*

tural Digest Visits Leo Castelli," Oct. 1995; Alex Nunez, "NYC Taxi Medallion Sold for Record $600,000," *Autoblog*, June 1, 2007, http://www.autoblog.com/2007/06/01/nyc-taxi-medallion-sold-for-record-600-000.

71 "FELT SORRY FOR": Tom Wolfe, "Upward with the Arts: The Success Story of Robert and Ethel Scull," *New York*, Oct. 30, 1966, 12–13; Kramer, "Man Who Is Happening Now," 82, 84, 88; Parke-Bernet announcement of Robert Scull sale, pamphlet file, Art and Architecture Division, New York Public Library.

71 "IT IS VERY SATISFACTORY": Leo Castelli interviews by Paul Cummings; Wolfe, "Upward with the Arts."

72 "YOU COMMIT YOURSELF": Richard Leslie, *Pop Art: A New Generation of Style* (London: Tiger Books International, 1997), 44.

72 "IMMENSELY ARROGANT": Leo Castelli interviews by Paul Cummings; Zinsser, *Pop Goes America*, 12.

72 "KEEN SENSE FOR ART": Andy Warhol and Pat Hackett, *POPism: The Warhol '60s* (New York: Harper & Row, 1980), 86–87.

72 "GANGSTERS AND DOUGH": Kramer, "Man Who Is Happening Now," 84; Calvin Tomkins, *Off the Wall: A Portrait of Robert Rauschenberg* (New York: Picador, 1980), 163.

72 "DE' MEDICI OF POP": Vincent Canby, "'Painters Painting' Explores the Art Scene Here," *New York Times*, Mar. 20, 1973.

73 "THE INSTALLMENT PLAN": "At Home with Henry," *Time*, 68; Wolfe, "Upward with the Arts," 4.

73 "I LOVE IT": "You Bought It, Now Live with It," 53.

73 "WACKED OUT ART": Wolfe, "Upward with the Arts," 7, 19.

73 "THE INSIDE COVER": Kramer, "Man Who Is Happening Now," 64, 84.

73 "HOW TO APPROACH THEM": Author interview with Ivan Karp, New York, Feb. 21, 2006.

74 "RUN A BUSINESS HERE": Henry Geldzahler, "The Sixties as They Were," lecture delivered Sept. 22, 1991, at Guild Hall, Easthampton, NY, reprinted in *Making It New* (New York: Turtle Point Press, 1990), 351, 338–39; Grace Glueck, "U.S. Arts Council Picks 3 Directors," *New York Times*, Jan. 7, 1966.

76 "MISUNDERSTOOD AND UNPATRONIZED": Peter Selz, "A Symposium on Pop Art," *Arts*, April 1963, 36–37; Peter Selz interview by Paul Karlstrom, Nov. 3, 1999, AAA; "Tentative Listing for Five-Year Publications Program," handwritten notes, undated, 1958; "Tentative Proposal of Exhibitions," Sept. 2, 1958, MoMA news release for magazines, May 20, 1959; all in Papers of Peter Selz, Roll 1384, frames 108, 119–20, 226, and 278, AAA; announcement of symposium on Pop Art, Roll 4384, Papers of Peter Selz; Tomkins, *Off the Wall*, 162–63.

76 "SURROUNDED BY APACHES": Jill Johnston, "The Artist in a Coca-Cola World," *Village Voice*, Jan. 21, 1963, reprinted in *Pop Art: The Critical Dialogue*, ed. Carol Anne Mahsun (Ann Arbor: UMI Research, 1989), 42–43; Selz, "Symposium," 36–45.

77 "PRESENTED AS AVANT-GARDE": Peter Selz, "Pop Goes the Artist," *Partisan Review*, Summer 1963, 313–16.

THE POP REVOLUTION

77 "VIEW OF CULTURE": "Art: Pop Pop," *Time*, Aug. 30, 1963, 40.

78 "BUILT-IN OBSOLESCENCE": Henry J. Seldis, "The 'Pop' Art Trend: This, Too, Will Pass," *Los Angeles Times*, Aug. 4, 1963.

78 "WITH THE NEW STAR": Norbert Lynton, "London Letter," *Art International*, Feb. 1964, 42.

78 "OUT OF THE SKY": Paul Gardner, "Channel 13 Plans Study of Pop Art," *New York Times*, Mar. 16, 1964; "American Art Exhibition Opens Jan. 11 in Chicago," *New York Times*, Jan. 3, 1963.

78 "HAVE YET TO ARRIVE": Rose, "Art Talent Scouts," 19.

79 "JUST WHAT IS THAT": Alice Goldfarb Marquis, *Art Lessons: Learning from the Rise and Fall of Public Arts Funding* (New York: Basic Books, 1995), 123.

79 "PENTECOST OF HIPSTERS": Max Kozloff, "Pop Culture, Metaphysical Disgust, and the New Vulgarians," *Art International*, Mar. 1962, reprinted in *Pop Art: A Critical History*, ed. Steven Henry Madoff (Berkeley: University of California Press, 1997), 29–32; Fulbright National Screening Committee, Papers of Peter Selz, Roll 4383-846.

79 "ARTIST HIMSELF TO DINNER": Thomas B. Hess, "The Phony Crisis in American Art," *Art News*, Summer 1963, 25–27; Clement Greenberg, *The Collected Essays and Criticism*, ed. John O'Brian, vol. 4 (Chicago: University of Chicago Press, 1995), 262–63; Harold Rosenberg, *The Anxious Object* (New York: Collier, 1966), 74, 232.

80 "IN THE WORLD TODAY": "Pop Art: Cult of the Commonplace," *Time*, May 3, 1963, 69–70.

80 "AND THE BEAUTIFUL": Wolfe, "Upward with the Arts," 8. In asserting that museum committees had replaced charity committees as venues for ambitious newcomers, Wolfe overlooked a Pop Art show presented a year earlier by Castelli and six other galleries. Chaired by Mrs. Winthrop Rockefeller, it had attracted a posh audience to the elegant Four Seasons Restaurant to benefit mental health organizations: "Pop Art Display to Raise Funds for Mentally Ill," *New York Times*, Feb. 22, 1965.

80 OBSERVERS AND COLLECTORS: Alan Solomon, catalogue essay for the exhibit "The Popular Image" (Washington Gallery of Modern Art, 1963), reprinted in *The New Art*, ed. Gregory Battcock (New York: E. P. Dutton, 1966), 69.

81 "ALL POSSIBLE WORLDS": G. R. Swenson, "What is Pop Art?" parts 1 and 2, *Art News*, Nov. 1963 and Feb. 1964, reprinted in Madoff, *Pop Art*, 83, 103–11, 112–17.

81 "THEY HAD NO PART": Marco Livingstone, *Pop Art: A Continuing History* (New York: Thames & Hudson, 2000), 37.

81 "SOMETHING WILD, MAN": Reyner Banham, "No Dave," *New Statesman*, Nov. 15, 1963, 714–15.

82 "IS PRETTY ROSY": Thomas B. Hess, "Editorial: Pop and Public," *Art News*, Nov. 1963, 23.

82 "SALES-EXPERT HYPNOTISTS": Alfred Frankfurter, "Pop Extremists," *Art News*, Sept. 1964, 19.

83 "THE SCATTERED FRAGMENTS": Paul Gardner, "The Elite Mingle at Art Previews," *New York Times*, May 21, 1962.

83 "WAS TO ASTONISH": Edward Lucie-Smith, "Round the New York Art Galleries: Letters and Figures," *The Listener,* Jan. 10, 1963, 71; 1964 Annual Report to the Mayor, Office of Cultural Affairs and Report of Cultural Alliance Conference, New York, April 2–3, 1965.

83 "AND WESTERN CULTURE": Eric Hobsbawm, *Interesting Times: A Twentieth Century Life* (New York: New Press, 2005), 222–24.

84 "FASHION BECOMES UNIVERSAL": C. Wright Mills, "Power and Politics," in *The Sixties: Art, Politics, and Media of Our Most Explosive Decade,* ed. Gerald Howard (New York: Paragon House, 1991), 74, 79.

84 "HAS NO VALUES": David Newman and Robert Benton, "The New Sentimentality," *Esquire,* July 1964, cover, 25, 29–31.

84 "ON TIDES OF FAD": Harold Rosenberg, "The American Art Establishment," in *Discovering the Present: Three Decades in Art, Culture, and Politics* (Chicago: University of Chicago Press, 1973), 110–11, 114–15; first published in *Esquire,* Jan. 1965.

85 "HAVE TIME TO REACT": William Seitz, "The New Perceptual Art," *Vogue,* Feb. 15, 1965, 79.

86 "MIXED WITH ADMIRATION": Barbara Rose, "Pop in Perspective," *Encounter,* Aug. 1965, 59–60.

87 "TO BE TAKEN SERIOUSLY": "Pop Goes Art — for Art's Sake," *Pocono Journal,* Mar. 5, 1965, Castelli Gallery Papers, Group II, Roll N68-50.

87 "STOPPED SMILING YET": "Pop Art Exhibited, and It's Crazy, Dad," *Milwaukee Journal,* Apr. 9, 1995, reprinted in Madoff, *Pop Art,* 130.

87 "AT ONE STROKE": "Dealer Believes Art Need Only Click with the Clique," *Minneapolis Star,* Apr. 26, 1965.

88 "OR WE FIX MOLDINGS": Leo Castelli interviews by Paul Cummings; Leah Gordon, "America's Art Heritage — Going, Going, Gone?" *New York Times,* Oct. 7, 1973, 177; Ivan Karp interview by Paul Cummings.

88 "AS A POP STATUE": "Year of the Mechanical Rabbit," *Time,* June 24, 1966, 64, 67.

88 "OVER HIS DEAD BODY": Author interview with Robert Rosenblum; Lawrence Alloway, lecture at the Guggenheim Museum, Apr. 11, 1965, reprinted in Alloway, *Topics in American Art since 1945* (New York: Norton, 1975); National Screening Committee, 1964–65, Papers of Peter Selz, Roll 4383-846, and Peter Selz, undated memo to Alfred H. Barr Jr., Papers of Peter Selz, Roll 4348, 410–11.

Chapter 4: A Most Unlikely American Hero

89 "PAINTINGS LIKE THAT": David Bourdon, *Warhol* (New York: Abrams, 1989), 80.

90 "FROM THE ART WORLD": Ibid., 6, 80.

90 "TREMORS DAY AND NIGHT": Ivan Karp interview by Paul Cummings, Mar. 12, 1969, Smithsonian Archives of American Art (hereafter AAA); Patrick S. Smith, *Andy Warhol's Art and Films* (Ann Arbor: UMI Research, 1986), 306; Steven Watson, *Factory-Made: Warhol and the Sixties* (New York: Pantheon, 2003), 74.

90 "ABOUT TO HAPPEN": Andy Warhol and Pat Hackett, "In the Beginning," *New York,*

THE POP REVOLUTION

Mar. 3, 1980, 62; Ivan Karp, "Andy Starts to Paint," in *Andy Warhol "Giant" Size* (New York: Phaidon Press, 2006), 86; Ivan Karp interview by Paul Cummings.

91 MORE THAN DOUBLED:Victor Bockris, *Warhol: The Biography* (London: Muller, 1989), 11; William Lerner, ed., *Historical Statistics of the United States* (Washington, DC: Bureau of the Census, 1975), 855–57.

92 "TONIGHT-SHOW FRIENDS": Warhol and Hackett, "In the Beginning," 66.

92 "SAY SOMETHING": Henry Geldzahler, *Making It New* (New York: Turtle Point, 1994), 42–44.

92 "EVEN MORE PECULIAR": Karp, "Andy Starts to Paint," 86.

92 "THE SOUP CANS": Bourdon, *Warhol*, 100; Warhol and Hackett, "In the Beginning," 70.

93 "WRONG WE WERE": Bourdon, *Warhol,* 86; Leo Castelli interviews by Paul Cummings, May 14, 1969–June 8, 1973, AAA, and Ivan Karp interview by Paul Cummings.

93 ENTHUSIASTIC COLLECTORS: Irving Blum interviews by Paul Cummings, May 31, June 15, and June 23, 1977, AAA; Amy Newman, *Challenging Art: Artforum, 1962–1974* (New York: Soho, 2000), 32.

94 "POP WAS ANDY": Henry Geldzahler, introduction to Frayda Feldman and Jörg Schellmann, *Andy Warhol Prints* (New York: Abbeville, 1985), 9; Bob Colacello, *Holy Terror: Andy Warhol Close Up* (New York: Harper Perennial, 1991), 28–29; Irving Blum interviews by Paul Cummings; Bockris, *Warhol*, 148; Smith, *Warhol's Art and Films*, 220.

94 "HE WANTED LESS": Ivan Karp, "The Contemporary Scene," *Arts Magazine*, May–June 1965, in Bourdon's *Warhol*, 99n3.

95 HIS REACTION: "WOW": Bourdon, *Warhol*, 130–31; Smith, *Warhol's Art and Films*, 504–5.

95 "A MATTER OF SECONDS": Jules Langsner, "Los Angeles Letter," *Art International*, Sept. 1962, 49; Peter Plagens, *Sunshine Muse: Art on the West Coast, 1945–1970* (1974; repr., Berkeley: University of California Press, 1999), 117; Irving Blum interviews by Paul Cummings.

96 "TO [FUTURE] GENERATIONS": Michael Fried, "New York Letter," *Art International*, Dec. 1962, reprinted in *The Critical Response to Andy Warhol*, ed. Alan R. Pratt (Westport, CT: Greenwood Press, 1997), 1–2; price list for Andy Warhol 1962 exhibition, Papers of the Stable Gallery, Roll 5823, AAA; Bourdon, *Warhol*, 134.

96 THE FOLLOWING SPRING: Bourdon, *Warhol*, 134, 132; Geldzahler, introduction to *Andy Warhol Prints*, 10.

96 "ABSOLUTELY DETERMINED": Quoted in Smith, *Warhol's Art and Films*, 299; Warhol and Hackett, "In the Beginning," 64. Johns's and Rauschenberg's rebuffs were nothing compared with de Kooning's reaction when Warhol tried to shake his hand at a party. "You're a killer of art!" the older artist screamed. "You're a killer of beauty, and you're even a killer of laughter! I can't bear your work!" Tony Scherman, "When Pop Turned the Art World Upside Down," *American Heritage*, Feb. 2001.

97 "HE NEVER STOPPED": Dave Hickey, introduction to *Andy Warhol "Giant" Size*, 9. For a discussion of the uncertainty surrounding Warhol's birth year (often reported as anywhere from 1930 to 1933), see Bourdon, *Warhol*, 25n2, which provides convincing support for August 1928 as the most reliable date.

97 "SOMETHING REVOLUTIONARY": Hickey, introduction to *Andy Warhol "Giant" Size*, 12; Kynaston McShine, introduction to *Andy Warhol: A Retrospective*, exh. cat. (New York: Museum of Modern Art, 1989), 13; John Richardson, "Warhol at Home," *Vanity Fair*, July 1987, 248–49.

98 MEANT BY "ANDY": Will Blythe, "South Toward Home," *New York Times Book Review*, Mar. 26, 2006, 16.

98 "MOST PERISHABLE NATURE": Carter Ratcliff, *Andy Warhol* (New York: Abbeville, 1983), 18; Andy Warhol, *The Philosophy of Andy Warhol (From A to B and Back Again)* (1975; repr., New York: Harcourt Brace Jovanovich, 1977), 92.

98 "OF EVERY ITEM": Author interview with Sally King-Nero, New York, Nov. 12, 2007.

99 "LOOKED MACHINE-MADE": Bourdon, *Warhol*, 169.

99 "THE TWENTIETH CENTURY": Brink Lindsey, *The Age of Abundance: How Prosperity Transformed America's Politics and Culture* (New York: HarperBusiness, 2007), 133.

99 "SUPERNOVA NEAR COLLAPSE": Kay Larson, "Death and Menace," *New York*, Apr. 21, 1986, 89–90.

100 "MY REAR GALLERY": "Elvis Studio and Ferus Type," in *The Andy Warhol Catalogue Raisonné*, ed. Georg Frei and Neil Printz, vol. 1 (New York: Phaidon Press, 2002), 355.

100 "THE SAME WAY AGAIN": Andy Warhol and Pat Hackett, *POPism: The Warhol '60s* (New York: Harper & Row, 1980), 37–40.

101 "THEY WERE DRESSED": Ibid., 42–43; Calvin Tomkins, *Duchamp* (New York: Henry Holt, 1996), 420–22.

101 "DISTINCTLY UNIQUE": Thomas Sokolowski, "Another Take," in *Andy Warhol: 365 Takes. The Andy Warhol Museum Collection* (New York: Abrams / Andy Warhol Museum, 2004), 2.

101 "TO SMUDGE IS HUMAN": Quoted in Bourdon, *Warhol*, 138.

102 "GOT THE MESSAGE": Robert Hughes, *American Visions: The Epic History of Art in America* (New York: Knopf, 1997), 508–9; Sam Hunter, *American Art of the 20th Century* (New York: Abrams, 1972), 262.

102 "ALWAYS TOO EXPENSIVE": Donna De Salvo, "'Subjects of the Artists': Towards a Painting without Ideals," in *Hand-Painted Pop: American Art in Transition, 1955–62*, ed. Russell Ferguson (New York: Rizzoli, 1993), 86.

103 "A BREATHLESS SEXUALITY": David Thomson, *A Biographical Dictionary of Film*, 3rd ed. (New York: Knopf, 1994), 524; John S. Bowman, *Cambridge Dictionary of American Biography* (New York: Cambridge University Press, 1995), 509.

103 "MAN WHO CREATED IT": John Rublowsky and Ken Heyman, *Pop Art: Images of the American Dream* (London: Thomas Nelson, 1965), 110.

103 "WANT IT PERFECT": Author interview with Nathan Gluck, New York, Nov. 2, 2007.

104 "DISSEMINATED [MONROE'S] FAME": Robert Rosenblum, "Andy Warhol: Court

Painter to the 70s," in *Andy Warhol: Portraits of the 70s*, ed. David Whitney (New York: Random House, 1979), 10, 12.

104 "A COLLABORATOR": "Marilyn 'Flavors,'" in *Warhol Catalogue Raisonné*, ed. Frei and Printz, 1:227, 233, 248–49.

104 "THEIR OWN SUBJECT MATTER": Thomas B. Hess, "The Phony Crisis in American Art," *Art News*, Summer 1963, 27.

104 "CAN ALWAYS ACQUIRE": Dave Hickey, "The Importance of Remembering Andy," in *Robert Lehman Lectures on Contemporary Art*, ed. Lynn Cooke and Karen Kelly (New York: Dia Art Foundation, 2004), 74; Hickey, introduction to *Andy Warhol "Giant" Size*, 12.

105 "WERE VERY PHOTOGENIC": Warhol, *Philosophy of Andy Warhol*, 54.

105 RIOTS AND BURNING CARS: "Appendix 13: Pop Art in the United States," in *Warhol Catalogue Raisonné*, ed. Frei and Printz, 1:472–73.

105 VIENNA, BERLIN, AND BRUSSELS: "Appendix 14: Warhol's Reception in Europe," in *Warhol Catalogue Raisonné*, ed. Frei and Printz, 1:473.

106 "AS WE ALL WERE": Author interview with Joan Washburn, New York, Feb. 17, 2006; Joan Washburn to the editor, Oct. 23, 2009; Sokolowski, *Warhol: 365 Takes*, 133.

106 "THE REGULAR SIZE": Grace Glueck, "Art Notes: Boom," *New York Times*, May 10, 1964.

107 "PAYING FOR IT": Peter Joseph, *Good Times: An Oral History of America in the Nineteen Sixties* (New York: Charterhouse, 1973), 210–11; Watson, *Factory Made*, 149.

107 "WERE NOT SCULPTURE": Sidney Tillim, "Andy Warhol," *Arts Magazine*, Sept. 1964, reprinted in Pratt, *Critical Response,* 7–8; Arthur C. Danto, *Beyond the Brillo Box: The Visual Arts in Post-historical Perspective* (New York: Farrar, Straus and Giroux, 1992), 37.

107 "OUT OF PLYWOOD": Arthur C. Danto, "The Artworld" (proceedings of the 61st annual meeting of the American Philosophical Association, Eastern Division, Dec. 28, 1964), 573–74.

108 "A TERMINAL FERMENTATION": Arthur C. Danto, *The Philosophical Disenfranchisement of Art* (New York: Columbia University Press, 1986), x, xv, 87.

109 "SOMEHOW REMAINED ART": Arthur C. Danto, "Andy Warhol," *The Nation*, Apr. 3, 1989, reprinted in *Brushes with History: Writing on Art from* The Nation, *1865–2001*, ed. Peter G. Meyer (New York: Thunder's Mouth Press/Nation Books, 2001), 420.

109 "OF THE COMMONPLACE": Danto, *Beyond the Brillo Box*, 3–4, 10.

109 "WANT IT TO BE": Arthur C. Danto, *After the End of Art* (Princeton: Princeton University Press, 1997), 35–36, 122, 131–32.

110 "UNCOMPREHENDING SILENCE": Hickey, "Importance of Remembering Andy," 62; Arthur C. Danto, "The Abuse of Beauty," *Daedalus*, Fall 2002.

110 WHITE ACRYLIC PAINT: Colacello, *Holy Terror*, 28–29; "Flowers, 1964," in *The Andy Warhol Catalogue Raisonné*, ed. Georg Frei and Neil Printz, vol. 2A (New York: Phaidon Press, 2004), 282.

110 "HIS 'OLD MASTERS'": Bourdon, *Warhol*, 187–88.

111 "GLAMOUR SMELL OF CASH": Thomas B. Hess, "Reviews and Previews: New Names

This Month — Andy Warhol," *Art News*, Jan. 1965, reprinted in *Pop Art: A Critical History*, ed. Steven Henry Madoff (Berkeley: University of California Press, 1997), 281.

111 "ON MONET'S LILY-POND": Bourdon, in *Warhol: 365 Takes*, sections 10 and 11.

112 "THE WHOLE SHOW JACKIE": Robert Rosenblum, "Saint Andrew," in Pratt, *Critical Response*, 8–11, first published in *Newsweek*, Dec. 7, 1964.

112 "LAUGHED AT HIM": Hickey, "Importance of Remembering Andy," 59.

112 "SPHINX WITH NO SECRET": Paul Alexander, *Death and Disaster: The Rise of the Warhol Empire and the Race for Andy's Millions* (New York: Villard, 1994), 14.

112 "PERSON I'D EVER SEEN": Bockris, *Warhol*, 91–92; Watson, *Factory Made*, 302–3.

113 "ONLY NOBODIES HERE": Henry Geldzahler and Robert Rosenblum, *Andy Warhol: Portraits of the Seventies and Eighties* (London: Thames & Hudson, 1993), 24.

113 "THROUGH THE CAMERA": Henry Geldzahler interview by Patrick S. Smith, Nov. 17, 1978, in Smith, *Warhol's Art and Films*, 305.

113 "HICK OR A FREAK": Wayne Koestenbaum, *Andy Warhol* (New York: Viking Penguin, 2001), 101–2.

114 "INTO HER BUTTOCK": Ratcliff, *Andy Warhol*, 46, 48; Warhol and Hackett, *POPism*, 76–77.

114 "MISFITTING TOGETHER": Warhol and Hackett, *POPism*, 219.

114 "IT'S JUST GLOOMY": Richard Polsky, *I Bought Andy Warhol* (New York: Bloomsbury, 2003), 27.

114 "WHOLE WORLD IS HERE": Grace Glueck, "Warhol's Pad Is Scene of Blast Launching New 'Pop Art' Book," *New York Times*, June 30, 1965.

114 "THUS BECOMES UNIVERSAL": Rublowsky and Heyman, *Pop Art*, 7.

114 "THEY INSPIRE REVERENCE": Samuel Adams Green, foreword to Rublowsky and Heyman, *Pop Art*.

115 "EXCITING THIS ALL IS": Bockris, *Warhol*, 233–34.

116 BRUSSELS AND STOCKHOLM: Frei and Prinz, *Warhol Catalogue Raisonné* 2B:209; Bockris, *Warhol*, 497.

116 "NEWFOUND INACCESSIBILITY": Bourdon, *Warhol*, 279–80; Elliott Willensky and Norval White, *AIA Guide to New York City*, 3rd ed. (San Diego: Harcourt Brace Jovanovich, 1988), 185.

116 "CEDAR BAR OF ITS ERA": Yvonne Sewall-Ruskin, *High on Rebellion: Inside the Underground at Max's Kansas City* (New York: Thunder's Mouth, 1998), 4.

117 "EXPLODING INSIDE ME": Warhol and Hackett, *POPism*, 272–73. Solanas also wounded the art critic Mario Amaya, who was waiting to see Warhol, and put the gun to Fred Hughes's head, but it jammed. Hearing the elevator arrive at their floor, Hughes then calmly suggested Solanas take it, which she did; Freddie Baer, "About Valerie Solanas," in Valerie Solanas, *SCUM Manifesto* (San Francisco: AK Press, 1996), 54–55.

117 "THE CAMERA WAS ON": Bourdon, *Warhol*, 286–87; Baer, "About Valerie Solanas," 55.

THE POP REVOLUTION

Chapter 5: Art for All

118 A DECADE LATER: William Lerner, ed., *Historical Statistics of the United States*, part 2 (Washington, DC: Bureau of the Census, 1976), 707.

119 EUROPE AND AMERICA: Joann Moser, "Collaboration in American Printmaking before 1960," in *Printmaking in America: Collaborative Prints and Presses, 1960–1990*, ed. Elaine M. Stainton (New York: Abrams, 1995), 17; Stuart D. Hobbs, *The End of the American Avant-Garde* (New York: New York University Press, 1997), 149.

119 WEST ISLIP, LONG ISLAND: Principal information for the following paragraphs comes from Esther Sparks, *Universal Limited Art Editions: A History and Catalogue; The First Twenty-Five Years* (New York: Abrams/Art Institute of Chicago, 1989), esp. 18–19, 25, 28; "Lithography Workshop Turns to Etching," *New York Times*, May 4, 1967; Amei Wallach, "Tatyana Grosman: A Memoir," in Sparks, *Universal Limited Art Editions*, 11, 13–14; Steven W. Naifeh, *Culture Making: Money Success and the New York Art World* (Princeton: Princeton University Press, 1976), 105–6; and Riva Castleman, *Technics and Creativity*, exh. cat. (New York: Museum of Modern Art, 1971), pass.

120 A FAMOUS CREATOR: June Wayne interview by Betty Hoag, June 14, 1965, Smithsonian Archives of American Art (hereafter AAA); author interview with Robert Fritsch, lithographer trained by the Tamarind alumnus Clifford Smith, Oct. 6 and 13, 2007.

121 OUTPUT SEEMED LIMITLESS: Michael Botwinick, introduction to Mark Rosenthal, *Artists at Gemini G.E.L.: Celebrating the 25th Year* (New York: Abrams, 1992), 10; Castleman, *Technics and Creativity*, 18, 15–16, 10–11.

122 "BE WIDELY IMITATED": Hilton Kramer, "Art: Over 53 Feet of Wall Decoration," *New York Times*, Jan. 23, 1968.

123 "AUDIENCE FOR THE GALLERY": Elizabeth C. Baker, "Leo Castelli, 1907–1999," *Art in America*, Nov. 1999, 33; Castleman, *Technics and Creativity*, 15–16, 21, 23; undated announcement and brochure, Leo Castelli Gallery Papers, Group III, Roll N68-57, AAA; Leo Castelli interviews by Paul Cummings, May 14, 1969–June 8, 1973, AAA; author interview with David Lasry, Nov. 7, 2007; author interview with Rosa Esman, April 10, 2007 (and for the following paragraph); http://rosaesman.com; Wendy Weitman, *Printmaking in the Pop Era: The Medium and the Message* (New York: Museum of Modern Art, 1999), 13, 101, 108–9.

123 "HARD TO RETRIEVE YOURSELF": Donald Kuspit, Carter Ratcliff, and Joan Simon, "New York Today: Some Artists Comment," *Art in America*, Sept. 1977, 83; display advertisement in *New York Times*, Feb. 15, 1969.

124 "MORE TO THE PILE": Sidney B. Felsen, Gemini G.E.L. executive, to Lichtenstein, Oct. 27, 1969, May 6 and Feb. 23, 1970, Jan. 18, 1971, and Apr. 29, 1974; Lichtenstein to Felsen, July 27, 1976, Lichtenstein Foundation Archive; author interview with Ivan Karp, New York, Feb. 1, 2007.

124 OF LURING CUSTOMERS: Robert J. Samuelson, *The Great Inflation and Its Aftermath* (New York: Random House, 2008), 47–49; Trudy V. Hansen, "Multiple Visions: Printers, Artists, Promoters, and Patrons," in Stainton, *Printmaking in America*, 52–53.

125 AND U.S. STEEL: Sparks, *Universal Limited Art Editions*, 43; Earl C. Gottschalk Jr., "What's That Thing Resembling a Giant, Salmon-Hued Icebag," *Wall Street Journal*, May 5, 1971.

125 "REACTIONARY AND ACADEMIC": Barbara Rose, "Claes Oldenburg's Soft Machines," *Artforum*, June 1967, reprinted in *Pop Art: A Critical History*, ed. Steven Henry Madoff (Berkeley: University of California Press, 1997), 230.

125 "THE COMEDIAN-VISIONARY": Harold Rosenberg, *The De-Definition of Art* (New York: Collier, 1973), 117–20.

125 PULL OF GRAVITY: Grace Glueck, "Soft Sculpture or Hard — They're Oldenburgers," *New York Times Magazine*, Sept. 21, 1969, 100; Donald Judd, "In the Galleries: Claes Oldenburg," *Arts*, Sept. 1964, 63; Max Kozloff, "'Pop' Culture, Metaphysical Disgust, and the New Vulgarians," *Art International*, Mar. 1962, 35–36.

126 "SECOND AMERICAN REVOLUTION": Glueck, "Soft Sculpture or Hard," 100.

126 "YET BE ONLY ITSELF": Claes Oldenburg interview by Bruce Hooten, Feb. 19, 1965, Barbara Rose Papers, Getty Research Institute, Los Angeles.

127 "PEOPLE TOUCHING THEM": Calvin Tomkins, *The Scene: Reports on Post-Modern Art* (New York: Viking Press, 1976), 18; Constance W. Glenn, *The Great American Pop Art Store: Multiples of the Sixties* (Santa Monica: Smart Art, 1997), 52, 64.

128 "NUMBERED EDITIONS": Grace Glueck, *New York Times* article from Nov. 1965, quoted in Glenn, *Great American Pop Art Store*, 46, see also 40; author interview with Rosa Esman; Castleman, *Technics and Creativity*, pass.

128 MORE THAN $1 MILLION: Calvin Tomkins, *Duchamp* (New York: Henry Holt, 1996), 427–28; http://www.artprice.com.

128 "PAY FOR ALL THAT": Grace Glueck, "Duchamp Opens Display Today of 'Not Seen and/or Has Seen,'" *New York Times*, Jan. 14, 1965; Alice Goldfarb Marquis, *Marcel Duchamp: The Bachelor Stripped Bare* (Boston: MFA Publications, 2002), 284–85; Hans Richter, *Dada: Art and Anti-Art* (New York: Thames & Hudson, 1997), 208.

128 "AND HE SHOULD NOT": Moira Roth and William Roth, "John Cage on Marcel Duchamp," *Art in America*, Nov. 1971, 76.

128 "LIKE THAT VERY MUCH": *Andy Warhol: 365 Takes. The Andy Warhol Museum Collection* (New York: Abrams/Andy Warhol Museum, 2004), sec. 271.

129 "OUT OF ART COLLECTING": Elizabeth Stevens, "The Great Graphics Boom of the 50s and 60s," *Wall Street Journal*, Jan. 5, 1971.

129 "PARTIES AND OPENINGS": Amy Newman, *Challenging Art: Artforum, 1962–1974* (New York: Soho, 2000), 85, 123, 210.

129 "MAGAZINE HAS IMPORTANCE": Leo Castelli interviews by Paul Cummings.

130 "MYSTERIOUS WORLD OF ART": Author interview with Milton Esterow, New York, Feb. 7, 2007.

130 "OF THE AVANT-GARDE": Peter Plagens, *Sunshine Muse: Art on the West Coast, 1945–1970* (1974; repr., Berkeley: University of California Press, 1999), 5, 158.

130 "CHANGED ENORMOUSLY": Leo Castelli interviews by Paul Cummings; Lerner, *Historical Statistics of the United States*, 708, 769, 770.

130 "AND DEAL IN ART": Grace Glueck, "Looking Up with the Arts," *New York Times*, Oct. 5, 1969; Grace Glueck, "4 Uptown Dealers Set Up in Soho," *New York Times*, Sept. 27, 1971.

131 "IMPOSSIBLE TO FIND [ONE]": Baker, "Leo Castelli," 31.

131 DOUBLED AND TRIPLED: Grace Glueck, "Neighborhoods: SoHo Is Artists' Last Resort," *New York Times*, May 11, 1970.

132 "KIND OF ATMOSPHERE": Leo Castelli interviews by Paul Cummings.

132 "OF A FRENCH EMBASSY": Tom Wolfe, "Bob and Spike," in *The Pump House Gang* (New York: Farrar, Straus and Giroux, 1968), 195–97.

132 "INVADE ILEANA'S TERRITORY": Leo Castelli interviews by Paul Cummings.

133 "THIS INSANE OVERLAPPING": Ibid.; Tom Wolfe, "Upward with the Arts — The Success Story of Robert and Ethel Scull," *New York*, Oct. 30, 1966, reprinted in Tom Wolfe's *The Purple Decades* (New York: Farrar, Straus and Giroux, 1982), 18.

Chapter 6: "The Molds Are Breaking"

134 THICK WITH MARIJUANA: Calvin Tomkins, "Moving with the Flow," in *The Scene: Reports on Post-Modern Art* (New York: Viking Press, 1976), 5; first published in *The New Yorker* in 1972.

134 "COURSE OF RECENT ART": Henry Geldzahler, catalogue essay for "New York Painting and Sculpture, 1940–1970," reprinted in *Making It New* (New York: Turtle Point Press, 1994), 106–7; Tomkins, "Moving with the Flow," 1–2.

135 "TASTEMAKER-BY-APPPOINTMENT": Grace Glueck, "Hanging Henry's Show," *New York Times*, Aug. 3, 1969; Henry Geldzahler, "The Sixties: As They Were," lecture delivered Sept. 22, 1991, at Guild Hall, Easthampton, NY, reprinted in *Making It New*, 341; Richard F. Shepard, "Metropolitan Plans Modern Art Show; Xerox Is Sponsor," *New York Times*, Oct. 18, 1968.

135 "MUSEUM'S ACHILLES HEEL": John Canaday, "To the Metropolitan Museum: Happy Birthday — Are You Relevant?" *New York Times*, Oct. 12, 1969.

135 "GELDZAHLER'S FANCY": Hilton Kramer, "Ascendancy of American Art," *New York Times*, Oct. 18, 1969.

135 "INTELLECTUAL PROFILE": Hilton Kramer, "A Modish Revision of History," *New York Times*, Oct. 19, 1969.

135 "HARD TO HATE HENRY": Grace Glueck, "Deflecting Henry's Show," *New York Times*, Oct. 19, 1969.

136 "POSTWAR AMERICAN ART": Calvin Tomkins, *Off the Wall: A Portrait of Robert Rauschenberg* (New York: Picador, 1980), 255.

136 "HISTORICAL FASCINATION": John Russell, "Art People: Back at the Met 10 Years Later," *New York Times*, Apr. 27, 1979.

136 "BE RELEVANT TO IT": Grace Glueck, "The Total Involvement of Thomas Hoving," *New York Times Magazine*, Dec. 8, 1968.

136 IVORY MASTERPIECE: John O'Connor, "Drawing a Fine Line at the Metropolitan," *New York Times*, Dec. 15, 1967; Elliott Willensky and Norval White, *The AIA Guide to*

New York City (San Diego: Harcourt Brace Jovanovich, 1988), 466–67; Thomas F. Hoving, *King of the Confessors* (New York: Simon & Schuster, 1981).

137 "DOOR MARKED DIRECTOR": Calvin Tomkins, *Merchants and Masterpieces: The Story of the Metropolitan Museum of Art* (New York: Dutton, 1970), 353.

138 "SILVER-PAINTED SNEAKERS": Tomkins, "Moving with the Flow," 6–7.

138 "A SHARED FORMULA": John Canaday, "Bravo, Well Done, Don't Care, No No, and Bless You All," *New York Times*, Jan. 23, 1972.

138 "SWINGING CURATOR": Harold Rosenberg, "Ecole de New York," in *The De-Definition of Art* (New York: Collier, 1972), 190; first published in *The New Yorker*.

139 "OF OUR ECONOMY": Henry Geldzahler, "James Rosenquist's *F-111*," *Bulletin of the Metropolitan Museum of Art*, Mar. 1968, 280–81; Irving Sandler, *American Art of the 1960s* (New York: Harper & Row, 1988), 176–78; Jeanne Siegel, *Artwords: Discourse on the 60s and 70s* (Ann Arbor: UMI Research, 1985), 208; Laura de Coppet and Alan Jones, *The Art Dealers* (New York: Clarkson & Potter, 1984), 104.

139 "BETWEEN LIFE AND DEATH": Robert C. Scull, "Re the *F-111*: A Collector's Notes," *Bulletin of the Metropolitan Museum of Art*, Mar. 1968, 282–83.

139 "IT IS THE TERROR": Sidney Tillim, "Rosenquist at the Met: Avant-Garde or Red Guard?" *Artforum*, Apr. 1968, 46–49.

140 "DIFFICULT TO STOMACH": John Canaday, "It Would Be Awfully Nice if We Were All Wrong about the Whole Thing," *New York Times*, Feb. 25, 1968; Sidra Stich, *Made in the USA: An Americanization in Modern Art* (Berkeley: University of California Press, 1987), 8–9.

140 "DEAD. FINISHED": Doon Arbus, "The Man in the Paper Suit," *New York*, Nov. 6, 1966, 7–9.

141 "PUBLIC RELATIONS TECHNIQUE": Harold Rosenberg, "The Cultural Situation Today," in *Discovering the Present: Three Decades in Art, Culture, and Politics* (Chicago: University of Chicago Press, 1973), ix–xi; first published in *Partisan Review*, Summer 1972.

142 AFFORD THE RENTS: Thomas Bender, *New York Intellect* (Baltimore: Johns Hopkins University Press, 1987), 317, see also 342–43; Alexander Bloom, *Prodigal Sons: The New York Intellectuals and Their World* (New York: Oxford University Press, 1986), 375–76.

142 "AND NO INHIBITIONS": "A Proposition," advertisement in *New York Times*, Sept. 30, 1987.

143 "WITH OUR FRIENDS": Lionel Trilling, *Beyond Culture: Essays on Literature and Learning* (New York: Viking Press, 1965), xiii–xiv, 7–8, 12.

144 "IT IS 'TOO MUCH'": Susan Sontag, "Notes on Camp," in *Against Interpretation* (New York: Farrar, Straus and Giroux, 1966), 275–79, 284; first published in *Partisan Review*, Fall 1964.

144 "GRAIN OF ONE'S SEX": Ibid., 279.

144 "THINKING ABOUT IT": Quoted in Margalit Fox, "Susan Sontag, Social Critic with Verve, Dies at 71," *New York Times*, Dec. 28, 2004.

144 "AMERICAN INTELLECTUAL LIFE": Eric Homberger, "Susan Sontag" (obituary), *Guardian*, Dec. 29, 2004.

THE POP REVOLUTION

146 "'HIGH' AND 'LOW' CULTURE": Susan Sontag, "One Culture and the New Sensibility," in *Against Interpretation*, 295–97, 304, first published in *Mademoiselle*; Fox, "Susan Sontag Dies at 71."

146 "CANCER OF HUMAN HISTORY": Fox, "Susan Sontag Dies at 71"; Homberger, "Susan Sontag." Sontag's essays, first published in nine different periodicals, were collected in *Against Interpretation*.

146 "FROM GRANDMOTHER'S PATCHES": Quoted in Fox, "Susan Sontag Dies at 71."

146 "VERSE OF GENESIS": Leslie Fiedler, "Cross the Border — Close That Gap: Post-Modernism," in *American Literature since 1900*, ed. Marcus Cunliffe (New York: Peter Bedrick, 1987), 329, 331, 344–45; Michael Greenberg, "Freelance," *Times Literary Supplement*, Jan. 16, 2009, 16.

147 "OF THE WESTERN WORLD": Lois and Alan Gordon, *Columbia Chronicles of American Life, 1910–1992* (New York: Columbia University Press, 1995), 549.

147 "A MINORITY CULTURE": Irving Howe, *Decline of the New* (New York: Harcourt, Brace and World, 1970), viii, 255, 264.

147 "SPAWN NEW ARTISTS": Geldzahler, catalogue essay for "New York Painting and Sculpture," 123.

147 "DEPRIVED OF CONFIDENCE": Brian O'Doherty, "What Is Post-modernism?" *Art in America*, May–June 1971, 19.

148 SUM OF $2 MILLION: Grace Glueck, "Mark Rothko, Artist: A Suicide Here at 66," *New York Times*, Feb. 26, 1970; Lee Seldes, *The Legacy of Mark Rothko* (New York: Holt, Rinehart & Winston, 1978), 5–6.

148 "OF MEN TO ANOTHER": Jane Kramer, "Profiles: The Man Who Is Happening Now," *New Yorker*, Nov. 26, 1966, 88; Willi Bongard, *Kunst und Kommerz: Zwischen Passion und Spekulation* (Oldenburg: Gerhard Stalling, 1967), 151–53; John Russell Taylor and Brian Brooke, *The Art Dealers* (New York: Scribner, 1969), 63–64.

149 MASS ACQUISITIONS FOLLOWED: Peter Joseph, *Good Times: An Oral History of America in the Nineteen Sixties* (New York: Charterhouse, 1973), 208; Robert Wraight, *The Art Game* (New York: Simon & Schuster, 1966), 63–65; author interview with Ivan Karp, New York, Feb. 21, 2006; Tom Wolfe, *The Purple Decades* (New York: Farrar, Straus and Giroux, 1982), 13–14, 18; Kramer, "Man Who Is Happening Now," 88.

149 "THIS SORT OF THING": "Museum Gives a Party for the Robert C. Sculls," *New York Times*, Apr. 11, 1969.

149 "NOT INVOLVED WITH HISTORY": Grace Glueck, "Top Art Auctions Boom, though Economy Sags," Apr. 16, 1971; Kramer, "Man Who Is Happening Now," 64; Grace Glueck, "Auction Where the Action Is," *New York Times*, Nov. 15, 1970.

150 LIKE MADAME RECAMIER": Enid Nemy, "Two Painful Years Later, a Hostess Returns to Her 'Real People,'" *New York Times*, Feb. 4, 1973.

151 "ABOUT THE MONEY": *America's Pop Collector: Robert C. Scull — Contemporary Art at Auction*, dir. E. J. Vaughn with John Schott (Cinema Five Productions, 1974); Tomkins, *Off the Wall*, 296; author interview with Ethel Scull, May 20, 1989; Baruch D. Kirschenbaum, "The Scull Auction and the Scull film," *Art Journal*, Fall 1979, 50–52.

152 "A PICNIC AL FRESCO": Charlotte Curtis, "Artist Redefines Black-Tie Dinner for a Princess," *New York Times*, Oct. 29, 1972.

152 "SUPERSTARS, AND MEDIA": Olav Velthuis, *Talking Prices: Symbolic Meanings of Prices on the Market for Contemporary Art* (Princeton: Princeton University Press, 2005), 142–44.

152 "AS A BUSINESS": Leo Castelli and Nina Sundell interviews with Andrew Decker, May 22 and Sept. 2, 1997, Smithsonian Archives of American Art.

153 "OF CONTEMPORARY ART": Bob Colacello, *Holy Terror: Andy Warhol Close Up* (New York: Harper Perennial, 1991), 169; Barbara Rose, "Profit without Honor," *New York*, Nov. 5, 1973, 80–81.

153 "PULLING THE STRINGS": Peter Schjeldahl, "A Dog Days' View of Last Season's Sensations," *New York Times*, Sept. 1, 1974.

153 "OF POP ART": Hilton Kramer, "Signs of a New Conservatism in Taste," *New York Times*, Mar. 30, 1975.

154 "TO LIVE ON": "At the Sculls, Bare Walls Do Not a Friendship Make," *People*, Nov. 3, 1975, 42.

154 "AT THE DISCOTHEQUE": Daniel Bell, *The Cultural Contradictions of Capitalism* (New York: Basic Books, 1976), 136, 143; Daniel Bell, *The End of Ideology: On the Exhaustion of Political Ideas in the Fifties* (Glencoe, IL: Free Press, 1960).

155 "OF THE WORK ITSELF": Donald Kuspit, Carter Ratcliff, and Joan Simon, "New York Today: Some Artists Comment," *Art in America*, Sept. 1977, 78–79, 82–83.

155 "BATHS OF THE MIND": Bell, *Cultural Contradictions*, 122–23, 73

155 "INDEFINABLE AGGLOMERATION": Harold Rosenberg, "The Mona Lisa without a Mustache," in *Art and Other Serious Matters* (Chicago: University of Chicago Press, 1985), 6–7; first published in *ARTnews*, May 1976.

155 "IT IS BETTER SO": Henry Geldzahler, commencement address at the School for Visual Arts, New York, June 5, 1976; reprinted in *Making It New*, 158.

Chapter 7: Death & Transfiguration

156 "SAYING THANK YOU": Andy Warhol and Pat Hackett, *POPism: The Warhol '60s* (New York: Harper & Row, 1980), 216–19.

157 AND BARBRA STREISAND: Author interview with Lewis Robinson, La Jolla, Mar. 10, 2008; "Lewis Robinson — Antique Dealer to the Stars," *Midtown Antiques Quarterly Newsletter*, Fall 1985, 2.

158 "LIKE BERNARDO BERTOLUCCI": David Bourdon, *Warhol* (New York: Abrams, 1989), 324–26; William C. Ketchum Jr., *Furniture 2: Neoclassic to the Present* (New York: Cooper-Hewitt Museum, 1981), 93–95; Vincent Fremont to the editor, Dec. 9, 2009.

158 NICKNAME "LE DAUPHIN": Paul Alexander, *Death and Disaster: The Rise of the Warhol Empire and the Race for Andy's Millions* (New York: Villard, 1994), 29–34; Lindsay Pollock, "Art Market Watch," http://www.artnet.com/Magazine/news/pollock/pollock10-15-01.asp; Frank DiGiacomo, "A Farewell to Dapper Fred Hughes: He Oversaw Andy's Factory Empire," *New York Observer*, Jan. 28, 2001, http://www.observer.com/node/43903.

THE POP REVOLUTION

159 "ON UNION SQUARE WEST": Stephen Koch, *Star-Gazer: Andy Warhol's World and His Films* (New York: Praeger, 1973), 3–4.

159 "FOUND HIM TITILLATING": Henry Geldzahler and Robert Rosenblum, *Andy Warhol: Portraits of the Seventies and Eighties* (London: Thames & Hudson, 1993), 24; Richard Polsky, *I Bought Andy Warhol* (New York: Bloomsbury, 2003), 28.

160 SOLD FOR $75,000: Bob Colacello, *Holy Terror: Andy Warhol Close Up* (New York: Harper Perennial, 1991), 63; Bourdon, *Warhol*, 306–7, 310; Barbara Rose, "In Andy Warhol's Aluminum Foil," *New York*, May 31, 1971, 54; John Canaday, "Huge Andy Warhol Restrospective at Whitney," *New York Times*, May 1, 1971.

160 "BUT IT'S THE FIRST": Colacello, *Holy Terror*, 170; Geldzahler and Rosenblum, *Andy Warhol: Portraits*, 24.

161 THROW ANYTHING AWAY: Bourdon, *Warhol*, 347.

161 "SOMEBODY'S WASP GRANNY": John Richardson, "Warhol at Home," in *Sacred Monsters, Sacred Masters* (London: Pimlico, 2002), 248–49; first published in *Vanity Fair*, July 1987.

162 BOOKS AND PAPERS: Author interviews with Vincent Fremont, New York, Feb. 13 and Apr. 3, 2007; Vincent Fremont, "Andy Warhol's Portraits," in Geldzahler and Rosenblum, *Andy Warhol: Portraits*, 29; Wayne Koestenbaum, *Andy Warhol* (New York: Viking Penguin, 2001), 163; Colacello, *Holy Terror*, 33, 240; Vincent Fremont to the editor, Dec. 7, 2009.

162 "START PAYING YOU": Pat Hackett interview by Glenn O'Brien, Arts Publications, http://findarticles.com/p/articles/mi_m1285/is_5_38/ai_n25470237.

162 "THAT CREEP ANDY WARHOL": Colacello, *Holy Terror*, 5, 33.

162 "I STAYED": Ibid., 373.

163 FACTORY ADDITIONS: Artnet, Nov. 19, 2008; Frayda Feldman, Jörg Schellman, and Claudia Defendi, *Andy Warhol Prints: A Catalogue Raisonné, 1962–1987*, rev. ed. (New York: Feldman Fine Arts/Andy Warhol Foundation, 1997), 85.

164 THE CULTURAL REVOLUTION: Feldman, Schellman, and Defendi, *Warhol Prints*, 66–75, 76, 85, 160, 278; see also Donna De Salvo, "God Is in the Details: The Prints of Andy Warhol," ibid., 25; Mark Stevens, "Andy's Hall of Fame," *Newsweek*, Dec. 3, 1979, 143.

164 "COMES AFTER ART": Andy Warhol, *The Philosophy of Andy Warhol (From A to B and Back Again)* (1975; repr., New York: Harvest Books, 1977), 92.

164 "OF AMERICAN CULTURE": Jeffrey Deitch, "The Warhol Product," *Art in America*, May 1980, 13.

164 "VERY WELL DESIGNED": Warhol, *Philosophy of Andy Warhol*, 137; Charles Stuckey, "Heaven and Hell Are Just One Breath Away," in *Andy Warhol: Late Paintings and Related Works* (New York: Rizzoli, 1992), 14; Feldman, Schellman, and Defendi, *Warhol Prints*, 122–23.

165 "AWAITING FUTURE DEVOTIONS": Bourdon, *Warhol*, 327.

166 "AND A CAMP": Quoted in *Andy Warhol: Camouflage*, exh. cat. (New York: Gagosian Gallery, 1981), 8.

166 "TO DOUBT THEMSELVES": Warhol and Hackett, *POPism*, 108. Warhol also used to say that he liked reading what reporters wrote about the Factory because "you could tell more about the reporters than the Factory from reading their stuff" (ibid., 130).

166 "VIEW OF THE WORLD": Quoted in Smith, *Warhol's Art and Films*, 108.

166 "GENIUS OF THE PEOPLE": Peter Schjeldahl, "Warhol and Class Content," *Art in America*, May 1980, 113–19.

166 FUTURE "VICTIMS": Victor Bockris, *The Life and Death of Andy Warhol* (New York: Bantam Books, 1989), 302.

166 "PRACTICALLY SINGLE-HANDEDLY": Robert Rosenblum, "Andy Warhol: Court Painter to the 1970s," in *Andy Warhol: Portraits of the 70s*, ed. David Whitney (New York: Random House, 1979), 9–10; Pat Hackett, ed., *The Andy Warhol Diaries* (New York: Warner Books, 1989), xv.

167 "SHEEN OF TOMORROW": Tom Armstrong, foreword to Whitney, *Andy Warhol*, 5.

167 "TO ART IS NIL": Hilton Kramer, "Whitney Shows Warhol Works," *New York Times*, Sept. 19, 1980.

167 "ART EXPERIENCE INDUSTRY": Deitch, "Warhol Product," 9; Polsky, *I Bought Andy Warhol*, 37.

167 EVERY SINGLE YEAR: Frayda Feldman, Jörg Schellman, and Claudia Defendi, *Andy Warhol Prints: A Catalogue Raisonné, 1962–1987*, 4th ed. (New York: Feldman Fine Arts, 2003), 94–95, 102, 122, 133; Victor Bockris, *Warhol: The Biography* (London: Muller, 1989), 399; author interview with Vincent Fremont, Feb. 13, 2007.

168 "GOING TO BE THERE": Alexander, *Death and Disaster*, 13.

168 "EARLY THE NEXT MORNING": Hackett, *Warhol Diaries*, xv–xvi.

168 "A DRAG QUEEN AGAIN": Ibid., xii.

169 "WE ENCOURAGE THAT": Benjamin Stein, "What Bianca Wore at Diana's Party," *Wall Street Journal*, Jan. 31, 1975; Hackett, *Warhol Diaries*, xii; Linda Francke, "The Warhol Tapes," *Newsweek*, Apr. 22, 1974, 73; author interview with Vincent Fremont, Feb. 13, 2007.

169 TWO DECADES LATER: Department of Commerce, Bureau of the Census, *Statistical Abstract of the United States*, annual reports, 1971–1992.

170 "SCULPTURE BEFORE HIM": Entry for David Hockney, *American Collectors (Fred and Marcia Weisman)*, 1968, http://www.artic.edu/aic/collections/artwork/102234.

171 THEIR PATRONS' COLLECTIONS: Michael Kimmelman, "Marcia Weisman, Collector, 73; Supporter of Major Art Museums" (obituary), *New York Times*, Oct. 22, 1991; Feldman, Schellman, and Defendi, *Warhol Prints*, 4th ed., 88.

171 HOSPITAL NEARBY: Colacello, *Holy Terror*, 18, 52; Alexander, *Death and Disaster*, 6.

171 "TENSE AND TAUT": Colacello, *Holy Terror*, 488–90.

172 WARHOL WAS DEAD: Ibid., 492; Alexander, *Death and Disaster*, 8–9.

172 DEAD AT 6:31: Author interview with Vincent Fremont, Feb. 13, 2007; Bourdon, *Warhol*, 409.

173 "THE SEDATE BEDROOM": Richardson, "Warhol at Home," 249–53; Holland Cotter, "A Shopaholic's Art Collection Gets an Update," *New York Times*, Apr. 17, 2009;

THE POP REVOLUTION

Alexander, *Death and Disaster*, 104; Richard Hellinger, "The Archives of the Andy Warhol Museum," in *The Andy Warhol Museum*, ed. Fania Weingartner (Pittsburgh: Andy Warhol Museum, 1994), 195.

174 LIKE A HYMNAL: Uncredited photo, in *Andy Warhol "Giant" Size*, ed. Steven Bluttal (New York: Phaidon Press, 2002), 606; Grace Glueck, "Warhol Is Remembered by 2,000 at St. Patrick's," *New York Times*, Apr. 2, 1987. See also Christophe von Hohenberg and Charlie Scheips, *Andy Warhol: The Day the Factory Died* (New York: Empire Editions, 2006).

175 "SOMETHING FABULOUS": Rita Reif, "Warhol Cookie Jars Sell for $247,830," *New York Times*, Apr. 25, 1988; Hellinger, "Archives of the Warhol Museum," 195; Rita Reif, "Record Price for Johns Work," *New York Times*, May 4, 1988; Rita Reif, "Warhol's World on View," *New York Times*, Apr. 15, 1988.

176 ABOUT $600 MILLION: Alexander, *Death and Disaster*, 104, 108–9, 124–25, 144–45, 179; Douglas McGill, "Marketing of Andy Warhol," *New York Times*, Dec. 10, 1987. By the terms of their original agreement, Hayes's fee as legal adviser would now have exceeded $12 million.

176 IN FEBRUARY 1989: John Russell, "The Season of Andy Warhol: The Artist as Persistent Presence," *New York Times*, Apr. 11, 1988.

176 "MAKES MUSEUMS NERVOUS": All quotes from Kynaston McShine, ed., *Andy Warhol: A Retrospective* (New York: Museum of Modern Art, 1989), 25–37, 402, 439, 455; Glenn Collins, "A Warholian Whirl of Friends and Memories," *New York Times*, Feb. 2, 1989.

177 "AND JACKSON POLLOCK": Richard Corliss, "Raggedy Andy Warhol," *Commonweal*, July 28, 1967, 470.

177 "OTHERS REDEFINIED THEMSELVES": Russell, "Season of Andy Warhol."

178 "OUT OF BUSINESS": Eric Hobsbawm, *Behind the Times: The Decline and Fall of the Twentieth-Century Avant-Gardes* (London: Thames & Hudson, 1999), 36.

178 "IT RUNS ME": Warhol, *Philosophy of Andy Warhol*, 92.

178 "SAME OLD SHY ACT": Hackett, *Warhol Diaries*, 6.

178 "SPACE OF AMERICAN CULTURE": Michael Brenson, "Looking Back at Warhol, Stars, Super-Heroes and All," *New York Times*, Feb. 3, 1989.

PICTURE CREDITS

BLACK-AND-WHITE IMAGES

pp. 19, 115: Photos by Fred W. McDarrah / Premium Archive / Getty Images. © Getty Images

p. 26: Sylvia Sleigh, *Lawrence Alloway* (1952). Oil on canvas, 29 x 20 in. (73.7 x 50.8 cm). © The Estate of Sylvia Sleigh

pp. 39, 74, 91, 94, 145: Photos by Bob Adelman. © Bob Adelman / Corbis

p. 49: Robert Indiana with *The Brooklyn Bridge* (1964). Photo by Fred W. McDarrah / Hulton Archive / Getty Images. © Getty Images. Art © 2012 Morgan Art Foundation / Artist Rights Society (ARS), New York, DACS, London

pp. 54: Ugo Mulas, Alan Solomon transporting art in a gondola, 1964; and pp. 56–57: Ugo Mulas, 32nd annual Venice Biennale awards ceremony, 1964. Images courtesy of the Alan R. Solomon papers, 1930–1972, Archives of American Art, Smithsonian Institution. Photos Ugo Mulas © Ugo Mulas Heirs. All rights reserved

p. 85: Roy Lichtenstein with *As I Opened Fire* (1964). Oil on canvas, 3 panels, each 68 x 56 in. (173 x 142 cm). Photo © Bettmann / Corbis. Art © Estate of Roy Lichtenstein / DACS 2012

p. 86: Ray Johnson, *Mondrian Comb* (1969). Collage on cardboard panel, 25 x 27¾ in. (63.5 x 70.5 cm). © Ray Johnson Estate, Courtesy Richard L. Feign & Co.

p. 108: Andy Warhol with *Brillo Boxes* (1964). Photo by Fred W. McDarrah / Premium Archive / Getty Images. © Getty Images. Art © The Andy Warhol Foundation for the Visual Arts, Inc. / Artist Rights Society (ARS), New York / DACS, London 2012

p. 122: Robert Rauschenberg with *Autobiography* (1967). Color offset lithograph mounted on muslin, 199⅜ x 49 in. (506.4 x 124.5 cm). Photo by Fred W. McDarrah / Hulton Archive / Getty Images. © Getty Images. Art © Estate of Robert Rauschenberg / DACS, London / VAGA, New York 2012

p. 126: Claes Oldenburg with *Ice Bag – Scale C* (1971). Fiber-reinforced polyester resin painted with lacquer; nylon cloth impregnated with neoprene, metal, motor, 140 x 160 x 160 in. (355.6 x 406.4 x 406.4 cm); diameter: 160 in. (406.4 cm); base, 6 elements, each: 24 x 38 x 43 in. (61 x 96.5 x 109 cm); 12 ft. diameter rising to 10 ft. Photo by Malcolm Lubliner © Malcolm Lubliner / Corbis. Art Copyright 1971 Claes Oldenburg

p. 138: Photo by Steve Schapiro. © Steve Schapiro / Corbis. Art © The Andy Warhol Foundation for the Visual Arts, Inc. / Artist Rights Society (ARS), New York / DACS, London 2012

pp. 150–51: Photos by Fred W. McDarrah / Hulton Archive / Getty Images. © Getty Images

THE POP REVOLUTION

COLOR INSERT

i: Jasper Johns, *Flag* (1954–55). Encaustic, oil, and collage on fabric mounted on plywood, 42¼ x 60½ in. (107 x 154 cm). Digital Image © The Museum of Modern Art / Licensed by Scala / Art Resource, NY. Art © Jasper Johns / VAGA, New York / DACS, London 2012.

 Larry Rivers, *Washington Crossing the Delaware* (1953). Oil on canvas, 83 x 111 in. (211 x 282 cm). Digital Image © The Museum of Modern Art / Licensed by Scala / Art Resource, NY. Art © Estate of Larry Rivers / DACS, London / VAGA, New York 2012

ii: Eduardo Paolozzi, *I Was a Rich Man's Plaything* (1947). Collage on paper, 14 x 9⅓ in. (35.5 x 23.5 cm). Image: Tate, London / Art Resource, NY. Art © 2010 Trustees of the Paolozzi Foundation, Licensed by DACS 2012

 Richard Hamilton, *Just What Is It that Makes Today's Homes So Different, So Appealing?* (1956). Collage, 10¼ x 9¾ in. (26 x 25 cm). Image: Kunsthalle Tübingen, Collection Zundel. Art © R. Hamilton. All rights reserved, DACS 2012

iii: Jasper Johns, *Target with Four Faces* (1955). Encaustic and collage on canvas with objects, 26 x 26 in. (66 x 66 cm), surmounted by four tinted plaster faces in wood box with hinged front. Digital Image © The Museum of Modern Art / Licensed by Scala / Art Resource, NY. Art © Jasper Johns / VAGA, New York / DACS, London 2012

 Robert Rauschenberg, *Bed* (1955). Combine painting: oil and pencil on pillow, quilt, and sheet on wood supports, 75¼ x 31½ x 6½ in. (191 x 80 x 42 cm). Digital Image © The Museum of Modern Art / Licensed by Scala / Art Resource, NY . Art © Estate of Robert Rauschenberg / DACS, London / VAGA, New York 2012

iv: Roy Lichtenstein, *Look Mickey* (1961). Oil on canvas, 48 x 69 in. (122 x 175 cm). Image © Board of Trustees, National Galley of Art, Washington. Characters © Disney Enterprises, Inc.

 Andy Warhol, *Popeye* (1961). Synthetic polymer paint on canvas, 68¼ x 58½ in. (173 x 150 cm). Image: The Andy Warhol Foundation, Inc. / Art Resource, NY. Art © The Andy Warhol Foundation for the Visual Arts, Inc. / Artist Rights Society (ARS), New York / DACS, London 2012

v: Roy Lichtenstein, *Whaam!* (1963). Oil and magna on canvas, 68 x 160 in. (173 x 406 cm). Image: Tate, London / Art Resource, NY. © Estate of Roy Lichtenstein / DACS 2012

Andy Warhol, *Red Disaster* (1963). Silkscreen ink on synthetic polymer paint on canvas. Two panels, each 93 x 80¼ in. (236 x 204 cm). Image: Museum of Fine Arts, Boston. Charles H. Bayley Picture and Painting Fund, 1986.161a–b. Art © The Andy Warhol Foundation for the Visual Arts, Inc. / Artist Rights Society (ARS), New York / DACS, London 2012

vi: Richard Hamilton, *My Marilyn* (1965). Screenprint on paper, 20¼ x 24½ in. (52 x 63 cm). Digital Image © The Museum of Modern Art / Licensed by Scala/ Art Resource, NY. Art © R. Hamilton. All rights reserved, DACS.

Andy Warhol, *Marilyn* (1967). Color photoscreenprint and color screenprint on paper, 36 x 36 in. (91.4 x 91.4 cm). Image: Museum of Fine Arts, Boston. Lee M. Friedman Fund, 1998.69. Art © The Andy Warhol Foundation for the Visual Arts, Inc. / Artist Rights Society (ARS), New York / DACS, London 2012

vii: Claes Oldenburg, *Soft Pay-Telephone* (1963). Vinyl filled with kapok, mounted on painted wood, 46½ x 19 x 9 in. (118.2 x 48.3 x 22.8 cm). Solomon R. Guggenheim Museum, New York. Gift, Ruth and Philip Zierler in memory of their dear departed son William S. Zierler, 80.2747. Photograph by David Heald © The Solomon R. Guggenheim Foundation, New York. Art Copyright 1963 Claes Oldenburg.

Claes Oldenburg, *Lipstick (Ascending) on Caterpillar Tracks* (1969). Cor-Ten steel, aluminum; coated with resin and painted with polyurethane enamel, 282 x 298½ x 131 in. (716 x 758 x 333 cm). Collection Yale University Art Gallery, Gift of Colossal Keepsake Corporation. Art Copyright 1969 Claes Oldenburg

viii: Robert Indiana, *American Dream* (1971). Screenprint, 30 x 35¾ in. (76 x 91 cm). Image: Museum of Fine Arts, Boston. Gift of Mary-Brenda and Jason M. Cortell, 2001.583. Art © 2012 Morgan Art Foundation / Artist Rights Society (ARS), New York, DACS, London

James Rosenquist, *F-111* (1964–65; installation view). Oil on canvas with aluminum, 120 x 1032 in. (518 x 1402 cm). Digital Image © The Museum of Modern Art / Licensed by Scala / Art Resource, NY. Art © James Rosenquist / DACS, London / VAGA, New York 2012.

INDEX

Index

THE POP REVOLUTION

Index

Rahv, Philip, 142
Randall, Richard, Jr., 137
Ratcliff, Carter, 98, 113
Rauschenberg, Robert, 14, 16–21; art critics, on, 18, 40, 42, 52, 57–58, 62–63, 145; as artistic influence, 53, 96, 179; artistic influences on, 17, 18, 51, 52, 53; art prices, 17, 119, 121–22, 151, 152; *Autobiography,* 121–22, *122; Bed,* 16–17, 58; *Broadcast,* 51; and Castelli, 16–17, 20, 54–56, 58, 87, 121, 122; Coenties Slip residence, 14, 19, 21; and collages, 16–17, 58; *Collage with Red,* 17; collectors, of, 16–17, 51, 132, 151; combines, 16–17, 51; described, 31, 52, 152; *Double Feature,* 151; exhibitions, 16–17, 41–42, 51, 52, 53–59, *56–57,* 75, 87, 96, 125; and family, 17, 18; found-object boxes, 18; international representation, of, 30; and Johns, *19,* 19–20; limited-edition art, 119, 121–22, *122;* military service, 17–18; NASA commission, 121; photographs of, *19, 56–57, 74, 122; Rebus,* 17; and Sculls, 151–52; *Sky Garden* and *Waves,* 121; at Tamarind Workshop, 120; *Thaw,* 151; *Trophy II,* 51; and Warhol, 96
Rebay, Hilla, 9
Rebus (Rauschenberg), 17
Reed, Lou, 174
Restany, Pierre, 43
Reynolds, Joshua, 18
Richardson, John, 172, 173, 174
Rivers, Larry, 102, 119, 152; *Washington Crossing the Delaware,* 102
Robertson, Nan, 65
Robinson, Lewis, 157
"Role of the Avant-Garde, The" (1962 symposium), 46
Romanticism, 84
Rorimer, James, 72, 136
Rose, Barbara, 63, 78; *American Art since 1900,* 52; on Oldenburg, 125, 126; on Pop Art collectors, 68–69, 85–86, 152; on Warhol, 96, 159–60
Rose Art Museum (Brandeis University), 105
Rosenberg, Harold, 10; "The American Art Establishment," 84–85; on art criticism, role of, 130, 140, 141, 155; on Geldzahler, 138; on McLuhan, 34; on Oldenburg, 125; as opponent of Pop Art, 61, 63, 79, 84–85
Rosenblum, Robert, 42, 82; and Castelli, 12–13; on "The New Realism" exhibition, 43; on Pop aesthetic, 62–63; and Selz, 88; on Warhol, 104, 111–12, 166, 176

Rosenquist, James, 38, 152, 179; art critics, on, 139–40; art prices, 70, 119, 139; and Castelli, *39,* 40; collectors of, 39, 70, 139; exhibitions, 52, 75; *F-111,* 138–40; *The Light That Won't Fail,* 38–39; limited edition art, 119; at "New Realists" exhibition, 43; and Sculls, 70, 72, 139; *Silver Skies,* 49, 70; studio, *39;* and Warhol, 106
Rothko, Mark, 71, 148
Rouault, Georges, 8, 118
Rousseau, Henri, 4, 93
Rubin, William, 68, 148
Rublowsky, John, 50, 103, 114
Ruhlmann, Emile-Jacques, 157, 175
Ruscha, Ed, 100
Russell, John, 125, 136, 177

Saint Phalle, Niki de, 41–42, 76
Schapira, Ileana. *See* Sonnabend, Ileana (née Schapira)
Schapira, Mihail, 5, 6, 8
Schapiro, Meyer, 14
Scheips, Charlie, 174
Schjeldahl, Peter, 15, 153, 166
School of Paris (art style), 37, 42, 53
Schwarz, Arturo, 128
Schwitters, Kurt, 53
Scull, Robert and Ethel, 28, 127; art auctions, 148–53, *150, 151,* 152, 160; art-collecting strategy, 70–73, 148–49; artists' works purchased by, 38–39, 49, 70–71, 107, 127, 138, 139, 148–49, 151; death of Robert, 173; described, 70–73; *Ethel Scull 36 Times* (Warhol), 153; on *F-111* (Rosenquist), 138, 139; magazine articles, on, 71, 73; marital breakup, 153–54; at MoMA symposium (1962), 75; party at the Factory (1964), 106–7; photograph of, *150;* and Rauschenberg's protest, at art auction, 151–52; salons, 72, 150
sculpture-assemblages, 11, 76, 119
sculptures, art: and art prices, 153
sculptures, box, 47; Johns, 13; Rauschenberg, 18; Warhol, 105–10, *108, 159
sculptures, limited-edition, 127–28
Secrest, Meryle, 12
Sedgwick, Edie, 115
Seedbed (Acconci), 155
Segal, George, 49, 73, 123, 150; *Artist's Model,* 66
Seitz, William, 46, 85
Seldes, Henry, 95
Seldis, Henry J., 78

THE POP REVOLUTION

ABOUT THE AUTHOR

Alice Goldfarb Marquis was born in Munich, Germany, and immigrated to New York in 1938. She attended Hunter College and earned a Master's degree in art history from San Diego State University and a PhD in modern European history from the University of California at San Diego. In addition to her work as a journalist, she spent twenty-five years as a visiting scholar and lecturer in the Department of History at UCSD. Her previous books for MFA Publications, both widely acclaimed, are *Marcel Duchamp: The Bachelor Stripped Bare* (2002) and *Art Czar: The Rise and Fall of Clement Greenberg* (2005). She is also the author of *Art Lessons: Learning from the Rise and Fall of Public Arts Funding*, which was chosen as the best nonfiction book of the year by the San Diego Book Awards (1995); *The Art Biz: The Covert World of Collectors, Dealers, Auction Houses, Museums, and Critics*; *Alfred H. Barr, Jr.: Missionary for the Modern*; *Hopes and Ashes: The Birth of Modern Times 1929–1939*, an Alternate Selection of the History Book Club; and numerous articles and reviews for *The Nation*, *The Journal of American History*, *American Historical Review*, *Biography*, *Chronicle of Higher Education*, *American Heritage*, and others. Ms. Marquis died in 2009, shortly after completing *The Pop Revolution*.